Approximate location
of the left leg of a
rainbow viewed from
the F train at Smith/
9st overpass, Brooklyn
October 24, 1999 3pm

COLOUR AFTER KLEIN

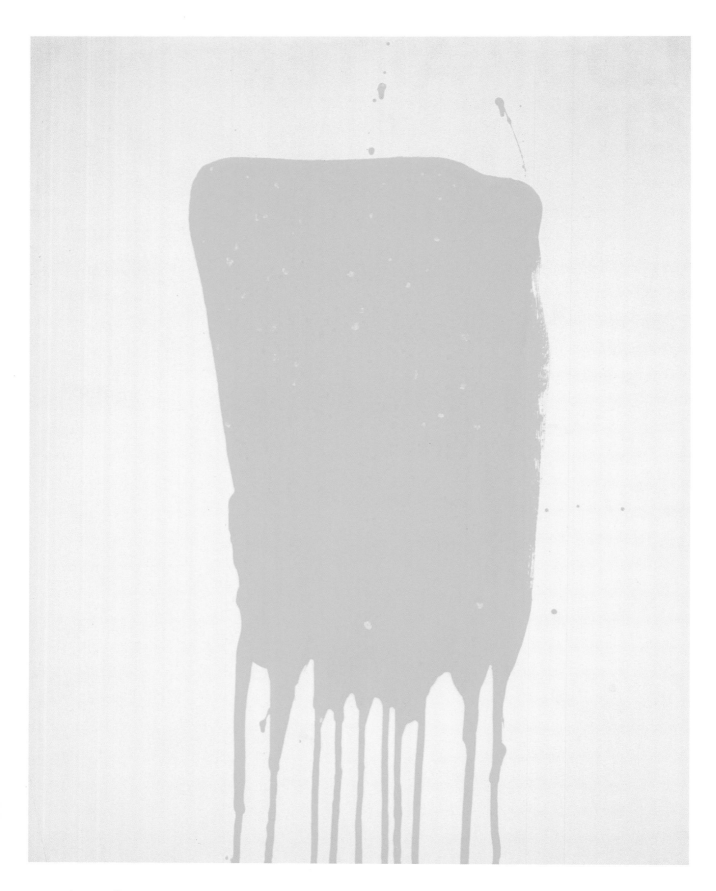

Yves Klein *Yellow Monochrome, Untitled (M 8)* 1957

COLOUR AFTER KLEIN RE-THINKING COLOUR IN MODERN AND CONTEMPORARY ART

EDITED AND INTRODUCED BY JANE ALISON

ESSAY BY NUIT BANAI

INTRODUCTORY ARTIST TEXTS BY
JANE ALISON, KATHLEEN MADDEN, ALONA PARDO

TEXTS BY
DONALD JUDD, YVES KLEIN, HÉLIO OITICICA

BARBICAN ART GALLERY
BLACK DOG PUBLISHING

CONTENTS

FOREWORD

We are delighted to present *Colour after Klein*, an exhibition featuring the most significant group of post war artists to ever be shown at the Barbican. The scope and importance of *Colour after Klein* means that this is the first exhibition to fill the entire Gallery since it was re-opened after a major refurbishment in April 2004. We are extremely grateful to all the artists and lenders for agreeing to contribute, and for making this accompanying publication possible. It is clear that the range of painting, installation, sculpture, video and photography—some works being shown here in Britain for the first time—will look spectacular within the 'new' Gallery space and that *Colour after Klein* will be a memorable and thought provoking experience.

Graham Sheffield
Artistic Director
Barbican Centre

PREFACE

A chromatic experience of beauty and a provocation of the sensory receptors of the viewer; *Colour after Klein*, the exhibition which this book accompanies, is first and foremost a celebration of colour, a phenomena of extraordinary potency.

Colour after Klein tracks how colour emerges in diverse and uniquely important works of art; a selection inspired by the iconic and plural nature of Yves Klein's oeuvre. Within a context that foregrounds colour, it is possible to see these works in a way that they haven't been principally considered before. Equally, juxtapositions occasioned by colour have allowed new correspondences or conversations between works to arise. In a sense, *Colour after Klein* sets out to confound expectations of what an exhibition about colour should be.

The significance of Klein to this project is addressed at length within the essays included here. Suffice to say that his choice as a starting point was made at first instinctively, and it was only as the project developed that I have come to fully realise what a timely and important decision that was.

My first debt of thanks is to the gallerist and curator Sean Kelly, as it was an exhibition he made, *Remarks on Colour* of 2002 after the Gary Hill work of the same title, which first inspired me to make an exhibition that centres on colour. After that I would like to thank the artists themselves and the estates of those no longer with us, for generously supporting and contributing to this project. I would like to especially thank Daniel Moquay of the Yves Klein Archive for agreeing to lend to the exhibition and to him and Philippe Siauve for their valuable assistance. There are also many gallerists and private collectors to whom I am further indebted for lending work, as without them the exhibition would not have been possible.

I have been admirably assisted by my colleague, Alona Pardo, Assistant Curator, who has enriched this project with her ideas and could at all times be relied upon to provide valuable feedback. She, along with Clementine Hampshire, Exhibition Assistant, have also been responsible for the bulk of the logistical work on the exhibition and the compilation of material for this book. I would also like to thank

ACKNOWLEDGEMENTS

Kathleen Madden for her research assistance, undertaken with great enthusiasm and thoroughness. She has also co-written, along with myself and Alona Pardo, the introductory artist texts herein. Nuit Banai's essay for the book pushes forward the thinking on Klein and I am extremely grateful to her for agreeing to participate in this project. She has been a delight to work with and her advice on Klein and in general has been extremely beneficial. I am also particularly grateful to Ingrid Pfeiffer, Curator at the Schirn Kunsthalle, Frankfurt for her advice that came at a time when it was much needed. Catherine Grant, Editor at Black Dog Publishing has been extremely professional, knowledgeable and calm under pressure and James Goggin has provided the inspired design for this book. Lastly, I would like to thank my family for their support and invaluable guidance as this project has progressed.

The making of the exhibition, some two years in the planning, has been a journey of discovery that is now about to be realised. I wait for that moment with eager anticipation and consider it a privilege to be able to present such a stunning array of important works by 20 of the most exciting artists to have emerged post 1955.

Jane Alison
Curator
Barbican Art Gallery

Marcia Acita
Asha Agnish
Nuit Banai
Carlos Basualdo
David Batchelor
Xavier Barral
Douglas Baxter
Alex Bradley
Chris Burnside
Daniel Congdon
Michael Corris
Anthony d'Offay
Anna Dezeuze
Michael Donlevy
Wendy Dunaway
Jacob Fishman
Oriana Fox
Mark Godfrey
Catherine Grant
Antonio Homem
Madeleine Hoffmann
Michael Hue-Williams
Chrissie Illes
Rainier Judd
Sean Kelly
Peggy LeBoeuf
Simon Lee
Kathleen Madden
Zoe Morley
Daniel Moquay
Juliet Myers
Sina Najafi
César Oiticica
Klaus Ottmann
Ingrid Pfeiffer
Cornelia Providoli
Farah Rahim Ismail
Howard Read
Michelle Reyes
Laura Ricketts
Magda Sawon

Philippe Siauve
Matt Schreiber
Owen Smith
Graham Southern
Stuart and Judy Spence
Niklas Svennung
Gordon Veneklasen
Angela Westwater
Wendy Williams
Queenie Wong
Dr Armin Zweite

Jane Alison

COLOUR ME IN

Colour will always be interpreted in a new way...
infinite change may be its constant nature.
—Donald Judd [1]

I want to think of colour. I look around me. This quality, this
phenomena, this substance—chroma—appears before me as
a fact, a reality of my perceptual existence; out there in the
world. Yves Klein, the French artist around whom this
exhibition pivots, insists that line can only suggest, whilst
colour "is"[2] and his American contemporary, Donald Judd,
writes that it is colour's existence which is the most important
thing about it.[3] This publication and the exhibition that it
accompanies celebrates that immanence, a quality of being.
But colour also has a psychic, interior dimension; I can
imagine it and dream it with lucidity, and in a lyrical passage,
characteristic of Klein's best writing, he describes the body's
ability to internally generate phosphenes, our very own light
show, as "a marvellous assemblage of linked lozenges,
flowing like water, soft as velvet, which becomes liquid and
pour out phosphorescent light like a flowering bush at night...
sumptuous like colour charged with thoughts of the garden,
without the appearance yet of mouldy matter."[4]

It is December as I write this and London is cloaked in a
shallow limp grey. The exhibition, Colour after Klein, already
named, exists in my mind and on paper only; imagining it
into existence, it hovers like a spectral mirage, something
akin to Newton's "coloured image of the sun", his prismatic
spectrum refracted onto the wall of his "very dark chamber"
one night in 1676. Newton's experiment, to my mind still
magical and improbable, appeared to deny the poetics or
mystery of colour as found in nature (the wonder of a rainbow
reduced to a scientific experiment), and yet, paradoxically,
his discovery heralded a shift of colour's function in art from
that of imitating nature to one aligned with the symbolic and
the subjective. Whilst Newton gleaned that colour was a
property of light, he also recognised that it could only be
perceived by our perceptual apparatus, the 'sensorium'.[5]

The subjective experience of colour and the limitations of
language render colour hermetic and elusive. The philosopher
Ludwig Wittgenstein feels bemused when trying to unravel the
complexities of colour; like "an ox in front of a newly painted
stall door".[6] His Remarks on Colour point to its indeterminate
nature, maintaining that nothing about it can be considered
stable or straightforward.

Imagine someone pointing to a place in the iris of
a Rembrandt eye and saying: 'The walls in my room
should be painted this colour.'
—Ludwig Wittgenstein [7]

The art historical axis of Colour after Klein charts the
monochrome paradigm at its most eloquent, colour
transferred from two-dimensional painting to the object, with
raw pigment taking on a new materiality and autonomous
presence; and colour as space and light and the virtual
expanses of film and video. Rather than charting one or
alternative colour theories or systems, Colour after Klein takes
pleasure in the space that colour opens up, the space
between the aesthetic and the conceptual, the material and
the immaterial, simplification and mystification, between
erasure and colouring in. Each work is chosen for the way
colour is uniquely probed; each work an individual act of
illumination. As the phenomenologist, Maurice Merleau-Ponty
pointed out, to perceive colour entirely I must "abandon
myself to it and plunge into this mystery, 'it thinks itself within
me'".[8] My body and the colour perceived are in a constant
imperceptible exchange: I am enfolded in colour.

The question of whether black and white can be truly
considered colours has perplexed thinkers for centuries. For
Newton they certainly were not, but for Goethe they
emphatically were. I take them to be true colours, believing
that for their wider cultural and psychological significance
alone it would be perverse to exclude them from a study of
chroma.[9] There is too, the insistence with which artists employ
black and white—as colours—often directly alluding to
darkness and light in so doing. Think for instance of the white
line of a Joseph Beuys drawing as he generates an idea on a
blackboard; or the art of James Lee Byars, whose palette
consisted exclusively of four colours; black, gold, white and

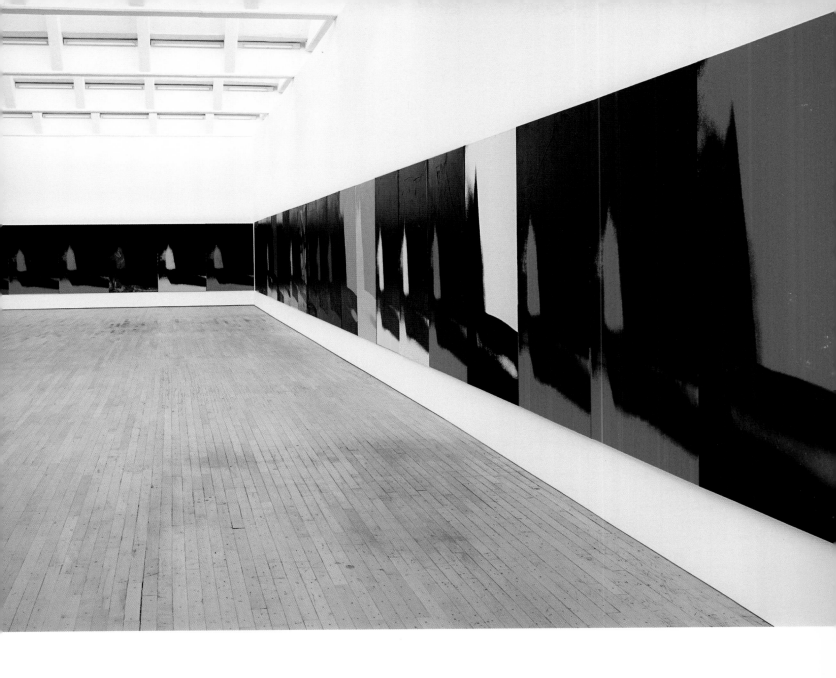

Andy Warhol *Shadows* 1978-1979

red; or Donald Judd who considers "black, grey and white to be colour, as Leonardo did".[10] It is black and white that gives potency, drama and significance to the chromatic spectrum that resides between.

Isn't white that which does away with darkness?
—Ludwig Wittgenstein[11]

If Wittgenstein charted colour at the furthest reaches of language ("Philosophy is a battle against the bewitchment of our intelligence by means of language") then psychoanalysis offers ways of thinking about colour as that which is before, and beyond language. Yves Klein proposed that colour is the path to freedom, a view echoed in the writings of the influential post-structuralist psychoanalyst and theorist, Julia Kristeva. In the opening words of Klein's *The Monochrome Adventure*, an anthology of texts conceived in 1958, the artist writes: "Through colour I experience a feeling of complete identification with space. I am totally free. If colour is no longer pure, the drama may take on disquieting overtones. For those who don't know what it is, total freedom is dangerous."[12] Whereas Kristeva, writing in Paris nearly 20 years later, concludes that "colour enjoys considerable freedom" in contrast to form, space, drawing and composition, which are all subject to the "strict codes of representation and verisimilitude".[13]

The "dangerous" freedom alluded to by Klein also parallels Kristeva's view that colour "is the shattering of unity". This psychological potency of colour is occasioned by the unconscious or 'instinctual drives' erupting into a culturally determined symbolic language, where its transgressions pose "a menace to the self".[14] However, due to the fact that colour is first experienced before the infant has a sense of itself as an individual separate from its mother and surroundings, colour is also, simultaneously experienced as a cradling of "the self's attempted reconstitution".[15] Kristeva's psychoanalytic insights unsettle conventional wisdom about colour, allowing for readings that acknowledge both the subjective and the poetic; a chromatic unconscious.

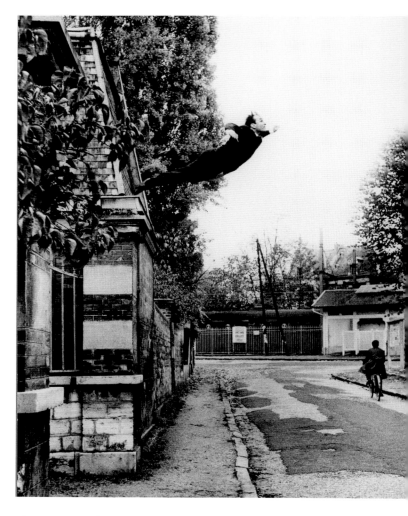

The painter of space launches himself into the Void
Dimanche, 27 November 1960[16]

Yves Klein *Leap into the Void* 1960

THE SPACE OF COLOUR

> Colour to continue had to occur in space.
> —Donald Judd[17]

> I loved that blank canvas thing…
> —Andy Warhol[18]

Within the particular post war context of emerging nationhood, Yves Klein clearly reinvents, along spectacular lines, a strategy of reduction originally pioneered by the Suprematists, Malevich and Rodchenko in the early years of the twentieth century.[19] But Klein also pushed painting to a place beyond painting, pursuing both a conceptual strategy of erasure and a genuine bid for transcendence; an art that attempted to be simultaneously radical and spiritual; an avant gardism of the numinous, a mystical efflorescence rooted in the body and the industrialisation of materials. His diverse practice, that encompassed painting, installation, performance, actions and phantasmagorical utopian visions for the future, is open to multiple interpretations that present an animated spectral field that in many other artists would be closed down. Within this selection of artists, the work of Joseph Beuys offers the most direct parallel; but Klein's intentions also resonate strongly with those of James Lee Byars and Anish Kapoor, who have each made work at the threshold of the material and immaterial, the conceptual and the aesthetic, raising further questions as to the place and significance of the modern and contemporary sublime.

"Come with me into the void!" intones Klein; and this portentous invitation continues to reverberate in the present, strung somewhere between a romantic desire to become immersed in the universal ether and Freud's death drive. The photographic record of Klein's launch into space, *Leap into the Void*, 1960, apparently suspended in mid-air over a Paris street has become one of the most talismanic images of the twentieth century. No matter that the bid for transcendence is bound to fail, because in the blink of the camera shutter, the artist is immortalised as though succeeding. Here, it is Bas Jan Ader that most closely resembles Klein the performance artist,

with his sober emotion and a conceptualism that is underpinned by a deeply romantic sensibility. In Ader's *Fall* films of 1970–1974, the artist documents himself falling from trees and houses—revisiting Klein's utopian launch, but investing it with pathos. In Ader's last work, entitled *In Search of the Miraculous*, 1975–1976, the artist attempted to sail across the Atlantic Ocean single handed and in doing so was lost at sea. Again, there is a powerful resonance with Klein, as Ader tests the capabilities of his body to the absolute limits and tragically illustrates the inescapable connection between the void and death. In *Primary Time*, 1974, Ader re-works Modernism's paradigm of chromatic reduction in a work that is both an homage and humorous critique.

In an earlier act of conceptual speculative bravado, Klein and his artist friends, Claude Pascal and Arman, famously carved up the world into zones of elemental property, with Klein choosing the sky, inscribing it with his signature while lying on the beach at Nice in 1948. Klein was to later declare that the sky was his "first and biggest monochrome".[20]

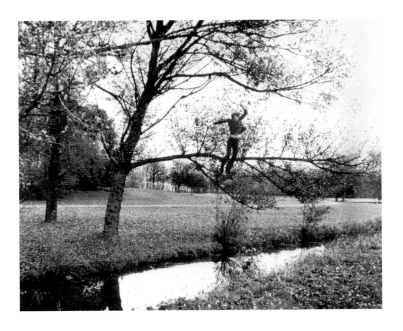

Bas Jan Ader *Broken Fall (Organic)* 1974

Andy Warhol embraced the monochrome with a similar passion. When asked his favourite colour, he answered, "silver... like the sky." Warhol, it turns out, liked to walk by the ocean to get away from it all: "it's sort of the biggest abstract thing around", he added.[21] Witness Klein and Warhol gazing heavenward, 'spaced out'; the sky, like the monochrome, limitless and unfathomable, a retreat from the chaos that is both culturally invasive and internally driven.

Warhol came to be an admirer of Klein's work, although he had far more significant influences closer to home; in terms of the monochrome, the painters Robert Rauschenberg and Ellsworth Kelly especially. However, like Klein, Warhol's principal subject was the void, with the monochrome and repetition his central means to articulate it. Warhol's void was more of an accurate reflection of the word, a gaping hole or wound, psychically experienced but also a direct manifestation of the void at the heart of the 'American Dream', rather than the kind of fullness in nothingness that Klein had in mind for his portals to the infinite.

> I never understood why when you died, you didn't just vanish and everything could just keep going the way it was, only you just wouldn't be there. I always thought I'd like my own tombstone to be blank. No epitaph, and no name. Well, actually. I'd like it to say 'Figment'.
> —Andy Warhol[22]

The meditation on the sky, the necessity of losing oneself in an expanse of colour and space, is a recurring theme within Modernism. Here we find it again in William Eggleston's *Wedgewood Blue* series of photographs from 1979, a stark contrast to the psychological intensity and claustrophobic quality of many of his interior images. The infinite space of cosmic plenitude is also handsomely framed in the *Skyscapes* of James Turrell; the recording of light in the atomic test ground at Los Alamos in the work of Spencer Finch; and in less obvious places too; the planetary orbit in which the menstruating Pipilotti Rist is set adrift in her video *Blutclip* (Bloodclip), 1993.

Just eight years before Warhol made his installation *Silver Clouds*, a work in which he filled a room with free floating cushion-shaped silver mylar balloons filled with helium and air, Klein created a work that would shock and astound the bourgeois Paris art scene; the installation that came to be known as *The Void*, held at Galerie Iris Clert in Paris between 28 April–5 May 1958. A bare room, devoid of content—apart from a few pieces of strange fitted furniture and the visitors and artist himself—is put forward as the object of contemplation in which the viewer is invited to experience "coloured matter that is intangible".[23] Klein grappling with his own idea and how to conceptualise it, suggested "it is no longer a question of seeing colour but of perceiving it".[24] Unadorned, this white-out was a psychic space of enclosure that provoked strong reactions in those that came to see it. Always on the edge and beckoning us to follow, Klein's work is enriched not only by the artist as performer, but by the way the body of the spectator is comprehensively implicated in the work.

William Eggleston *Wedgewood Blue* 1979

COLOUR AFTER KLEIN

The early monochrome panels or *Monochrome Propositions* as named by Klein's principal supporter, Pierre Restany, exhibited in 1956, introduce Klein's radical intentions. The paint is applied with a roller in a deliberately de-personalised method and is continued round the edges of wide stretchers, which endows them with the quality of objects; the colours are candy sweet, akin to the palette of Warhol working as an illustrator in the 1950s with the same joie de vivre. However, Klein quickly found these monochromes, with their polychrome effect when exhibited together, too decorative. In Klein's case, a single colour, blue, would more adequately achieve the transcendental resonance that his belief in the mystic doctrine of Rosicrucianism inspired. He rejected the diverse palette of the first monochromes in favour of the more symbolically loaded, blue, pink and gold— the colour of icons—with the emphasis being on his favoured deep ultramarine blue. In January 1957 Klein exhibited an entire room of blue canvases, identical in size at the Galleria Apollinaire in Milan and his so called Blue Period was announced.[25]

Klein's iconic status rests on his signature "International Klein Blue" (IKB), an artificial ultramarine pigment mixed with a binder, a 'polyvinyl acetate' formulated by Rhone-Poulenc Industries and distributed under the name, Rhodopas M: patent no. 63471, issued in 1960 by L'Institut National de la Propriété Industrielle;[26] the colour that for Klein signified "infinity and dematerialisation".[27] The special quality of the IKB mixture, instantly apparent when you stand in front of a work by Klein and largely lost in reproduction, is that somehow the chemical binder holds the pigment together without smothering or altering it. Coloured pigment literally takes on a life of its own. The Klein who aspires to become one with the universe through his work, at the same time points to the radical use of industrially produced materials in art, a characteristic of the work of his American contemporaries.

Colour would remain the springboard for the space without limit that Klein desired. The material quality of the early *Monochrome Propositions* and then the *Sponge Reliefs* begin to shift in favour of an increasingly uniform application of dazzling shallow all-over blueness. Klein's IKBs of 1961–1962 are as if processed through *The Void* space; vaporous, floating, timeless, they exhibit the space of colour.[28] It is no longer adequate to describe them as purely paintings, with their strange air of unreality and lack of any discernible facture; they appear theatrical, 'sci-fi' even. In Judd's seminal text, "Specific Objects" of 1964, in which he explores the need to go beyond painting and sculpture to the object, Judd singles out Klein's work for its "unspatial" qualities.[29] Significantly, Judd's exposure to Klein's work in New York in the early 1960s is thought to have inspired his own use of sand and wax in the breakthrough early works that announce his move from painting to "specific objects".[30]

The same year that Gerhard Richter began an inventory of his painting, 1963, he visited an exhibition of Klein's work at Galerie Iris Clert in Paris (Klein had died the previous year).

Donald Judd *Untitled* 1962

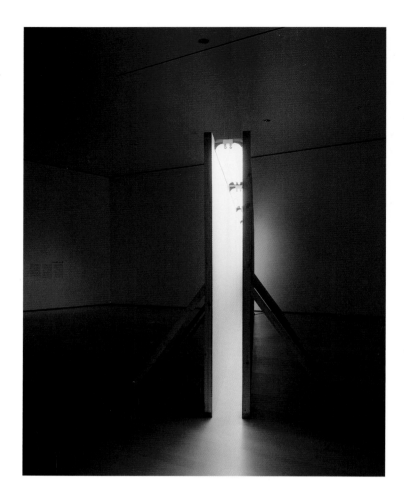

It is difficult to view the ongoing monochromatic strand within Richter's work and the choice of a signature colour, grey, as being unrelated to Klein's IKBs. Two years previously, in 1961, Joseph Beuys had become a Professor of Monumental Sculpture at the Düsseldorf Art Academy and Richter a student there. Beuys's predilection for the colours brown and grey appears therefore equally relevant in this context. Recalling Klein's uneasy space of contemplation that was *The Void*, in Richter's *Mirror Paintings* the spectator literally becomes the subject of the painting; occupying the space of colour, confronted only with themselves, an equally deliberate "provocation of the viewer".[31]

Neons have presented a lush chromatic medium for Bruce Nauman to equally provoke and harangue the viewer, as well as test his own attitudes. Like many of his contemporaries, especially on the West Coast of America, Nauman gave up painting as a discipline but since then has consistently found ways in which to integrate colour into his art—neons being just one of them—twinned with an equally compelling attention to the rhythms, capabilities, limits and ruptures of the body, both of which, separately and in tandem, have informed and expanded his practice.[32] Installations such as *Green Light Corridor*, 1970–1971, and *Yellow Room (Triangular)*, 1973, invite the spectator to experience disquieting physical and psychological sensations brought about by the strategic use of architectural space and acid colouration. These spatial experiments that utilise fluorescent light to achieve their alienating effect are not so dissimilar to Klein's *Void*, although Nauman's antagonism of the spectator was more direct. Where previously Nauman had put his own body under the duress of confinement and repetitive actions, he now invited the spectator, through his use of colour and manipulated space, to experience the same discomfort. Given the existential and conceptual concerns and anti-formalist aesthetic of Nauman, it is not surprising that he found in Europe, more so than in America, a widespread appreciation of his early work.

Turrell's light and colour installations similarly activate the senses, but here the artist's intention is to heighten levels of body awareness and transform consciousness to a plane of new experience and understandings. A successor to Klein's legacy of colour realised in space, Turrell's light installations take Klein's project to new levels of Zen purity. In *Shallow Space Construction* works such as *Prana*, 1991 and *St Elmo's Breath*, 1992, or indeed, *Rise*, 2002, Turrell builds on a fusion of Klein's IKB and *Void* projects and infuses them with coloured light. In Turrell's installations all blemishes and physical distractions are eliminated to create an exceptional space in which breath becomes sacred and the act of seeing a "revelation".[33]

Bruce Nauman *Green Light Corridor* 1970–1971

THE BODY OF COLOUR

> The quality that is intense is, however, extremely foreign. Klein's paintings have an unmitigated, pure but very sensuous quality.
> —Donald Judd[34]

> Bodies keep coming into this eternal landscape.
> —Anish Kapoor[35]

As if to demonstrate that being a colourist need not be about the utilisation of pure colours of the spectrum, Joseph Beuys's work is characterised by an acute sensitivity to the chromatic properties of materials. In a move that mirrors Klein's naming of International Klein Blue, Beuys too had his own signature colour, *Braunkreuz* (Brown-cross), a reddish brown made up variously of oil based house paint, rust proofing material and sometimes hare's blood. The blue of Klein and the brown of Beuys, both have a powerful material quality and yet function to simultaneously denote the transcendental. The interpretation of Beuys's insistent use of brown, and equally the grey of another signature material, felt, depends to what extent it is possible to enter into Beuys's world. In an infamous and much debated critique of Beuys, written in 1980, the art historian Benjamin Buchloh equated his use of brown with the scatological and hence 'infantile'; unwilling to see in it any redeeming qualities or further layers of meaning.[36]

A more sympathetic reading is that *Braunkreuz* is an expression of both that which Beuys aspired to and that which he wanted to exorcise. The Christian cross, The Red Cross and the 'Rosy Cross' of Mystic Rosicrucianism that Klein was devoted to are all referenced, whilst militaristic and Nazi symbolism is suggested too; the Iron Cross, the Swastika or Hooked Cross, Brown shirts and even *Gelbkreuz* (Mustard Gas). As Ann Temkin points out in her study of *Braunkreuz*, brown came to be *the* colour associated with the Nazis.[37]

The first use of *Braunkreuz* in the early 1960s is linked to that moment when Beuys came out of a long period of self-healing

that followed World War II. Significantly, he emerged onto the German art scene at the same time that Klein was showing in the city and his influence within the prominent Zero Group was both central and readily acknowledged as such.[38] The Zero Group had a chosen colour too—white—employed as a statement of eradication of all that had gone before; point zero. It is against this backdrop that Beuys's much more complex use of *Braunkreuz* should be viewed as all the more provocative and ultimately, poignant.[39] A work such as *For Brown Environment*, 1964—monochromatic, anti-illusionistic and envisioned as architectural space—can be seen as a direct equivalent of Klein's late expansive IKB monochromes. However, the German context meant that for Beuys, colour was one way of addressing the personal and collective trauma, loss and shame of the war and its horrors. It was impossible for Beuys to make a simple gesture toward the immaterial without first addressing the reality of the German situation.

Beuys clearly indicated his intentions concerning materials and colours regarded as 'ugly'. They should set off, he believed,

Joseph Beuys *Houses of the Shaman* 1965

a train of internalised perception of their complementary opposite; "a lucid world, a clear, lucid, perhaps transcendentally spiritual world". Beuys also described the process as a "suppression" by which bright colour is "thrown up by contrast and emphasised".[40] By the time these statements were made in the early 1970s, Beuys was also at pains to deny that there was any simple connection between his use of grey and concentration camps; "People are very short sighted when they argue that way" he commented, aware of the body of thinking that was gaining acceptance, namely that his subject would come to be seen as a systematic project of mourning for the Holocaust and a working through of his own traumatic war time experience.[41]

The Fascist regime that Beuys had grown up with and served under, had sought to purge society of all that was in their view considered unclean and impure, soiled. Beuys was compelled to reclaim "what had become untouchable".[42] With his all embracing belief in natural history and the healing forces of nature combined with a life long pursuit to wed culture and nature, it is entirely consistent that Beuys should seek to merge his own personal identity with a traditional feminine archetype: mother earth. In presenting all that had been impossible in recent German history, Beuys seeks to re-energise post war Germany and society at large along ethical lines.

Contemporaneously with Beuys's development of *Braunkreuz*, but on the other side of the world, Hélio Oiticica, a Brazilian artist, was developing radical ideas and practices unique to his cultural situation. Colour is the nucleus around which all Oiticica's work revolves, emerging from two-dimensionality to autonomous objecthood. As early as 1960 Oiticica was writing about the "body of colour" by which, as the art historian Guy Brett has pointed out, Oiticica referred to the total incorporation of the body in the work and the work in the body, a "two way link between the world of painting and the world of the spectator", a total incorporation of art into life.[43]

> The experience of colour, [the] specific element of painting, has become for me the very axis of what I do... it possesses its own essential development, since it is the very nucleus of painting, its reason for being. When, however, colour is no longer tied to the rectangle... it tends to 'incorporate' itself; it becomes temporal, creates its own structure, so the work then becomes the 'body of colour'.
> —Hélio Oiticica[44]

Oiticica's so-called *Bolides* are essentially containers—either boxes or bottles—that Oiticica also named *Trans-Objects* to denote their in-between status, situated at the critical transitional point in Oiticica's development, when colour is no longer painting but has not yet expanded to encompass the installation pieces that characterise his fully mature work.[45] Oiticica's intention in exploring pure pigment is to convey a positivity and life affirming poetic energy in the present, rather than a meditation on the immaterial as with Klein. The *Bolides* were originally designed to encourage participatory involvement in colour as material. For instance in *Basin Bolide 1* of 1966, Oiticica's intention was for the spectator to handle the brown earth that it contained and in doing so to activate all the senses. After the *Bolides* came further participatory manifestations; the *Parangolé*, a cape that could also function as a banner to be worn by a performer, and thereafter immersive environments that invited the full integration of life within art and within colour. For Oiticica, colour would come to have a socio-ethical as well as aesthetic dimension:

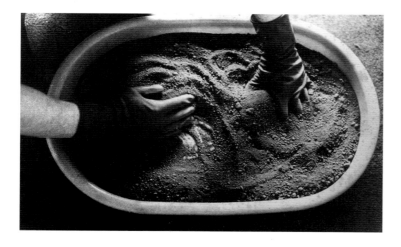

Hélio Oiticica *Basin Bolide 1* 1966

COLOUR AFTER KLEIN

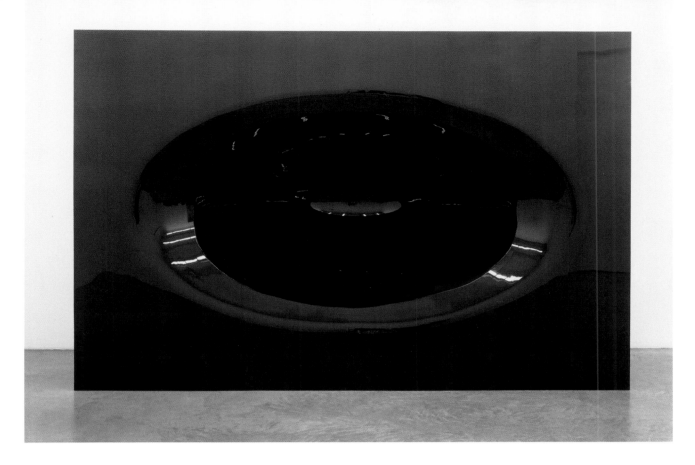

For me, in my development, the object was a passage to experiences increasingly engaged with the individual behaviour of each spectator: I must insist that the search, here, is not for a new conditioning of the participator, but an overturning of every conditioning in the quest for individual liberty, through increasingly open propositions, aimed at making each person find within themselves, through accessibility, through improvisation, their internal liberty, the path for a creative state— what Mário Pedrosa prophetically defined as the 'experimental exercise of liberty'.[46]

Whereas for Beuys this integration of colour in life was directed toward the healing of society, in Oiticica's work art and colour are ciphered through popular culture and music as a unifying, celebratory and provocative gesture.

Anish Kapoor's oeuvre also represents a sustained homage to chroma. When combined with simple archetypal forms, colour gives access to metaphysical and psychological impulses that are equally respected and nurtured by the artist. For Kapoor form alone is of little interest, what is significant are the reverberations created by the work in a given space. In the early 1980s Kapoor emerged onto the British art scene with work that was immediately recognised for its originality,

sensuality and lightness of touch. Pure pigment, memorably re-discovered on a trip to his birthplace, India, is applied to forms and allowed to spill around them in such a way as to accentuate their generative life affirming properties and complicate and enliven our experience of them. A key work from this period, *Part of the Red*, 1981, is one of the first pieces to introduce the colour blue into a field hitherto dominated by red. As with other early pieces such as *1000 Names* of 1979 – 1980, Kapoor explores the inner luminosity and expansive aura of the pigment, calling upon the universal idea of metaphysical light emanating from within. As such, they have an affinity with both Klein's IKBs and Oiticica's *Bolides*.

In more recent pieces, Kapoor's attention has turned toward the search for colour within darkness or as revealed out of blackness. His choice of form in which to embark upon this quest is most often a womb-like cavity or enfolding, a boundless return.

I seem to be moving from light to darkness. I think I know why that is. One of the things that has always had a very strong pull for me has been what I might call a matriarchal view of creativity, of energy. It seems to me that that is towards darkness, perhaps toward the womb... darkness is formless.
—Anish Kapoor[47]

Anish Kapoor *Untitled* 2001

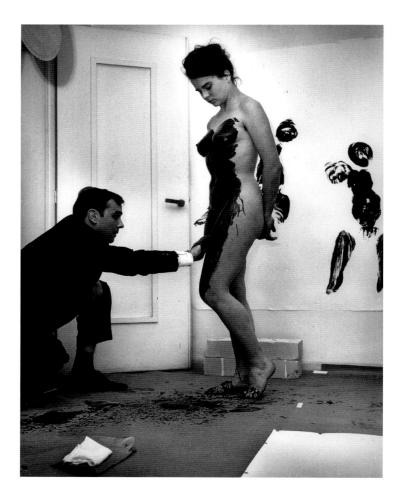

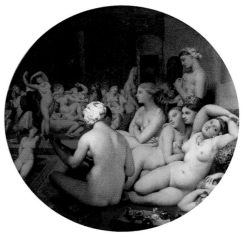

A pursuit of a transcendental sublime of other-worldliness has been replaced by a desire to experience the sublime that is within us.[48] There is an echo here of Beuys in his guise as Mother Earth, who said "Black—to me, that's the interior space."[49]

The saturated chromatic fields of Kapoor with their lips and crevices, mounds and poke holes, connect back to the sensual, if not erotic undercurrent that is a subtext to Klein's entire output. Photographic records of Klein's *Anthropometry* preparations and the performances are ample testament to that. If the body is implicated in terms of Klein directing women's bodies awash with paint; or, as enacting his own drama as a space cadet; or, as the spectator who is invited to participate in the work, it is also integral to the monochrome —whether Klein's IKB or Kapoor's differentiated fields of individual single colour objects seen together—as an abstract metaphor for the body.

Within a European context it is not difficult to find artists who have an affinity with Klein the poet-prankster, or Klein the

conceptualist, or a conflation of the two, but the gulf between Europe and America became apparent when Klein's first show in the United States at the Leo Castelli Gallery in 1961 met with little enthusiasm and no works were sold. By contrast, Judd's review of Klein's exhibition at the Alexander Iolas Gallery, New York, in 1962 is marked by an appreciation, albeit a grudging one. In a moment of inspiration, Judd compares Klein's monochromes to Ingres's painting *Le Bain Turc*, 1862, and in so doing aligns Klein with an artist that he would, had he still been alive, view as antithetical to his own approach; a draughtsman as opposed to a colourist. Judd elaborates by writing about the eroticism to be found in Klein's IKBs and describes his *Sponge Reliefs* as "voluptuous". The Ingres immediately calls to mind Klein's statement "Only the essential pure affective climate of the flesh is valid."[50]

In her analysis of the relationship between Judd and Klein, the art historian Briony Fer deduces that it is not just that Judd singled out the erotic in Klein long before anyone else, but that, in this review, he wrote about Klein in such a way as to suggest that he represents his own repressed sensuality.[51] *Untitled*, 1972, epitomises the sensualism that is suggested by Judd's response to Klein. The glowing red interior emanating from within the copper box transcends its geometry and minimal credentials to evoke the essence of what Judd described in Klein's work, the monochrome as an 'erotic object'. Another work of minimalism in which colour is closely aligned with the body is the diagonal fluorescent tube of Dan Flavin; the line of colour he described as a "diagonal of personal ecstasy".[52]

Bruce Nauman's four screen film installation, *Art Make-Up*, 1967–1968, gives literal expression to the idea of the body as a monochrome; the artist systematically covering the upper half of his body and face in body paint, first white, then pink,

Yves Klein applying blue paint to an Anthropometry model, Paris 1960

Jean-Auguste-Dominique Ingres *Le Bain Turc* 1862

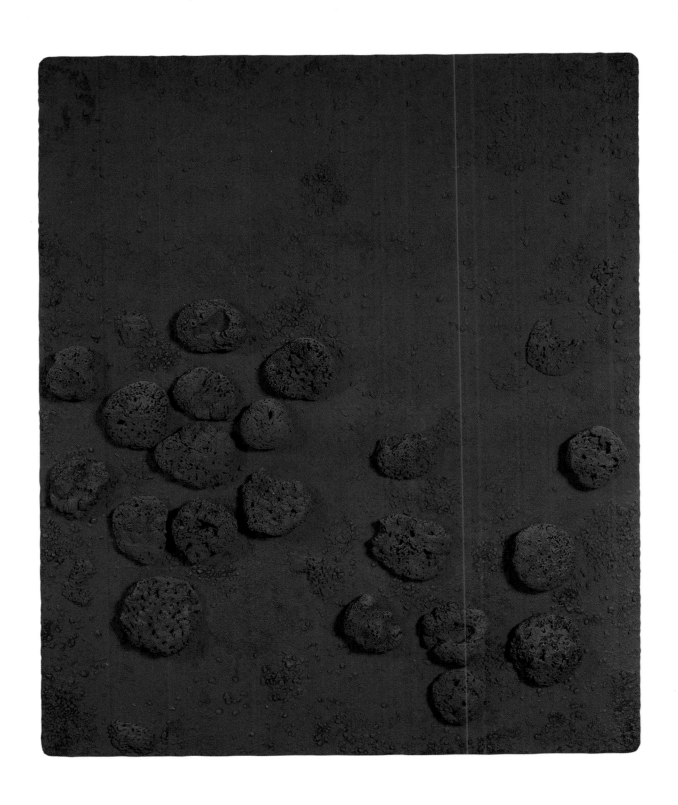

Yves Klein *Do-Do-Do (RE 16)* 1960

then green, then black. Although it defies any clear logic or meaning, the piece may be considered a study in self exposure and erasure through masking. Within this context there is a curious but nonetheless inescapable throwback to Klein self-consciously smearing the bodies of 'nubile' young women with paint, although the differences are more marked than the similarities. Nauman's work is decidedly unmoving and whereas Klein sought to produce a trace of the body on paper or canvas, in Nauman the simple act of applying paint to his own body and recording it constitutes the final art work. Nauman's facial mask more accurately recalls Beuys smeared in honey and gold leaf for the performance action *How to explain paintings to a dead hare*, 1965 and the work of James Lee Byars, who, inspired by Japanese Nō Theatre, would often wear a full or half mask. Walker Art Center Director, Kathy Halbreich has concluded that in Nauman's work "linguistic and facial masks are employed continuously" as the artist courts a "nameless anonymity and an infinitely flexible identity". She concludes, "While these disguises deliberately conceal, they also reveal an unambiguous distrust in the ability to locate finally either oneself or another."[53] It is tempting to think of this masking of the self as a reflection, a desire to be absorbed by colour, to dematerialise within it.

THE CHROMATIC UNCONSCIOUS

Colour is stronger than language. It's a subliminal communication.
—Louise Bourgeois[54]

Who can feel as intensely as a child the impact of the colour red? One child in his passion, in his lust for life, will spread great layers of red across the page, it delights him beyond words, it excites him. Red is trumps. He will never relinquish it, like nothing else it is a means of life and violence.
—Henri Michaux[55]

Louise Bourgeois's attention to colour is profound, and only minimally addressed in criticism and historical texts on her work. Her paintings, sculptures and drawings reflect a distinct and selective palette; but whereas Klein's use of blue, gold and pink is ostensibly outward looking, celestial and driven by transcendental aspirations, Bourgeois has assigned personal meaning to colour as part of an elaborate symbolic and personally resonant vocabulary. In 1992 she described her colours as follows:

Blue represents peace, meditation, and escape. Red is an affirmation at any cost—regardless of the dangers in fighting—of contradiction, of aggression. It's symbolic of the intensity of the emotions involved. Black is mourning, regrets, guilt, retreat. White means go back to square one. It's a renewal, the possibility of starting again, completely fresh. Pink is feminine. It represents a liking and acceptance of the self.[56]

There is also, however, a suggestion of colour plumbing deeper layers of experience and feeling in the way Kristeva has suggested, a quality in the intensity and obsessional nature of chromatic usage that is difficult to pin down. Colour is both painted on and intrinsic to the material, either to be fashioned by the artist or used as readymade. Bourgeois's *The Red Room (Child)*, 1994,

In *The Red Room (Child)* Bourgeois addresses childhood trauma, a theme that recurs throughout her work and is often realised in monstrous, abject terms. This trauma has to be addressed daily, an apparent necessity if Bourgeois is to restore the house which is the body; the "femme-maison". The restoration to psychic wholeness mirrors the mending of the tapestries that enveloped her childhood hideaways. In a *Cell* such as *The Red Room (Child)* the visitor becomes a voyeur, unable to enter fully, but nonetheless allowed to peek through the doors that enclose the interior. Due to the strategic placement of a mirror, the onlooker finds themselves enfolded in colour.

The ultimate survivor as she herself has concluded, Bourgeois has maintained a singular vision and exceptional commitment to the realisation of sculptural form.[59] Art historian Rosalind Krauss has pinpointed the importance of the 'part-object' within Bourgeois's work; by this she refers to the artist's apparent fixation with urgent internal demands which are sublimated and expressed through the various parts of the body and are experienced as separate from oneself. Equally, Krauss draws on Bataille's notion of the 'informe' in which all oppositions are collapsed, to assist her understanding of Bourgeois's contribution to sculptural form in the twentieth century.[60] "Materials, space and colour", the essential ingredients of art practice that Donald Judd so famously articulated, are manipulated in her work to very different ends— in such a way as to communicate psychological and as Robert Storr has suggested, even 'primordial' feelings of remarkable intensity.[61]

Probing the crosscurrents of technology and the unconscious, Pipilotti Rist's videos have a distinct affinity to Bourgeois's intensely visceral articulations. Both artists embrace the hysterical, often focus on genitalia and give an account of female desire in a way that is both playful and transgressive.

> **Our eyes are blood operated cameras.**
> **Colour mars, do you understand the scars?**
> —Pipilotti Rist[62]

along with its partner work, *The Red Room (Parent)* of the same year, although punctuated by some blue, marks the climactic moment in Bourgeois's use of red.

A cell for the storage of memories, *The Red Room (Child)* is like the make-shift camp of a child, built from bits of scraps collected and full of peculiar treasures, or, perhaps an attic or workshop stuffed with a combination of surreal and everyday items that have been discarded and forgotten. Picasso said that "Painting is stronger than I am. It makes me do what it wants" and there is this sense that Bourgeois is similarly driven by her own practice and materials.[57] Although very different kinds of artists, their work has a compulsive quality that is also suggested by Paul Klee when he says "Colour possesses me. I don't have to pursue it."[58] Where and when language falters, colour takes over.

Louise Bourgeois *The Red Room (Child)* 1994

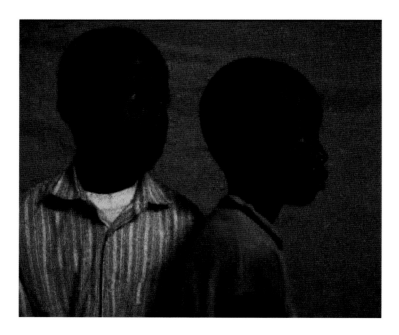

and intrinsically poetic turn. The black skin of the boys melts, chiaroscuro-like, into the space that they inhabit, a windowless space lit only by a fluorescent tube, reminiscent of Flavin's single diagonal, but here attracting moths that are drawn to it. Sound takes on a haunting rhythmic beauty and the eyes of the boys pierce the darkness to speak silently of a life in the process of becoming. The work ultimately succeeds by effecting a distinct change of consciousness in the spectator.

Bourgeois has described her work as "fantastic reality" and this could just as well apply to Rist whose presence, whether psychic or actual, is equally embedded in the work.[63] The three single channel videos *I'm Not The Girl Who Misses Much*, 1986, *(Entlastungen) Pipilotti's Fehler* ((Absolutions) Pipilotti's Mistakes), 1988 and *Blutclip* (Bloodclip), 1993, exemplify Rist's skill as a techno-colourist. Witness Rist's frantic flappings as she squeals "I'm not a girl who misses much" before dissolving into a spectral haze of shimmering red and blue.

In stark contrast to the colour that intoxicates in Rist's work, Anri Sala has a particular predilection for making films and videos that occur in indeterminate places of semi-darkness. Whereas Rist's work presents a delirium of colour, Sala's is a meditation on what it is we see and how we see it. Both artists delight in the relationship between sound and image. A recent work of Sala's, *Làkkat*, 2004, suggests a place of enclosure that resonates strangely with Bourgeois's *Cells*, but also with the womb-like cavities to be found in the work of Kapoor. In the film, three young Senegalese boys are instructed to recite different words in ancient Wolof that describe a rich strata of naming between black and white, the origins of which Sala speculates result from earlier colonial rule.[64] His stated aim for the piece is to explore the limitations and slippage of language in different cultural contexts around race. Wherever the work is exhibited, translations have to be made and words must be found where there were none before. Whilst the work is successful in these terms alone, illustrating a knotted conceptual proposition that might have been inspired by Wittgenstein, there is another way of understanding it entirely, one that is driven by Sala's aesthetic

Like Sala, Spencer Finch eschews the grand gesture in favour of quieter, lyrical work that is equally informed by conceptualism. Assuming the role of amateur scientist and romantic artist combined, Finch journeys to places both near and far—internal and external—in a desire to represent the specific experience of light and colour he finds in places that are culturally resonant or personally significant. In a work that combines both clarity and playfulness, Finch documents in black and white photographs the ends of the rainbow in Brooklyn, New York. In another, the ceiling over Freud's couch at 19 Berggasse, Vienna, Austria, is painstakingly copied and recreated in the form of Ruskin's ellipses. Here, a representational monochrome, suggestive of the psychoanalytic projections that were once floating there, invites us to do the same.

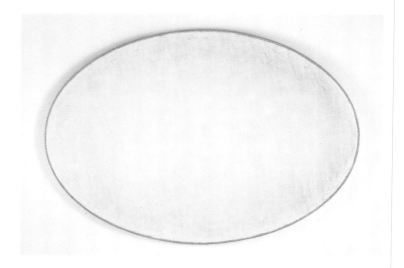

Anri Sala *Làkkat* 2004

Spencer Finch *Ceiling (above Freud's couch, 19 Berggasse, 2/18/94—morning effect)* 1995

COLOUR AFTER KLEIN

In a moment of psychic and chromatic intensity comparable with Bourgeois, red erupts once more in the work of William Eggleston. His *Greenwood, Mississippi, 1973*—a blood red ceiling with electric light and cables radiating out from its centre—has become the most iconic colour photograph of the twentieth century. Although Eggleston started using colour film in the mid 1960s, *The Red Ceiling*, as it has come to be known, is one of the first the artist printed using the dye transfer technique. Eggleston described his first experience of the colour effects achieved in dye-transfers for the advertising industry as "overwhelming", whereupon he immediately embarked on his own prints with staggering results.[65] The dyes were so colour saturated as to give the images an air of unreality, a quality manifestly apparent in *The Red Ceiling*.

> I've never seen it reproduced on the page to my satisfaction. When you look at a dye-transfer print it's like it's red blood that is wet on the wall. The photograph was like a Bach exercise for me because I knew that red was the most difficult colour to work with. A little red is usually enough, but to work with an entire red surface was a challenge.... The photograph is still powerful. It shocks you every time.[66]

Like *The Red Ceiling*, many of William Eggleston's photographs from the 1970s present us with sumptuous chromatic images and awkward angles—taken from the ground or from the camera held high in the air—claustrophobic and disquieting interior scenes, that have the quality of a dream or, perhaps more accurately, a nightmare revealing itself. Eggleston took colour photography out of the commercial arena and turned it into an art.

DEATH IN COLOUR

> You may not want to be here...
> *Study for Poem Piece*, Bruce Nauman, 1968[67]

> It is said art is a matter of life and death, this may be melodramatic, but it is also true.
> —Bruce Nauman[68]

> I realised that everything I was doing must have been Death.
> —Andy Warhol[69]

Andy Warhol's palette in the 1960s changes little from the candy hues of his 1950s illustrational work, although his themes become manifestly darker and more complex. I imagine that somehow his colours must have changed, become more sullied, less intense, but on closer inspection it becomes clear that it is largely Warhol's subjects that influences how we remember the colour in the work. His aesthetic of beauty has quite often been discounted at the expense of foregrounding his radical critique of commodity culture, as though in the 1960s and beyond, colour and beauty didn't matter to him. In fact, as Trevor Fairbrother has pointed out, Warhol's concern was to make everything he did "pretty".[70] It is in the border areas of the colour field expanse or, sometimes critically, in the second purely monochrome panel of his diptychs that Warhol's vibrant colouration is most apparent, whereas the black ink of the silkscreen overlay in the representational image subdues the radiance of the colour washes underneath.

In the early 1960s Warhol embarked on a body of work that became known as his *Death in America* series, a title he himself toyed with for his first Paris show in 1963.[71] The series brought together some very bleak themes: car crashes, suicides, race riots and celebrity deaths; the beauty and optimism of the 1950s illustrations replaced with trauma and loss; cats in purple are replaced by *Lavender Suicide*. The art historian Thomas Crow has forcefully argued that in these pictures of death and disaster, Warhol exhibits a "clear authorial voice" to articulate what amounts to a thoughtful

humanist critique of American society that reflects genuine feelings of anger and compassion. Crow views the *Death in America* pictures as "a stark disabused pessimistic, vision of American life... a pulp derived, bleakly monochrome vision that held, however tenuous the grip, to an all but buried tradition of truth telling in American commercial culture."[72]

In Warhol's *Car Crashes* his apparent intention is to pinpoint the violent death of the nameless American citizen, who in enjoying that most cherished object of desire and freedom, the car, had become its victim. Warhol collected pictures of these events, clearly seeking out those that were the most shocking. In typical examples of this work, *5 Deaths on Turquoise, 5 Deaths on Yellow* and *5 Deaths on Orange*, all of 1963, or the diptych *Orange Car Crash*, 1963, Warhol aligns colour and subject matter in a manner that is marked by a tension or duality between colour and violent death, that is both compelling and deeply unsettling. The flat expanse of colour that provides the backdrop to the *5 Deaths* series is suggestive of the flawless, seductive surface of the once pristine car. These disturbing images do more than point to the ubiquity of media ciphered death, they also represent a comprehensive crisis of disintegration that is simultaneously restored within the unified field of colour.

One of Warhol's most important, if not the most important, contribution to the exploration of colour is his exhaustive series of *Shadow* paintings from 1978. Comprising 102 canvases in total, each one painted with a single colour—red, silver, blue, pink, white, green and black over which is silkscreened one of two shadow variants. Of these Warhol wrote: "They are all sort of the same except for the colours... Someone asked me if they were art and I said no. You see, the opening party had a disco. I guess that makes them disco décor."[73]

Whilst Warhol ostensibly celebrates their lowly status as decorative backdrop, it is clear that these works, with their play of black shadow superimposed over varying monochromatic colours, simultaneously represent a monumental meditation on the life-death duality that permeates Warhol's work after 1960. Colour was Warhol's liberation, a cradling in the shadow of violence and death.

There is a parallel between Bruce Nauman's project of articulating social injustice and Warhol's depiction of the void at the heart of the 'American Dream'. Equally, an existential concentration on death is as relevant to Nauman as it is to Warhol. Nauman has famously said that he likes work to function like a "hit in the back of the neck" and this commitment to an art that jolts and shocks results from a deep belief in the moral responsibility of the artist.[74] His 1985 neon *White Anger, Red Danger, Yellow Peril, Black Death* is driven by an anger and frustration that motivate much of his work.[75] Its success centres on the word play that links colour with global, but perhaps more specifically American, attitudes of racial intolerance and fear. In the present context, given the racial paranoia that underpins the policies of the George Bush administration and the extent of the Aids crisis in Africa particularly, this work can be viewed as prescient of this escalating crisis, an untreatable canker. Adopting the colouration and methodology of commercial signs, the visual pleasure resulting from the play of colour in the neon is destabilised by its uncomfortable meaning.

If death permeates these works by Warhol and Nauman, it is also the case that the void presented by Richter's grey monochromes, painted since the late 1960s, is ultimately as the artist has said a representation of the "unthinkable", or the "ineluctable void", or "a lack of differentiation, nothing, nil, the beginning and the end": death.[76]

Grey, the 'in-between' of black and white, a colour without luminosity, a colour referred to by Marcel Duchamp who insisted that what counted was the "grey matter" (i.e. the intellect) at the expense of retinal gratification. In formal terms the use of grey allows the artist to concentrate on the most subtle nuances of surface treatment, but the works cannot help but resonate culturally and despite their apparent eschewing of aestheticism remain visually alluring. At the outset Richter's intention in choosing grey was that it was the colour nearest to a non-colour that he could find; a colour without illusion that turned out to be the most illusionistic of all.[77]

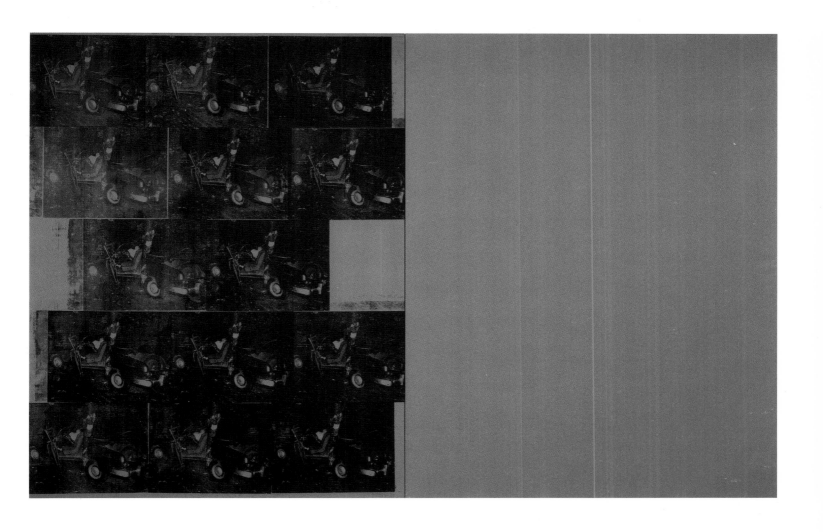

Andy Warhol *Orange Car Crash Fourteen Times* 1963

When pressed further by Robert Storr on the question of reduction and erasure at the time of his Museum of Modern Art retrospective in 2002, Richter is clear in his acceptance of the idea that this tendency within Modernism signifies all three objectives within the practice of making, suggested by the curator: "destruction", "loss" and "essence".[78] Richter's grey monochromes present us, like Warhol's *Skulls* and *Shadows*, but using even sparer means, with a picture of our own mortality.

In a well known interview with Benjamin Buchloh, Richter and he fail to agree on the meaning of his work. The art historian and theorist wants to view his work as an ironic critique of the failure of painting to convey anything other than what it manifestly is, but Richter, having none of it, insists that his work involves a search for some kind of truth, "for lost qualities, for a better world, for the opposite of misery and hopelessness".[79] There are many points of connection between Richter and Warhol, the principal one being that, as the philosopher Arthur C Danto has said, each conveys to us the reality of their time, a reality marked in different ways by violence, conflict and trauma.[80] It is not surprising that Richter therefore clings to his belief in art to be more than just an illustration of theory, just as a critique of Warhol that misses the existential and human is the less for it. So whilst one truth of Richter's grey is death and the inescapable void, the other is that, in a manner akin to Beuys's strategy of contrast and reverse logic, we might become aware of our own colour, our own beauty, our own quivering fragility in a "lucid world" and in so doing become better people for it. In Richter's painting of his daughter, *Betty*, 1988, her face is turned away from us, gazing into one of his own grey monochromes, speculating upon the grey void as we do. For the moment she represents all that is life and love, the colour of our lives.

Felix Gonzalez-Torres's *Untitled (Public Opinion)*, 1991, an installation of 700 lbs of black rod liquorice sweets, can be shown as a spill or pile, or flat on the ground like a carpet. The bullet-like forms of the black metallic-looking sweets—stock piled as it were—suggests the intention of the artist when he named the piece. Torres points to the militarism of the United States, but also the unpalatable truth of the American majority who support it. Set alongside Nauman's *White Anger, Red Danger, Yellow Peril, Black Death* or Warhol's *Skulls*, another meaning is also suggested; a monument to all those who have died of Aids and a further comment upon anti-gay prejudice. And like Richter's grey *Mirror Painting* included here, which on a formal level it reinvents, it is also a provocation that confronts us with who we are. As with all Torres's so called *Candy Spills* we are invited to consume the work, but here the suggestion is that doing so will leave a distinctly sour taste.

Mona Hatoum's *The Light at the End* of 1989 is, like the Torres, another appropriation of minimal form designed to suggest, if not directly cast light upon, institutionalised violence and oppression in society. The fierce heat that seemed so alluring when perceived at first as coloured light, repulses as we get close, and yet we are compelled to linger. The red painted walls and spectator entrapment recall Bourgeois's *Red Room Cell*, another distillation of troubled memory; and the electric bars with their inevitable referencing of violent punishment link here to Warhol's electric chairs.

Gerhard Richter *Betty* 1988

COLOURED UTOPIAS

Can I believe that I see and be blind,
or believe that I'm blind and see.
—Ludwig Wittgenstein [81]

Through colour, I experience a feeling of complete
identification with space. I am truly free.
—Yves Klein [82]

Sophie Calle's *The Blind* of 1986 presents an alternative way
of thinking about the monochrome-void project. Ambitious in
scale and intention, poignant in what it reveals, *The Blind*
comprises in total 23 suites of photographs and accompanying
text, each one a record of an encounter between Calle and
a blind person who has never known what it is to see in the
way that we conventionally understand it.

**I met people who were born blind. Who had never
seen. I asked them what their image of beauty was.**
—Sophie Calle, *The Blind*

The portraits of each of the interviewees are ruthlessly
candid, close cropped into the face, photographed in black
and white. Utterly exposed without being able to return
our gaze, their lack of sight renders them "all body".[83]
The responses to Calle's probing question are carefully
recorded in text and juxtaposed against an image of each
vision of beauty. By contrast to the portraits, these photographic
representations of objects, vistas, textures, loved ones,
celebrities, all shot in colour, combine the matter-of-fact
snapshot, the found photograph and the romantic landscape.
The colour of the 'visions' serves to contrast with the black
and white of reportage reality.

The Blind prompts within the sighted a sharpened perception
of what it is to see. Or, to put it another way, blindness,
the impossibility of seeing, illuminates through its absence—
it is that which gives us greater sight. Our complacency
in the face of a generally disregarded optical abundance is
revealed in Calle's work and colour is rendered kaleidoscopic.

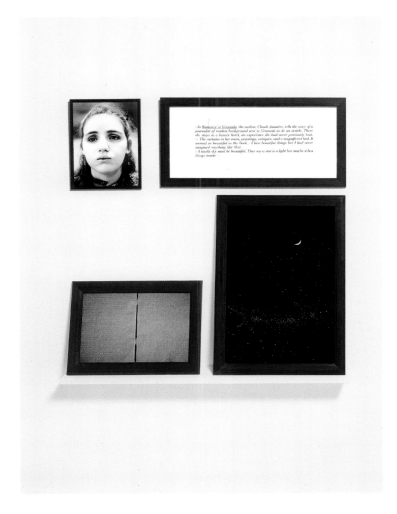

And whilst we marvel in that plenitude, the blind person
hovers on the edge of the void; Klein's adventure in space.
In a related work by Calle, *Colour Blind*, 1991, the artist
compares the various accounts given by blind people of what
they actually see, with texts by artists known for their
monochrome paintings—Klein, Richter and Ad Reinhardt
among others—as well as Klein's favourite, Gaston Bachelard's
famous quote: "First there is nothing, next there is a deep
nothing, then a blue depth." In one such description,
the blind person says: "I experience it more as an emptiness
than as a blackness. It's not the colour black, it's not a
black curtain, it's not a stormy sky, it's not a masked head."

However, whilst it foregrounds absence, *The Blind*
simultaneously points to the multi-sensory and imaginary
world that is beyond both colour and sight. One young girl
who is questioned, replies: "A starlit sky must be beautiful.
They say a star is a light but maybe it has things inside."
Unable to conceptualise light, this young woman imagines
something tactile, a treasure trove perhaps? What she has
lost in sight, she gains in other perceptual faculties. This
experience is echoed in a moving autobiographical account
written by John Hull about the experience of going blind.[84]

Sophie Calle *The Blind* 1986

It takes him about six years to mourn the loss of his sight and then slowly but surely he begins to savour his other senses and finally comes to see blindness as a gift. There is a wonderful passage in the book where the author describes his love of the rain in which he can sense the vastness of space; like Klein and Warhol gazing at the sky and sensing the infinite.

James Lee Byars's body of work represents a quest to create perfect beauty, an aesthetics of thought as well as form. Whereas the respondents in *The Blind* imagine beauty, Byars's gives it shape and makes it real. Through actions, words, drawings, sculpture and installations, Byars, like Klein and Beuys, (both of whom he admired) also sought to probe the most perplexing questions that we face in life and in death. His *The Rose Table of Perfect*, 1989, a spherical monochrome of 3,333 red roses, is a perfect reflection of the artist and a perfect embodiment of death which gives shape to life. This work activates our senses in a moment of overwhelming pleasure. All Byars wishes us to do is attend for a moment so that we might be transported, fleetingly, to a time when colour enwrapped us, a place of return where seeing was thinking, a place before time and boundary.[85]

"Every sensation carries within it the germ of a dream" writes Merleau-Ponty.[86] Anri Sala has witnessed one such utopian dream unfold in a film he made in Tirana that takes us on a nocturnal car ride with the artist-Mayor, Edi Rama, as he describes what instincts propelled him to paint great swathes of the city in a patchwork of colour. Tirana will become a city that people will want to live in; chroma will restore what has been lost, the catalyst for change in a city that was 'dead'. The expanded field of "supra-sensation" that Hélio Oiticica sought to activate in individuals as a result of his participatory objects and environmental installations, his wish that people should be able to find themselves and their internal liberty, the "path of a creative state", could equally describe the kind of transformation the artist-Mayor envisioned.

Scanning the colours on the facades of the reinvigorated city under the spotlight of Sala's sensitised eye, I find a metaphor for my own curatorial journey to re-think colour, from the *Monochrome Propositions* of Yves Klein and the dazzling radiance of IKBs to the reinvention of Tirana, a city awakening from a nightmare of impoverished building to a new chromatic dawn.

Notions of colour harmony and contrast have their place and relevance, but in this essay and the exhibition it accompanies, I have highlighted colour's immanence, its hermetic and indeterminate nature. Colour functions within artists' work to provoke or envelop us; to use Kristeva's terminology, to simultaneously menace and cradle. In the service of the artist, colour can ultimately transgress all boundaries of understanding. Located within the realm of desire and provocation, it resonates psychically, existentially and transcendentally. Colour can even alter our consciousness and through masking and decoration can re-invent individuals and societies. As suggested by Klein particularly, I have drawn inspiration from the compulsive return to the monochrome and the essence of colour. In this particular narrative colour becomes detached from painting, is aligned with the object and enters space and life. Oiticica called it "the body of colour", the zone where colour and the body are enmeshed and revitalised. Colour unites, new pathways are opened up and boundaries eclipsed. Warhol's void was colour—a moment of freedom—just as it was for Klein. The artists included here all utilise colour so that we may experience it afresh, as if for the first time; colour which is spread before us, colour that has the power to take us over, colour us in.

Anri Sala *Dammi i Colori* (Pass me the Colours) 2003

COLOUR AFTER KLEIN

NOTES

1 Judd, Donald, quoted in "Some Aspects of Colour in General and Red and Black in Particular" published in 1993 on the occasion of an exhibition at the Stedelijk Museum, curated and installed by Rudi Fuchs. The exhibition is held on the occasion of Judd receiving the Sikkens Prize, awarded by Akzo, for the use of colour in art. Essay reprinted in full in *Donald Judd*, Nicolas Serota ed., London: Tate Gallery, 2004, p. 157. Excerpts included here on pp. 170–171.

2 From a text Klein wrote on 16 April 1958, for the first issue of *Zero*, a publication that accompanied the Red Painting exhibition-event that the Zero Group in Germany organised on 24 April 1958 in the artist Otto Piene's studio. This text is entitled "Ma position dans le combat entre la ligne et la couleur" (My position in the battle between line and colour). The full quote from *Zero* reads: "Colours alone inhabit space, whereas line merely travels through space and furrows it. Line furrows the infinite, while colour is. Through colour I feel a total identification with space; I am truly free." Quoted in Sidra Stich, "From Blue Monochrome to the Void", *Yves Klein*, London: Hayward Gallery, 1995, p. 132.

3 "Colour is like material. It is one way or another, but it obdurately exists. Its existence as it is is the main fact and not what it means, which may be nothing." Judd, "Some Aspects of Colour", p. 158.

4 Klein, Yves, "The War: A brief personal mythology of monochromy, dating from 1954, adaptable in film or in ballet", published in Klein's journal *Dimanche, le journal d'un seul jour*, 27 November 1960. Quoted in *Yves Klein: A Retrospective*, Houston: Institute for the Arts, 1982. Klein text translated and edited by Thomas McEvilley, p. 218–219.

This text is developed from "La Guerre, de la ligne et de la couleur, ou vers la proposition monochrome" (The War, between line and colour, or toward the monochrome proposition), 1954, re-printed here pp. 157–164.

5 Discussed at length in an excellent article by Mikhail Iampolski, "Colour as a Language" included in *Re: The Rainbow*, Lund: Propescus, 2004. He writes: "Strangely enough, mimesis was turned by Newton from the outside world toward a subjective world of our own sensations." p. 18.

6 Wittgenstein, Ludwig, *Remarks on Colour*, Berkeley, CA: University of California Press, 1978, p. 16e.

7 Wittgenstein, *Remarks on Colour*, p. 9e.

8 Merleau-Ponty, Maurice, *Phenomenology of Perception* [1945], London: Routledge, 2003, p. 249. The quote, it "thinks itself within me" is from Paul Valery, *Le Cimetière marin*.

9 For a discussion on the place of black and white as colours, see Iampolski, "Colour as a Language": "They denote the poles of light and darkness between which all colours exist", p. 19. Such a position is broadly that of Johann Wolfgang von Goethe, who in his *Theory of Colours* in 1840 wrote: "We see on the one side, light, brightness; on the other, darkness, obscurity; we bring the semi-transparent medium between the two, and from these contrasts and this medium the colours develop themselves", Cambridge, MA: MIT Press, 1989. For a psychoanalytic perspective, see Kristeva: "Colour, therefore, is not the black cast of form, an undefinable, forbidden, or simply deformable figure; nor is it the white of dazzling light, a transparent light of meaning cut off from the body, conceptual, instinctually foreclosed.... Within the distribution of colour, when black and white are present, they too are colours, that is to say, instinctual/diacritical/representational condensations." From "Giotto's Joy" [1977], *Desire in Language*, Leon S Roudiez ed., New York: Columbia University Press, p. 222.

10 Judd, "Some Aspects of Colour", p. 155.

11 Wittgenstein, *Remarks on Colour*, p. 15e.

12 Klein, Yves, "The Monochrome Adventure", re-printed in *Yves Klein: A Retrospective*, p. 220.

13 Kristeva, "Giotto's Joy", p. 220.

14 Kristeva, "Giotto's Joy", p. 220.

15 Kristeva, "Giotto's Joy", p. 220.

16 Caption that accompanies the famous photographic image of Yves Klein leaping from a wall, as if suspended in space. The image appeared on the front of a broadsheet that Klein made to accompany his *Theatre of the Void*, an 'action' in which he appropriated one calendar day in order that everyone could participate. It was, he said, the "ultimate form of collective theatre... a Sunday for everyone... a holiday... a veritable spectacle of the void, the culminating point of my theories." See Stich, *Yves Klein*, pp. 209–221, for a full exploration of the *Theatre of the Void*, Klein's broadsheet *Dimanche*, and the Harry Shunk photograph.

17 Judd, "Some Aspects of Colour", p. 157.

18 Warhol, Andy, in an interview with Barry Blinderman, "Modern Myths: An Interview with

Andy Warhol" *Arts Magazine 56*,
October 1981, pp. 144–147, quoted by
Benjamin H D Buchloh in "Andy Warhol's
One-Dimensional Art", *Neo-Avantgarde
and Culture Industry*, Cambridge MA: MIT Press,
2000, p. 49.

19 See Benjamin H D Buchloh's influential essay
on this subject, "The Primary Colours for
the Second Time: A Paradigm Repetition of the
Neo-Avant-Garde", *October*, no. 37, Summer
1986, pp. 41–52.

20 Stich, *Yves Klein*, p. 19. Stich tells us
that Klein described the sky signing event as
"a fantastic realistic-imaginary voyage".

21 Andy Warhol interviewed by David Bailey,
*Andy in Car Sequence, Roll 25/Andy Warhol's
TV 4661*, Warhol/Bailey, 1980–1983.
Transcript reprinted in *Andy Warhol: The Late
Works*, Mark Francis ed., Munich: Prestel, 2004,
p. 26. Full quote:

DAVID BAILEY: What we going to do in the country,
going to do horse riding?
ANDY WARHOL: Uh, oh, oh yes, I guess walk along
the ocean because it's so quiet and peaceful,
and, and you get away from all the drugs in
New York... and the ocean is... uh, uh, it's, it's
sort of the biggest abstract thing around... there's
a lot of rocks here too....

22 Warhol, Andy, *America*, New York:
Harper & Row, 1985, pp. 126–129.
Quoted in Trevor Fairbrother, "Skulls" in *Andy
Warhol: The Late Works*, p. 74.

23 Klein, Yves, "Ma position dans le combat
entre la ligne et la couleur", 16 April 1958.
Quoted in Stich, *Yves Klein*, p. 133.

24 Klein, "Ma position dans le combat entre la
ligne et la couleur", p. 133.

25 See Stich, *Yves Klein*, p. 81. All 11 paintings
that form the *Proposte Monochrome,
Epoca Blu* (Monochrome Proposition, Blue
Period) were unframed and 78 x 56cm in format.
The paintings were attached to poles
bracketed out from the wall by about 20–25cm.

26 For an excellent account of
International Klein Blue, see Carol C Mancusi-
Ungaro, "A Technical Note on IKB",
Yves Klein: A Retrospective.

27 McEvilley, Thomas, "Yves Klein and the
Double Edged Sublime", *On the Sublime:
Mark Rothko, Yves Klein, James Turrell*, Berlin:
Deutsche Guggenheim 2001.

28 I am indebted to Nuit Banai who used the
term "The Space of Colour" as a thematic
heading in her introductory essay, "From the
Myth of Objecthood to the Order of Space:
Yves Klein's Adventures in *The Void*" for the
recent Yves Klein retrospective, Schirn Kunsthalle,
Frankfurt, 2004.

29 Donald Judd "Specific Objects", 1964.
Published in *Arts Yearbook 8* at the end
of 1965, reprinted in *Donald Judd Complete
Writings, 1959–1975*, Halifax and
New York: The Press of Nova Scotia College of
Art and Design, 1975.

30 See for instance, John Coplans, *Donald
Judd*, Pasadena: Pasadena Museum, 1971, p.16

31 Richter, Gerhard, *The Daily Practice of
Painting: Writings 1962–1993*, Hans-Ulrich Obrist
ed., London: Anthony d'Offay, 1995, p. 99.

32 For this insight I am indebted to
Neil Benezra in *Bruce Nauman*, Minneapolis,
MN: Walker Art Center, 1994, p. 17.

33 Huberman, Georges-Didi, "The Fable of
Place", *James Turrell: The Other Horizon*, Vienna:
MAK, 1998.

34 Judd, Donald, "Review of Yves Klein
exhibition, Alexandre Iolas Gallery, New York",
1962. Reprinted in *Donald Judd* and here
p. 166.

35 Kapoor, Anish, in conversation with
Germano Celant, July 1995, *Anish Kapoor*,
Germano Celant ed., Milan: Charta, 1998,
p. xxv.

36 Buchloh, Benjamin H D, "Beuys: The Twilight
of the Idol" first published in *Artforum*, 1980,
pp. 35–43. Re-printed in *Neo-Avantgarde and
Culture Industry*.

37 For essential reading concerning Beuys
and *Braunkreuz*, see Ann Temkin for her
comprehensive and brilliant exploration of it,
in "Joseph Beuys: Life Drawing" in *Thinking is
Form: The Drawings of Joseph Beuys*,
Philadelphia: The Philadelphia Museum of Art
and The Museum of Modern Art, 2003,
pp. 37–46. For the specific reference to the
references inherent in *Braunkreuz*, see p. 38.

38 Temkin, "Joseph Beuys: Life Drawing",
p. 43. For a more specific discussion on the
influence of Klein on the Zero Group see
Ingrid Pfeiffer's "Yves Klein: Stations in Germany"
in *Yves Klein: A Retrospective*, pp. 55–85.

39 Temkin, "Joseph Beuys: Life Drawing",
pp. 43–44.

40 Schellmann, Jörg and Bernd Klüser, "Questions to Joseph Beuys", *Joseph Beuys: The Multiples*, Cambridge, MA and Minneapolis, MN: Harvard Arts Museums and Walker Art Center, 1998, p. 11 and also quote from "Coyote", p. 28, published in *Joseph Beuys: The Multiples* on p. 428.

41 Schellmann and Klüser, "Questions to Joseph Beuys", p. 11.

42 Tisdall, Caroline, "Joseph Beuys, Bits and Pieces", Tate Modern Talk, Social Sculpture Research Unit, 2003.

43 Brett, Guy, "Hélio Oiticica: The Experimental Exercise of Liberty", *Carnival of Perception; Selected Writings on Art*, London: inIVA, 2004.

44 Oiticica, Hélio, diary entry 5 October 1960. Reprinted in *Hélio Oiticica*, Paris and Rotterdam: Galerie nationale du Jeu de Paume and Witte de With, Centre for Contemporary Art, 1992, p. 33.

45 Oiticica, Hélio, *Bolides* diary entry, 29 October 1963, *Hélio Oiticica*, p. 66.

46 Oiticica, *Hélio Oiticica*, p. 127.

47 Kapoor, Anish, quoted in Constance Lewallen, "Anish Kapoor", *Interview*, VII, no. 4, 1991. Also quoted by Celant, *Anish Kapoor*, p. x.

48 Author in conversation with the artist, January 2005.

49 Quoted by Reiner Speck in "The Perfect Tear", *James Lee Byars—The Epitaph of Con. Art is which Questions have disappeared*, Carl Haenlein ed., Hannover: Kestner Gesellschaft, 1997, p. 214.

50 Klein, Yves, "The Chelsea Hotel Manifesto", New York 1961. This text appears in print to accompany the exhibition at the Alexander Iolas Gallery that Judd reviewed. Reprinted in *Yves Klein: Long Live the Immaterial*, Gilbert Perlein and Bruno Cora ed., Nice and New York: Musée d'Art Moderne et d'Art Contemporain and Delano Greenidge Editions, 2000, p. 87.

51 I am indebted to Briony Fer for her persuasive and insightful account of Judd's review of Klein's work. See Briony Fer, "Judd's Specific Objects", *On Abstract Art*, New Haven, CT: Yale University Press, 1997: "What is striking in Judd's response to Klein is the way the object might exceed the formal description and become an 'erotic object'. Judd's language here oversteps the limits of description to which he normally keeps, as if Klein represents a kind of uncanny insurgence onto the field occupied by the specific object." p. 146.

52 For a full exploration of Flavin's diagonal see *Dan Flavin: A Retrospective*, Michael Govan and Tiffany Bell eds., New York and Washington: Dia Art Foundation and National Gallery of Art, 2005, p. 33.

53 Halbreich, Kathy, "Social Life", *Bruce Nauman*, Halbreich and Benezra eds, Minneapolis, MN: Walker Art Center, 1994, p. 87.

54 Bourgeois, Louise, quoted in Christiane Meyer-Thoss, *Louise Bourgeois: Designing For Free Fall*, Zurich: Ammann Verlag, 1992, pp. 178–179.

55 Michaux, Henri, "Essais d'enfants, Dessins d'enfants" (Children's ventures, Children's drawings), 1985, re-printed in *Henri Michaux,*

Spaced, Displaced, Newcastle-upon-Tyne: Bloodaxe Contemporary French Poets: 3, 1992. p. 113.

56 Bourgeois, *Louise Bourgeois: Designing For Free Fall*, pp. 178–179.

57 Picasso, Pablo, quoted in Rosalind E Krauss, *The Optical Unconscious*, Cambridge, MA: MIT Press, 1994, p. 196.

58 Klee, Paul, "Trip to Tunisia, 1914", *The Diaries of Paul Klee: 1898–1918*, Berkeley, CA: University of California Press, 1964, p. 297.

59 See for instance, when talking about her attitude to parenthood, "I don't try to influence them [her children], nor anyone else. Though if I could teach a course, it would be in survival. I would be very good at that." Quoted in *Louise Bourgeois: Blue Days and Pink Days*, Jerry Gorovoy and Pandora Tabatabai Asbaghi, eds., Milan: Fondazione Prada, 1997, p. 87.

60 See Rosalind Krauss "Louise Bourgeois: Portrait of the artist as Fillette" [1989], *Bachelors*, Cambridge, MA: MIT Press, 1999.

61 Storr, Robert, "A sketch for a Portrait", *Louise Bourgeois*, Robert Storr, Paulo Herkenhoff and Alan Schwartzman eds, London: Phaidon, 2003, p. xx.

62 Rist, Pipilotti, quoted in *Himalaya (50 Kg)*, Zurich: Kunsthalle Zurich, 1999.

63 Quoted in Krauss, "Louise Bourgeois: Portrait of the artist as Fillette", p. 66.

64 Sala, Anri, in conversation with Mark Godfrey at the Tate Gallery, London, 2004.

65 Eggleston, William, quoted in Mark Holborn, *William Eggleston; Ancient and Modern*, London: Barbican Art Gallery, 1992, p. 16.

66 Eggleston, quoted in *William Eggleston; Ancient and Modern*, p. 28.

67 Nauman, Bruce, illustrated in *Bruce Nauman*, p. 134.

68 Nauman, Bruce, in Ian Wallace and Russell Keziere, "Bruce Nauman Interviewed", *Vanguard* 8, no. 1, February 1979, p.16. Quoted in *Bruce Nauman*, p. 85.

69 Warhol, Andy, in Gene Swenson "What Is Pop Art: Answers from Eight Painters, Part I", *Art News* 62, November 1963, p. 60. Also quoted in Hal Foster, "Death in America" in *October Files 2: Andy Warhol*, Annette Michelson ed., Cambridge, MA: MIT Press, 2001, p. 79. Warhol is referring to his 1962 painting, *129 Die in Jet! (Plane Crash)*, 1962, which began his *Death and Disaster* series. Entire quote reads: "I guess it was the big crash picture, the front page of a newspaper: 129 Die. I was also painting the Marilyns. I realised that everything I was doing must have been Death. It was Christmas or Labour Day—a holiday—and every time you turned on the radio that said something like, '4 million are going to die' That started it."

70 Fairbrother, "Skulls", p. 68.

71 Warhol, Andy, originally quoted in Swenson "What Is Pop Art: Answers from Eight Painters, Part I", p. 60. Also in Fairbrother, "Skulls", p. 73: "My show in Paris is going to be called *Death in America*. I'll show the electric chair pictures and the dogs in Birmingham and car wrecks and some suicide pictures."

72 Crow, Thomas, "Saturday Disasters: Trace and Reference in Early Warhol" [1996], *October Files 2: Andy Warhol*, p. 60.

73 Warhol, Andy, in "Painter Hangs own Paintings", *New York Magazine* 12, February 5 1979, reprinted in *Andy Warhol: The Late Works*, pp. 80–81.

74 Nauman, Bruce, quoted in Paul Richard, "Watch Out! It"s Here!", *Washington Post*, 3 November 1994. Re-printed in *Bruce Nauman: Art + Performance*, Robert C Morgan ed., Baltimore and London: John Hopkins University Press, 2002, p. 217. Full quote:

"'From the beginning' Nauman told an interviewer in 1988, 'I was trying to see if I could make art that... was just there all at once. Like getting hit in the face with a baseball bat. Or better, like getting hit in the back of the neck. You never see it coming; it just knocks you down'."

75 See Joan Simon, "Breaking the Silence", *Bruce Nauman: Art + Performance*, p. 280.

76 Richter, Gerhard, from a letter to Benjamin H D Buchloh, 23 May 1977, quoted in Buchloh, *Gerhard Richter: Eight Grey*, Berlin: Deutsche Guggenheim 2002, p. 84.

77 Richter, Gerhard, interview with Amine Haase, 1977. Reprinted in *The Daily Practice of Painting*, p. 94.

78 Interview with Robert Storr, *Gerhard Richter: Forty Years of Painting*, New York: The Museum of Modern Art, 2002, p. 297.

79 Richter, interview with Buchloh, *The Daily Practice of Painting*, pp. 154–57.

80 Danto, Arthur C, "History in a Blur", *The Nation*, 13 May 2002.

81 Wittgenstein, *Remarks on Colour*, p. 13e.

82 Klein, "The Monochrome Adventure", p. 220.

83 Derrida, Jacques, *Memoirs of the Blind: The self-portrait and other ruins*, Chicago, IL: The University of Chicago Press, 1993, p. 106.

84 Hull, John, *Touching the Rock: An Experience of Blindness*, London: Vintage, 1992.

85 Discussed by Joachim Sartorius, "The Archaic Smile of James Lee Byars", *James Lee Byars: The Epitaph of Con. Art is which Questions have Disappeared?*, pp. 217–220.

86 Merleau-Ponty, *Phenomenology of Perception*, p. 250.

Nuit Banai

MONOCHROMATIC INTERVENTIONS:
YVES KLEIN AND THE UTOPIA OF SPECTACULAR SENSIBILITY

> Colour is sensibility in material form,
> matter in its primordial state.
> —Yves Klein, "Ma position dans le combat
> entre la ligne et la couleur" (Paris 1958)

Yves Klein has yet to be recognised as one of the foremost colourists of the twentieth century. It does not matter that he is known for using a single colour—an enduring devotion to a monochromatic practice. Between 1954, when he appeared with a sentimental and sometimes kitschy polychromatic palette and 1962, when he became virtually synonymous with International Klein Blue, his fidelity to chromatic unity was nonpareil. Colour was his empire. This ardour still resonates as a pivotal moment in post war aesthetic production. His intensive experiments with the monochrome created a condition in which the internal plurality of colour opened into an expanded field of possibilities and paradoxes. As Klein stressed colour's overwhelming materiality—the physicality of pigment pushed to the point of reification—he also pointed to its complex and elusive identity as a differential and discursive space.[1] In other words, the more Klein emphasised colour's accepted status as a physical property of painting— and painting's primary condition as a physical object—the more it became evident that such a reductive definition could not support the many shifting and contradictory layers of meaning contained in both colour and painting. The conventional belief that these two elements have a necessary, stable, and singular relationship to each other—and to themselves—was shattered. This tension signalled the implosion of a strand of modernist practice committed to a purity and intrinsic unity of forms and the emergence of an order of communicative aesthetic structures founded on hybridity.

In its double identity as both materially bound and immaterially inflected, chroma became the site for an expansive and often overlapping network of aesthetic and socio-political issues and experiences. Most significantly, on an aesthetic level, this doubling pointed to the destabilisation of the medium of painting. This condition began to free colour from its immanent connection to a physical support and transformed it into a medium in its own right. Through Klein's practice, colour became a passage between the materiality of the object and a range of experiences beyond its physical limits. Paradoxically, the tension between materiality and immateriality led to the interrogation of the status of the art object at a historical moment marked by the frenzied growth of mass culture and object production. By adopting strategies of spectacular production and publicity, Klein participated in the expansion of commodity culture even as he claimed to signify his objects differently. While his practice is clearly marked by an emphasis on object production—monochromes, sponge reliefs, anthropometries, fire paintings—his aesthetic approach and discourse accentuates the dissolution of forms. Klein's effacement of the physical limits of form was generated by the mediation of human bodies, natural elements such as rain, wind and fire, artificial elements like industrial paint-rollers and Bengal flares, and, of course, the specialisation of colour.

Klein's deployment of colour began in all earnestness in 1954, with the publication of *Yves: Peintures* and *Haguenault, Peintures*. In these curious catalogues, he presented a series of brightly coloured, mechanically reproduced monochromatic 'plates' that were supposed to represent his extant aesthetic production. Each coloured 'plate'—mandarin orange, cherry blossom pink, glacial white, sunflower yellow—is in fact a rectangular piece of commercially inked paper affixed to a high-grade support, which almost has the consistency of cardboard. Since there is no physical evidence of Klein's monochromatic work before 1955, these catalogues should be approached as a deliberate conceptual statement. Without

Yves Klein *Green Monochrome Untitled (M 51)* c. 1957

doubt, the use of mechanically manufactured ink in place of traditional, hand-made materials complicates the status of the medium of painting. There is no evidence of expressive texture or idiosyncratic brushwork, no erratic pigment or intensive finish, no indexical marks to represent either the labour necessary for the object's making or the individuality of the maker. If facture had long served as the material trace of the object's process of production and the index of the artist's subjectivity, here it operates on a different register altogether. Both the 'madeness' of the art object and the corporalisation, agency and inner depth of the artist—and viewer—are transformed through the fusion of facture with mechanical reproduction.

With the intrusion of the machine, the history of the object's production and the index of human presence are both effaced, leaving an inscription that duplicates its own absence. Again and again, plate after plate, Klein's coloured surfaces attest to the aporia lodged within the art object. His monochrome appears as a coloured surface that wipes out any memory of its own origin. It is a rootless, depthless surface, a flat itinerant plane that can circulate freely without any necessary context, without the weight of material history to tie it down. In this way, colour-equated-with-surface and the surface-of-colour function like a nomadic currency, producing and consuming multiple discourses, released from a hermeneutic responsibility to a single narrative or subjectivity. However, as a freshly minted commodity form, it simultaneously points to its own materiality, its fetishised, object-like identity, and its utter contingency. After all, it is a readymade object that remains specific to a historical context, which it both embodies and denies. Klein insists upon and subverts this historical context by pointing to his own monochrome's doubtful origin. The printed captions refer to the supposed location of each monochrome's production: Nice, Madrid, Paris and Tokyo. Yet this indexical refuge in a semblance of authentic origin is belied by the acknowledged fictiveness of this unique locus of creation. In this first public statement, Klein uses colour's commodified, readymade status to posit a paradoxical model of the monochrome: immaterial and material; historically negligent and conditioned by History; fictive and literal; unmitigated surface and physically-bound support.

Moreover, with his palette of colours derived directly from commercial samples of industrial paint purchased at the hardware shop of Edouard Adam in Montparnasse, Klein frames his aesthetic production within the realm of kitsch. As expected, these catalogues and the early monochromes that they engendered problematise and invert the concept of kitsch by combining its basic conditions with avant garde strategies. Kitsch, a "... debased and academicised simulacra of genuine culture", based on "... vicarious experience and fake sensations", is "... destined for those who, insensible to the values of real culture" are "hungry, nevertheless for the diversion that culture of some sort can provide".[2] It is an effortless form of aesthetic experience, one based on imitating the effects of art, rather than its processes. In other words, it is pure surface—a watered down, synthetic and immediate version of culture. If kitsch originally turned folk culture into market culture, to satisfy the tastes and needs of the newly enfranchised urban masses in the late nineteenth century, Klein reframes it as a form of aesthetic production for an emerging technocratic class that wishes to see itself as select, initiated and cultivated. His industrialised colours and their specialised binder, produced with the help of engineers at the Rhône Poulenc corporation, obey a mechanical logic of infinite reproducibility and universal access. The fusion with the rationalised techniques of science and industry complicates modernism's distinctions between 'art' and 'mass culture'. To this end, Klein's paint roller is like a democratising appendage, transforming the surface of the monochrome into a (technical) support and an open field to which any passer-by or art aficionado might contribute. His colours serve up the historical avant garde form of the monochrome, initiated by Kasimir Malevich, as 'monochrome-lite', a saccharine and spurious commodity. In this situation, the international captions may well serve to identify the new markets for the consumption of the monochrome brand. Thus the transformation of the monochrome, from supposedly unadulterated high modernist icon to debased pop art simulacra, passes through kitsch, an intermediary stage between being and forgetting.

On first appearance, Klein's personification of colour is a complete capitulation to kitsch: "For me", he proclaims,

"each nuance of colour is in some way an individual, a being who is not only from the same race as the base colour, but who definitely possesses a character and a personal distinct soul." He earnestly continues in this vein, "there are cheerful colours, majestic, vulgar, sweet, violent and sad colours.... In sum, each nuance of each colour is a 'presence', a living being, an active force who is born and who dies after having lived a sort of drama of the life of colours."[3] These élans of naive romanticism should not be taken at face value. Rather than unmitigated kitsch, his catalogues impose a certain critical distance by injecting a dose of irony that shifts sentimentality into a different register. Take for instance the hermetic 'preface' to the catalogues, a series of horizontal graphic lines in place of words, and the paradoxical and polysemic nature of the monochromatic plates—lodged somewhere between fraudulent claim and authentic concept. If the sentimental is fraught with the discharge of irony, then the binary opposition between 'high art' and kitsch reveals itself as a fractured artifice, one that can be productively deployed to rethink the narratives of modernism.

Following the polemical posturing of these catalogues, Klein launched into an intensive period of monochromatic object-production. In the logic of his mechanically reproducible catalogues, these early monochromes, produced between 1955 and 1957, are paintings that belong to a technological system. They are self-replicating object-machines that stake out a space for a different kind of aesthetic paradigm and visual experience. What is remarkable about these early works, which display an eclectic experimentation with a variety of colours, canvas sizes, and surface textures, is their insistence on their own object-like, material quality. They resemble pieces of hastily manufactured, negligently applied wallpaper, thick industrially produced concrete slabs and 'archaic' totems; they are impenetrable, monumental structures. However, once again, the story is not so simple. Klein destabilises the unity of the monochrome object by exposing its foremost paradox: it possesses (and always has possessed) a double and simultaneous identity as both support and surface. Yet the modernist *fiction* of the monochrome's totality, the desire to believe in its absolute

indivisible unity, had whitewashed this originary fissure. What Klein achieves is a splintering of modernism's principal myth, precisely by exacerbating this pressure point.[4]

Thus, on the one hand, these early monochromes announce themselves as three-dimensional supports for the artist's inscription, the ontological and physical scaffolding for the application of colour. Standing before Klein's early monochromes, you encounter discrete, physical objects in space, fully abiding by a grammar of an irreducible materiality. There are clefts and crevices in the paint, there are various thicknesses and modulations. It is as if Klein wants you to notice, on the one hand, that paint does not transcend its own materiality and that the monochrome is nothing but an object that supports commonly agreed upon painterly conventions. On the other hand, Klein also continues the process of 'peeling' the surface of the monochrome from its support so that it becomes an extended and autonomous two-dimensional membrane, a living organism. He achieves this through the continued fusion of colour with mechanical reproducibility, which elides colour with surface and transforms surface into both a depository for fiction and its enactment. Connected to machinic production through the use of an industrial paint roller rather than a traditional paintbrush, Klein accentuates a dynamic of ecstatic externalisation. That is, mechanical reproduction creates a centrifugal mode of subjectivity, a pure and empty form of energy always pushing outward to self-dissolution. There is nothing 'inside' a commodity; there is only a fetishised surface that participates in the fabrication of social relations, human desires, and cultural fictions, which appear like objective reality.[5]

With this literal surface as a base, the monochrome becomes a site of germination and legitimisation for the fiction of "sensibility". And unified colour is one of the primary strategies through which Klein hopes to transfigure concrete materiality and its investment in the quantitative into the elusive and all-encompassing qualitative notion of immaterial "sensibility". For Klein, sensibility is that "... which exists beyond us and which nevertheless always belongs to us".[6]

Yves Klein *Yves: Peintures* 1954

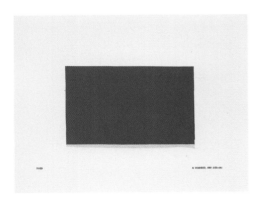

It is the ineffable, sensation of the individual's communion with that which is beyond them but which has always existed within them. Within this paradoxical realm of sensibility, embodied by specialised colour, Klein seeks a different order of existence, one that will compensate for the spiritual poverty of the reified, disenchanted world. This experience, coded in his writings as sensibility, enthusiasm, or the "indefinable" of Delacroix, is one

> ... with no more dimension, no more anything, no more infinite, no more nothingness, no more divinity. Instead, the inconceivable, that which we refuse—crazy as we are—to see and contemplate and utilise because it is too dazzling, because it burns Reason.[7]

In other words, the realm of sensibility is an aporia—or a Void. It is inconceivable to our rational minds yet emerges from it. Unthinkable and unreachable as it is, Klein sets out to create the conditions from which sensibility might possibly appear one day and which might contain it once it arrives. Little by little, he develops a terrain of potentiality for this messianic coming: colour becomes the medium for the passage and materialisation of sensibility, while bodies are the spatial sites for its diffusion. Thus chroma leads to a double narrative: on the one hand, it is bestowed the task of working through the objectivity of its own materiality to reveal a space and sensation of transcendence. For the viewer, who responds to chroma's affective power, this means striving to get beyond the carnal boundaries of his or her body to become pure energy. On the other hand, chroma is also the medium through which sensibility is to be internalised within the carnal architecture of the body. The viewer is to be transformed into an ambulatory spatial receptacle for the intensive universe of sensibility.[8]

In effect, what Klein imagined is a utopian state of existence in which sensibility replaces object-relations. In this quest, he was neither a radical in the sense of the Situationist International nor a complete charlatan as the detractors of the neo-avant garde might claim. His appearance was as an avatar of a postmodernist, readymade, technocratic utopia that nourished an aesthetic and social experience of pure and immediate intensity. Klein realised that this experience is both conditioned by and contains the internal fissure within and self-differential identity of both objects and subjects through their link to advanced capitalism and mechanical reproduction. It is not surprising therefore that Klein's strategies for reaching this utopia are rife with competition, paranoia, and paradox. In 1957, with the *Epoca Blu* exhibition in Milan, Klein brands the monochrome as a sign of 'freedom' by suggesting that each one of the identical blue panels possessed and imparted a unique essence or atmosphere. In his words, "each blue world of each painting, while [painted] with the same blue and treated in the same manner, reveals itself to be of a completely different essence and atmosphere; none resembled each other, no more than each pictorial moment or poetic moment resembles each other". As a result of this claim, each monochrome sold for a different, randomly assigned price, supporting Klein's belief that "the pictorial quality of each painting was perceptible by something other than its material and physical appearance" and that "those who chose recognised this state of things that I call 'pictorial sensibility'".[9] While it may be true that the phenomenological experience in front of each monochrome was qualitatively different, Klein was also conditioning the art viewer to equate consumption with self-fulfillment and personal freedom. An essential part of self-actualisation in the utopia of spectacular sensibility would be created by a system of objects that negate their objectivity. If all that were to remain of the monochrome would be the *quality of colour* transformed into a *sign* of freedom, then Klein made sure to patent this commodity. The advent of International Klein Blue, the industrially produced ultramarine pigment that Klein claimed as his rightful property, is an almost spontaneous manifestation of the capitalist system of fear, one in which freedom and paranoia go hand in hand.

The implications of Klein's strategies lead him to a critical juncture in his artistic production. On the night of April 28 1958, at the Galerie Iris Clert, he unveiled the most important 'work' of his career, *The specialisation of sensibility in the*

Yves Klein *The specialisation of sensibility in the state
of primary matter stabilised by pictorial sensibility. The Void*
Interior view of the exhibition, Galerie Iris Clert, Paris
April 28–May 5, 1958

state of primary matter stabilised by pictorial sensibility—also known as *The Void*. This spectacular event, which attracted over 3,000 people on the opening night and nearly incited a riot, 'displayed' a gallery space devoid of any traditional art objects. Instead, viewers were invited to bask in a state of pure sensibility, encased by a whitewashed gallery space that was lit by one neon light affixed to the ceiling. If during the previous four years chroma had been the material manifestation of sensibility, *The Void* liberated the "life of colours" so that they could completely and immaterially saturate space. Such a passage from the object to space was partly the result of the growing tension in the monochrome between support and surface, two independent variables that had long agitated against each other like tectonic plates. The monochrome's double identity—support and surface— subsumed for so long into an indivisible whole was finally rendered incommensurable and chroma was emancipated from the monochrome-object. With its destruction as a unified object, the monochrome splintered into a series of plural conditions, one being the spatial representation of the pure form of colour. In *The Void*, the viewer was invited to inhabit the realm of sensibility in its most unmediated form, with no objects to interfere with its transmission and reception. Pure space was pure sensibility. Klein's immersion in the white of *The Void* was an intense passage through an inconceivable state of being, a simultaneous merging of too much and not enough, of excess and negation. *The Void* was thus his attempt to find a way of representing an aporia: this is what it would be like to be inside nothing (negation of an object) and feel that it is something (sensibility). This is what it would be like to be inside something (space) and feel that it is nothing (fiction). And white was the colour of this paradox.

As a real-yet-other space, *The Void* was the transformation of the monochrome into a real and symbolic architectural container. On one level, Klein's unraveling of the monochrome transferred its identity as support to a new purpose. The monochrome-as-support became the primary structural condition of the 'white cube', framing the gallery space as the ultimate arbiter of aesthetic value and content. Through this expanded notion of support, Klein suggested that whatever is placed within the display mechanism of the 'exhibition' will be valued as art—and the seeds of institutional critique were sown.[10] *The Void* also functioned on the symbolic level, participating in the creation of discursive codes of subject formation in its specific historical context. It was a visual and spatial power structure in which the tensions of living within a contemporary aesthetic and social reality marked by a plurality of differences could be negotiated. The negation of the object lacking one fixed origin, the readymade monochrome, released what Klein called an "... ecstatic and immediately communicable emotion".[11] The space was saturated with the heightened *effect* of quality— or sensibility—an abstract, universal and homogeneous shroud of energy. *The Void* was a space where the sensuousness of abstraction, the spiritual glow of spectrality diffused in real and symbolic space, became the dominant mode of social experience and communication. In this empty form of emanation, marked by an equivalence that was always-already fissured, Klein recognised a presence that could be mined for its alterity. A negation of negation. The fetishisation of the fetish. Here was a seemingly unified circuit and surface of power that contained diverse, unforeseen intensities that could erupt at any moment.[12]

The experience within *The Void* was a blinding experience of literal and symbolic whiteness, the purest of colours that reflects and transmits all wavelengths of visible light. It was an uncanny intertwinement of activity and passivity, acceleration and inertia, transparency and opaqueness, both pushed towards their extreme. To be inside such an unthinkable condition as the pure effect of quality must have been both ecstasy and death. It meant experiencing a state of total self-exteriorisation—becoming a fetishised surface of pure visuality—and self-effacement—receding into a lack that was a space of plurality. This simultaneous spiraling into transcendence and disappearance was both the subjugation to an advanced industrial society and a space of freedom within it. The subject within *The Void*, fused with the readymade and its fissured identity, was left to pulsate as a bundle of energy between points becoming, in this way, a permeable, relational being. This model of

subjectivity simultaneously escaped totalisation by evading centralisation and consolidation and functioned like a machinic imprint that replicated and diffused *The Void* as a nascent type of power structure.

In Klein's own narrative, the blue monochromes and *The Void* were two sides of the same coin, namely material and immaterial forms of sensibility. However, while *The Void* maintained its criticality by remaining in a state of plasticity and potentiality, Klein's late works, the expansive altar-like edifices of blue of the 1960s, harness and reverse its empty energy and give it tactile form. Klein's return to blue pigment, after the radicality of *The Void*, needs to be framed differently from the use of blue preceding it. The late monochromes are the mimetic representation of pure abstraction, capturing the violence of *The Void* as a way of containing, controlling and understanding it.[13] They domesticate *The Void*'s blinding resonance, transforming its affective power of becoming into a concretised form, albeit an industrialised assemblage that does not exactly belong to the order of the copy. Perhaps realising the implications of the new reality that he had forecast, perhaps not taking them far enough, Klein retreated from the overflowing, self-replicating, originless mise-en-abyme of *The Void*.

Yet the late monochromes also signal Klein's full embrace of the problematic of space. They reveal that his passage through *The Void* and his architectural collaboration with Werner Ruhnau at the Gelsenkirchen Musiktheater in Germany, between 1957 and 1959, were crucial points of change that irrevocably altered his practice. These stark, billboard-sized blue panels project the conditions and requirements of their own viewing, positing a physical necessity for expansive space in order to be properly apprehended. More than this, they confirm that Klein was constructing a new type of audience, one that has internalised space as the arena in which contemporary life would be experienced. These late architectural monochromes might thus be viewed as an emerging, proto-form of public art rather than discrete art objects in a gallery. Before issues of 'site specificity' came to the fore, Klein's late monochromes had already dramatically complicated the terms of this art practice by at once affirming and erasing differential space. With blue functioning as the general equivalent, the expression of value of all things regardless of their particularity, Klein suggests that the distinction of space has to occur *via* this erasure of differences created by the conditions of commodification. At once inextricably linked to a lived bodily experience, the contingencies of their context, and a dematerialised set of discourses that they both produce and assimilate, these spatial paradigms exist 'in between' these three seemingly consolidated points of experience created by the flows of capital.[14] While they may seem homogeneous and coherent, Klein's abstract spaces decompose into fractured sites, which cannot fully neutralise or make concrete the desires of *The Void*.

By the time of his death in 1962, Klein's monopoly of colour had irrevocably altered the course of aesthetic production. Through colour's specialisation, Klein brought to the fore, and then intensified, the fissure within the monochrome-object. In the push and pull between surface and support, Klein liquidated the modernist fiction of the object's totality and its ontological singularity and transformed chroma into a plural discursive site. While Klein articulated this historical transformation as a search for a utopia of spectacular sensibility, his monochromatic interventions expanded colour into a potentially destabilising element. Spellbound in front of monochromatic screens or rapt within the white light of *The Void*, the viewer both consumed and was created by Klein's readymade images, diffracting infinitely into resonating points of colour.

Yves Klein's reliefs in the entrance hall of the Gelsenkirchen Music Theatre 1959

NOTES

1 For the seminal formulation of the generative possibilities provoked by the "self-differing" identity of mediums see Rosalind Krauss, *"A Voyage on the North Sea": Art in the Age of the Post-Medium Condition*, New York: Thames and Hudson, 1999. Krauss argues that the specificity of mediums cannot be reduced to the physicality of their support but must be understood as a layering of conventions—always differing from themselves—that are perpetually in the process of constitution and dissolution.

2 Greenberg, Clement, "Avant Garde and Kitsch", in *The Collected Essays and Criticism, Volume I*, John O'Brian ed., Chicago and London: The University of Chicago Press, p. 12.

3 Klein, Yves, "Texte de présentation de l'exposition Yves Peintures aux Éditions Lacoste, 15 Octobre 1955" in *Le depassement de la problématique de l'art et autres écrits*, Marie-Anne Sichère and Didier Semin eds., Paris: École Nationale Supérieure des Beaux Arts, 2003, p. 40. It is significant to note that Klein borrows many of these phrases regarding colour from Charles Baudelaire's *Salon* of 1846. I am indebted to Nan Rosenthal for this important observation, cited in *The Blue Worlds of Yves Klein*, unpublished dissertation, Harvard University, 1976, p. 107.

4 Krauss identifies the dominance of this modernist myth and discusses its unfurling in the work of Marcel Broodthaers. What is remarkable about Yves Klein is that, a full decade before Broodthaers, he mined the tensions of this myth through painting, splintering the monochrome into differentiated conditions that made possible the works of the artists who followed him. *"A Voyage on the North Sea"*, p. 53.

5 Karl Marx's notion of "commodity fetishism" makes the crucial link between the affect of market forces upon human life. Social relations between people are displaced onto that between commodities, rendering the commodity a powerful entity. The commodity becomes an animate thing, effacing its absorption of man's social relations by making them seem like an objective character of the commodity itself. See Marx, Karl, *Capital: A Critique of Political Economy*, vol. 1, New York: International Publishers, 1967.

6 Klein, "Conférence à la Sorbonne in Klein", *Dépassement*, p. 125.

7 Klein, "Des bases (fausses), principes, etc. et condamnation de l'évolution", *Dépassement*, p. 23.

8 Frédéric Migayrou explores the architectural implications of this relation between body, space, and sensibility, transformed into Klein's *Air Architecture* project and echoed in the work of Arte Nucleare, Groupe Espace, Situationist International, and Groupe Expérimental d'Architecture Mobile in "Architectures of the Intensive Body", in *Yves Klein: Retropective*, Frankfurt: Schirn Kunsthalle, 2004.

9 Klein, "L'aventure monochrome", *Dépassement*, p. 233.

10 O'Doherty, Brian, *Inside the White Cube: The Ideology of the Gallery Space*, Berkeley: University of California Press, 1986; Juli Carson, *Dematerialisms: The Non-Dialectics of Yves Klein in Air Architecture*: Yves Klein, Ostifidern-Ruit: Hatje Cantz Verlag, 2004.

11 Klein, "Préparation et présentation de l'exposition du 28 avril 1958", *Dépassement*, p. 85.

12 For an excellent discussion of the French neo-avant garde's complicity with the spectacularisation of experience, see Benjamin H D Buchloh, "Plenty or Nothing: From Yves Klein's *Le Vide* to Arman's *Le Plein*" in *Premises: Invested Spaces in Visual Arts, Architecture and Design from France 1958–1998*, New York: Guggenheim Museum, 1998. I extend Buchloh's analysis by suggesting that Yves Klein initiates a new aesthetic that goes beyond a mere submission to spectacle; the historical context is such that any form of critical negation can only occur from within the seemingly seamless shroud of spectacle via its ritualisation or fetishisation.

13 The importance of the mimetic faculty is articulated by Walter Benjamin in "On the Mimetic Faculty", *Reflections*, Peter Demetz ed. and intro., New York: Schocken Books, 1978. I am interested in developing the implications of Klein's creation of a monochromatic image to imitate abstraction, especially his use of the so-called mimetic copy as a means to harness and channel sensuousness into a mode of perception.

14 I am referring to the three paradigms of site specificity discussed by Miwon Kwon in "One Place After Another: Notes on Site Specificity", *October 80*, Spring 1997, pp. 85–110.

BAS JAN ADER / JO
JAMES LEE BYARS /
SOPHIE CALLE / WIL
SPENCER FINCH / DAN
GONZALEZ-TORRES /
DONALD JUDD / ANI
YVES KLEIN / BRUCE
OITICICA / GERHARD
RIST / ANRI SALA / JA
ANDY WARHOL

SEPH BEUYS /
LOUISE BOURGEOIS /
LIAM EGGLESTON /
FLAVIN / FELIX
MONA HATOUM /
SH KAPOOR /
NAUMAN / HÉLIO
RICHTER / PIPILOTTI
MES TURRELL /

BAS JAN ADER

In 1963, aged 21, Bas Jan Ader arrived in Los Angeles having sailed from Morocco, across the Atlantic Ocean, the only deckhand on board a 13ft yacht. Here Ader studied philosophy and art and quickly became influenced by the burgeoning conceptual and performance based art scene of the West Coast. Gordon Matta Clark, Robert Smithson and Ed Ruscha were contemporaries, as were Chris Burden and Bruce Nauman, with whom he shares a clear affinity in respect of how the body is articulated in space and under states of duress.

Ader's unique body of work comprises actions carefully documented in photographs, film and books and on audio and video tapes. The work he created in this way has been increasingly recognised for its curious and yet powerful fusion of melancholic romanticism, affect, pathos and absurdity. Among his most well known actions are those documented by film in 1970 and 1971, in which the artist's body is overtaken by gravity. In *Fall I*, 1970, Ader falls from the roof of his house into a shrubbery and in *Fall II*, of the same year, he rides a bicycle into a canal in Amsterdam whilst still clutching a bunch of flowers. *Broken Fall (Organic)*, 1974, in which the artist hangs from the branch of a tree before eventually, climactically, falling into a meadow below is complemented by its binary opposite, *Broken Fall (Geometric)* of 1971. In another extraordinary work from this period, *I'm Too Sad To Tell You*, the artist is filmed, apparently overwhelmed by his emotions, weeping and unable to communicate.

Primary Time, 1974, follows the artist methodically arranging and re-arranging a vase of flowers; the three primary colours are mixed, then segregated and then finally mixed again. The art historian Thomas Crow has described this work as Ader's "wry homage to and mockery of Mondrian, Rietveld and the floral clichés of his native country".[1]

In *Farewell to Faraway Friends*, 1971, Ader portrays himself as a lone figure silhouetted against a vivid ocean sunset in a calculated re-working of *The Wanderer above the Sea of Fog*, 1818, a painting by the nineteenth century German artist Casper David Friedrich. A philosophy of the sublime informs this work, as well as his last, *In Search of the Miraculous*, intended as the second part in a projected triptych, an attempt to document his single handed return voyage across the Atlantic, this time from Cape Cod to Falmouth in England. Ader set off on 1 July 1975 but tragically was never to reach his destination; his boat, the Ocean Wave, was eventually recovered off the coast of Ireland in April 1976; the artist lost at sea. Crow has written about this last work and the manner of his death as "a bridge too far", addressing the tragedy of an artist intent on using his "own fragile body, dwarfed and lost in a global span" as a means to reconcile the cultural legacies of Europe with those of West Coast America.[2] Art critic Jörg Heiser, by contrast, pinpoints the "unreal fable that completes his work"; the irony of his death reflecting the ultimate romantic trope, the death of beauty by drowning. Heiser equates that loss, in this case the artist's own death, with the loss of the art object within conceptual practice.[3] Whichever way you read Ader's complex and moving body of work, it is apparent that his death which is tragically integral to it, cannot help but influence how we perceive the rest.

1 Crow, Thomas, *Bas Jan Ader: A Bridge Too Far*, Brad Spence ed., Irvine, CA: The Art Gallery, University of California at Irvine, 1999, pp. 13–15.

2 Crow, *Bas Jan Ader: A Bridge Too Far*, pp. 13–15.

3 Heiser, Jörg, "Emotional Rescue", *Frieze*, no. 71, November/December 2002.

Farewell to Faraway Friends 1971

Primary Time 1974

COLOUR AFTER KLEIN

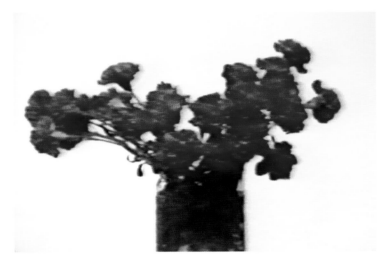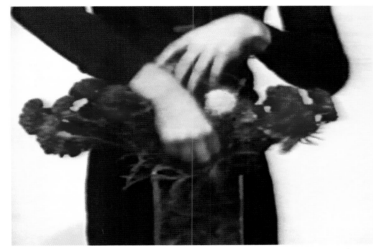

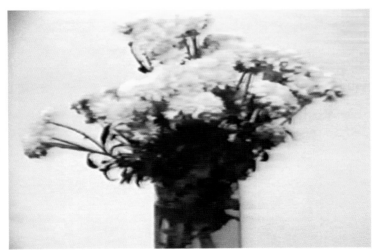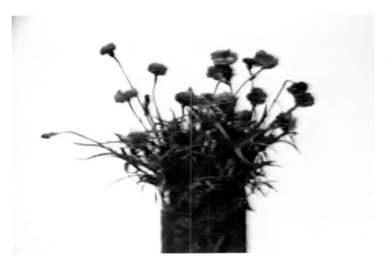

JOSEPH BEUYS

The German artist Joseph Beuys is one of the most influential and inspiring artists of the post war period. Legend has it that he was shot down in his plane over the Crimea in 1943, whereupon he was rescued by Tartars who tended to his wounds by covering him in felt and animal fat. These unorthodox materials subsequently became the building blocks of his artistic vocabulary, symbolic of energy transmission and nurturance. Whether the story, a key moment in his own personal mythology, is factually true or not, is largely academic. Indeed, Beuys's complex and open ended body of work, which incorporates sculpture, installations, performance, drawing and socio-political actions, lends itself to multiple interpretations that are still keenly elaborated and contested.

A protean creator of sculptural forms and assemblages, as well as a draughtsman of extraordinary delicacy, Beuys developed a formative interest in natural history, alchemy and the spiritual, which is reflected throughout his practice. He was the first artist in the post war era to confront the Nazi period; many of his works make actual or implicit reference to the impoverished conditions of the concentration camps and the chilling and unforgettable atrocities that were conducted there.[1]

Beuys's association with the European Fluxus movement in the early 1960s was of critical importance in the progression of his work, especially with regard to their anarchic use of materials and the central place of multi-disciplinary performance strategies. However, opposed to the anti-art ethos of neo-Dadaists within Fluxus, Beuys quickly established his own unique performative aesthetic. In an action such How to explain pictures to a dead hare, 1965, Beuys developed the persona of the shaman figure, the bearer of healing wisdom.

For Beuys, art, politics and teaching were inseparable and this led him to conceive of an expanded field for sculpture that encompassed socio-political engagement. To this end he was involved in the founding of a number of activist groups including the German Student Party in 1967, the Organisation for Direct Democracy by Referendum in 1970 and the Free International University in Düsseldorf in 1972. He was also a founding member of the Green Party and stood for the Eurpoean Parliament in 1979. Lectures held an important place in Beuys's unconventional pedagogy and these in turn informed his skill as a draughtsman. His spontaneous diagrams drawn in chalk on blackboards are filled with notations concerning the role of art in relation to education, science, politics, the environment and culture. The blackboards were both records of the performance and became autonomous pieces of art in their own right. They exemplify the artist's life long endeavour to improve society.

Another way in which Beuys sought to democratise art was in the development of an extensive body of works conceived as *Multiples* (objects produced by the artist in a number of identical copies), of which there are well over 500 separate subjects in total. Like the blackboards they encapsulate all aspects of Beuys's work. "If you have all my multiples, then you have me entirely."[2] One of Beuys's last multiples, *Capri-Battery* of 1985 demonstrates the fusion of nature and culture that is a consistent motif throughout Beuys's oeuvre.

1 See particularly Gene Ray, "Joseph Beuys and the After-Auschwitz Sublime" in *Joseph Beuys: Mapping the Legacy*, Sarasota, FL: The John and Mabel Ringling Museum of Art, 2001, pp. 55–74.

2 Beuys, Joseph, reported remark to the collector Günther Ulbricht, quoted in Peter Nisbet, "In/Tuition: A University Museum Collects Joseph Beuys", *Joseph Beuys: The Multiples*, Jörg Schellmann ed., Minneapolis, MN: Walker Art Center, 1997, p. 11.

The dazzling light that emanates from Beuys's nature-powered bulb in *Capri-Battery* is in marked contrast to the density of the superficially ugly or 'poor' materials and colours that are emblematic of his work. Two of the most significant of these are grey felt and a dense oil based brown paint that Beuys used as a signature colour and to which he gave the name *Braunkreuz* (Brown-cross). Beuys's stated intention in using these colours was to provoke their "complementary opposite" — that is that they should have the same effect as *Capri-Battery*, that in looking there might arise within our perceptual or feeling apparatus, a sense, not of darkness, but light:

> **Nobody bothers to ask whether I might not be more interested in evoking a very colourful world as an anti-image inside people with the help of this element, felt.... And I'm not interested in dirt either. I'm interested in a process which reaches much further.**[3]

However, Beuys's work is inherently multi-layered and the association that links his *Braunkreuz* to the earth and to Nazi symbolism cannot be overlooked: the alternative readings serve only to enrich each other.

In many ways, Beuys was his own most successful creation; his artistic persona embodied every aspect of his work. As the art historian Donald Kuspit has suggested, "Beuys's exhibition of himself and his art 'of his body self as art' was a profound act of giving."[4]

Capri-Battery 1985

3 Beuys, Joseph, interview with Jörg Schellmann and Bernd Klüser, "Questions to Joseph Beuys" in *Joseph Beuys: The Multiples*, p. 11.

4 Donald Kuspit, "The Body of the Artist" in *Joseph Beuys: Diverging Critiques*, Liverpool: Tate Gallery Liverpool, Critical Forum Series, vol 2., p. 103. Originally published in *Artforum*, Summer 1991 pp. 80–86.

For Brown Environment 1964

COLOUR AFTER KLEIN

Schmela 1966

COLOUR AFTER KLEIN

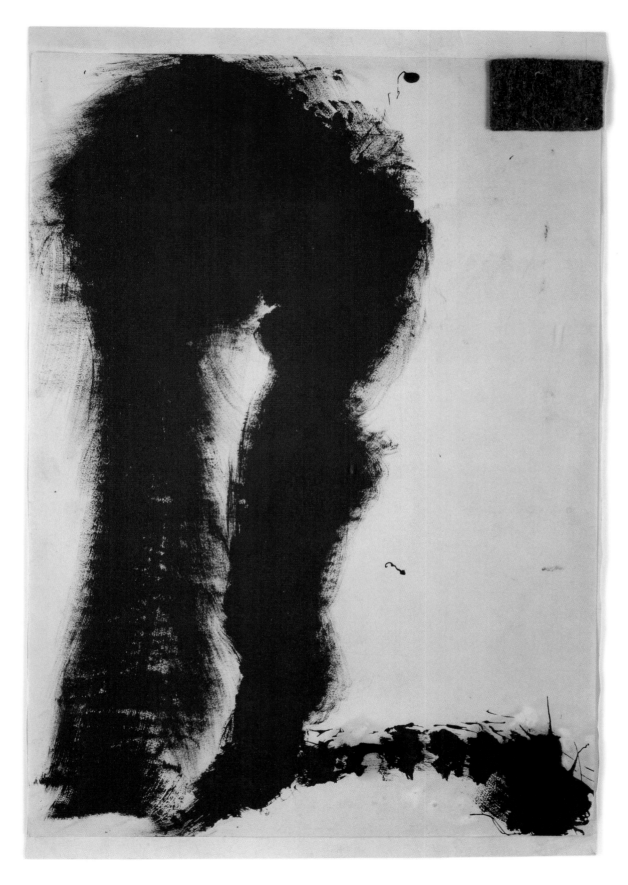

Felt Action 1963

LOUISE BOURGEOIS

"For me sculpture is the body. My body is my sculpture."[1]

Over the course of a career that spans more than half a century, Louise Bourgeois has consistently made work, principally drawing, sculpture and installation, that is intimately connected to her own biography but which nonetheless addresses universal human experiences, such as fear, vulnerability, loss, desire, anger and jealousy. Not surprisingly, given the subject matter of her work, Bourgeois thinks of herself as essentially an existential artist.[2]

Bourgeois's early family life in France was culturally rich but also fraught with tension. Her memories of this period, especially the undercurrent of secrets and lies that resulted from her father's prolonged affair with her live-in tutor, still inform much of her work. Bourgeois's mother and father owned and ran a prosperous tapestry gallery and restoration studio. A love of materials, sumptuous imagery and narrative must have been born in her at that moment, as well as an appreciation of both drawing and making, with motifs that centre on thread and sewing scattered throughout her work. Bourgeois has commented however, that unlike her mother, who was in the business of reparation, she herself must "destroy, rebuild and destroy again".[3] The premature loss of her mother in 1932, who Bourgeois as a young woman nursed on her deathbed, exacerbated the pain of familial ties.

Bourgeois moved from Paris to New York in the late 1930s when she married her new husband, the art historian Robert Goldwater. She began her career as a painter with *Red Night*, 1946–1948, announcing the important place of colour, especially the signature use of blue and red across all of her work. A swirling vortex of red dominates the painting, in which an icon-like maternal figure, a self-image of the artist, is set adrift with her infants that take the place of breasts and vagina. Bourgeois gave up painting for sculpture soon after, but the integration of colour in her work has remained of critical importance.

Since 1950 Bourgeois has established a personal and powerful vocabulary of visceral forms that centre on her experience of the body as a site of complex feelings.

Topiary IV 1999

1 Bourgeois, Louise, quoted in Jerry Gorovoy and Pandora Tabatabai Asbaghi eds., *Louise Bourgeois: Blue Days and Pink Days*, Milan: Fondazione Prada, 1997, p. 12.

2 Interview with Paolo Herkenhoff, *Louise Bourgeois*, London: Phaidon, 2003, p. 14.

3 Bourgeois, quoted in Gorovoy and Tabatabai Asbaghi eds., *Louise Bourgeois: Blue Days and Pink Days*, p. 21.

Three-dimensional work has been realised in an extraordinarily diverse range of materials that includes plaster, marble, bronze, glass, textiles, latex, aluminium and found objects. Drawing, diary keeping and note-taking provides a continuous outlet for Bourgeois's creativity and there is a marked synchronicity between the colouration of work in two- and three-dimensions, suggesting that they are totally integrated practices.

During the 1990s, a large group of so-called *Cells* dominated Bourgeois's output. Of these, the two *Red Rooms*, from 1994, are among the most important and mark the climax to Bourgeois's insistent use of the colour red. Allusive and open to interpretation, Bourgeois's *Cells* are a place of refuge but also a trap, the cell both protects and imprisons. Evocative of the womb, *The Red Room* is lonely but cradling, alluring but with a presentiment of danger.

Red Night 1946–1948

The Colour Red 1994

The Red Room (Child) 1994

COLOUR AFTER KLEIN

The Red Room (Parents) 1994

JAMES LEE BYARS

Internationally renowned, Byars's work is exemplified by minimal hermetic forms, reduction towards essence and absence, with an acute sense of the ephemeral. His persona was vital to his oeuvre, as he physically embodied the sensual aesthetic materialised in his work. He has been described as a mysterious, quiet man, surrounded by stillness, with a cultivated nature that imbued him with an aura of the exquisite. Beginning with his travels to Japan, but also drawing on philosophical and alchemical interests, he developed a unique aesthetic that centres on a search for the perfect form and the perfect idea, and their synthesis. All in all, his diverse oeuvre defies easy categorisation and many of his actions and performances, although legendary, were rarely recorded.

For Byars, gold was a sign of the transcendent, analogous to light and "untouched by time and change", with black being its complement.[1] As Carl Haenlein has noted, Byars was searching "between the brightest light and the most extreme darkness for the Absolute, for the perfect".[2] Enigmatic works like *The Red Angel of Marseille*, 1993, a work comprising of 1000 Venetian glass spheres, reveal a striving for transcendence, as does the perfectly formed *Eros*, 1992, an homage to love. *The Rose Table of Perfect*, a sphere comprising of 3,333 red roses which slowly wilt, is a reflection of Byars's endeavour to express the transitory character of beauty and perfection.

The sumptuous sculptures that make up his extant oeuvre were complemented by a commitment to performance and actions, suggesting an affinity with Fluxus and text-based conceptual artists. Equally influential in this respect was the time Byars spent in Japan in the early 1960s, where he was inspired by both Zen Buddhism and Nō Theatre and where he studied traditional Japanese ceramics and papermaking. He pursued the Zen notion of the ephemeral in series of 'performable sculptures' dating from the early 1960s, in which paper strips measuring as long as 1,000 feet were slowly unfolded in elegant public performances and in another 'performable sculpture' a mile of gold thread was launched with a helium balloon.

→

1 Sartorius, Joachim, quoted by Carl Haenlein, "James Lee Byars: the Epitaph of Con. Art is which Questions have Disappeared?" in *James Lee Byars: the Epitaph of Con. Art is which Questions have Disappeared?*, Hannover: Kestner Gesellschaft, 1997, p. 202.

2 Haenlein, "James Lee Byars: the Epitaph of Con. Art", p. 203.

The Rose Table of Perfect 1989

Overleaf:
The Black German Flag 1974

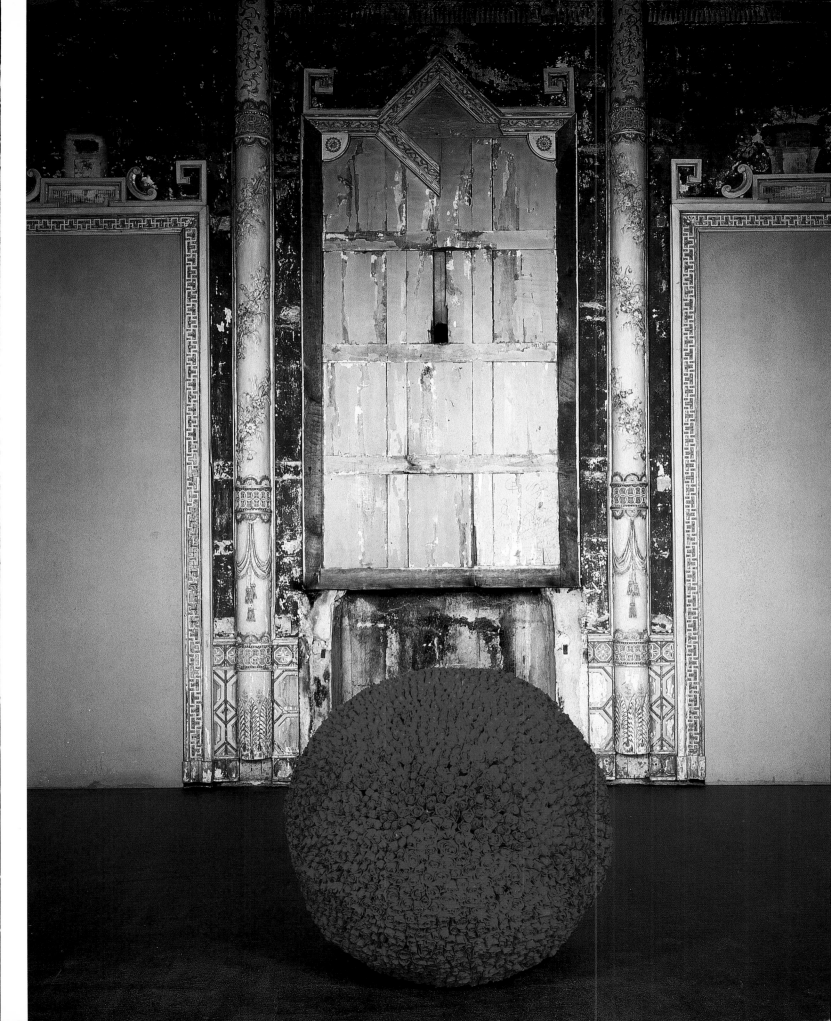

Philosophically inclined to assert the primacy of the question over the answer, in 1962 Byars made a work in which thousands of clear balloons printed with tiny question marks were distributed in New York, and in a work entitled *The Extraordinary Student in Philosophy*, 1969, Byars visited Oxford University to investigate the most important questions of our time. Equally, in another seminal work from 1969 the artist sent out 300 copies of white crinkly ribbon, on which he had written: "The Epitaph of Con. Art is which Questions have Disappeared?". Characteristically ambiguous, it is not clear if Byars is here referring to Conceptual Art or Contemporary Art, but inherent in the work is a plea for the metaphysical and an aesthetics of beauty that he felt was lacking in the art of his time. Not just concerned with aesthetic questions however, Byars created a provocative black German flag in 1974, which asks the question: "Move all the Js from I back to G?" (Move all the Jews from Israel back to Germany?).

Byars was noted for his beautifully and cryptically formed letters sent to friends and supporters, sending over 100 letters to Joseph Beuys over a period of 16 years, which were never replied to. However, the two artists met regularly and ultimately the letters were not written with the intention of receiving a response, but were elaborate, fragile manifestations of formative ideas.

Eros 1992

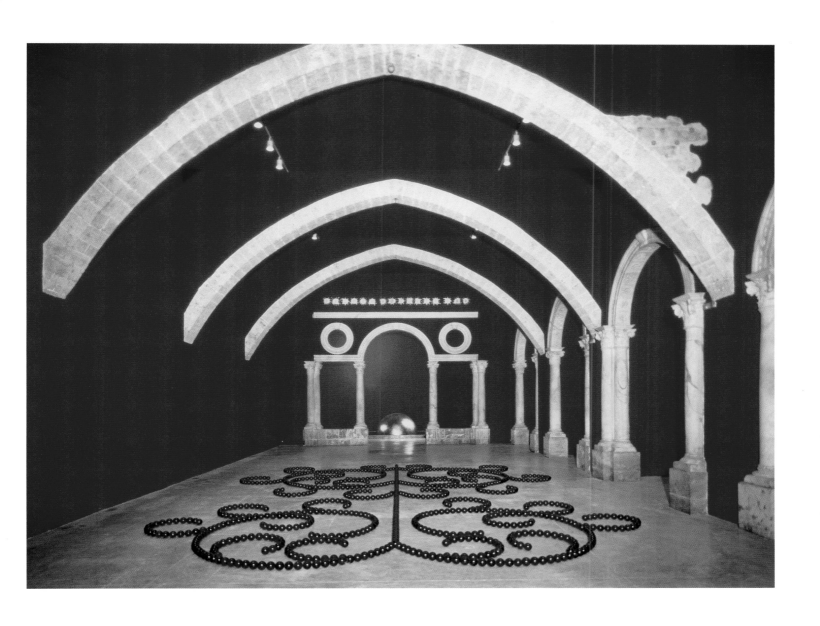

The Red Angel of Marseille 1993

SOPHIE CALLE

Considered one of France's foremost conceptual artists, Calle has produced work over the last three decades in the form of installations and photographs, accompanied by texts, many of which she has presented in book form. Calle has principally investigated the barriers and boundaries between public and private life as voyeur and provocateur.

Fond of rituals and ceremonies, Calle likes to probe the ways in which we control, or indeed fail to control ourselves. Since her return to France in 1979, following extended adventures abroad, Calle has made it her business to follow and blatantly spy on strangers, with results that illustrate human vulnerability and tend towards pathos.

Calle's work is autobiographical in the sense that it is based on her own experience of tracking her body in relationship to others in a way that is precise and systematic rather than sentimental. Photography and text are utilised to provide descriptive accounts of actions. In the celebrated 1980 work, *Suite Vénetienne*, Calle followed a stranger who boarded a train in Paris, shadowing her quarry all the way to Venice. Calle is effaced in her pursuit of the other, who in turn is robbed of something of himself. The artist loses control only to regain it through adopting a direction and having a function—Calle explained: "My only reason for doing this was that since I had lost the ability to know what to do myself, I would choose the energy of anybody in the street and their imagination and just do what they did."[1]

In the novel *Leviathan*, by Paul Auster, which is loosely based around the character of Sophie Calle, her alter-ego Maria Turner indulges in what she calls "The Chromatic Diet". During the week of 8–14 December 1997, Calle enacted this same dietary regime in order to 'become' the heroine of the novel. Tuesday found her eating Red, with the imposed menu being, "Tomatoes, Steak Tartare and Pomegranates". She completed the menu with "Roasted red peppers", and drank "Lalande de Pomerol, Domaine de Viaund, 1990". This work, a play on Modernism's fascination with the monochrome, exposes the tenuous boundary between her life and work, reality and fiction.

Another strategy that Calle employs is to become the interlocutor rather than the subject of her work. In the series *The Blind*, 1986, Calle asked a group of people who were born blind their idea of beauty. Their responses range from the prosaic to the poignant, with Calle's authorial distance lending this work a certain sobriety. Calle's probing question forces the interviewees to contemplate their relationship to objects or phenomena they perceive as beautiful, many of which must exist within the realm of the imagination.

The strength of Calle's work lies in her ability to evoke and challenge the limits of human experience and behaviour, surreptitiously invading and helping to redefine our own daily rituals and obsessions.

1 Quoted in "Sophie Calle in Conversation with Bice Curiger", in *Talking Art I*, Adrian Searle ed., London: Institute of Contemporary Arts, 1993, p. 30.

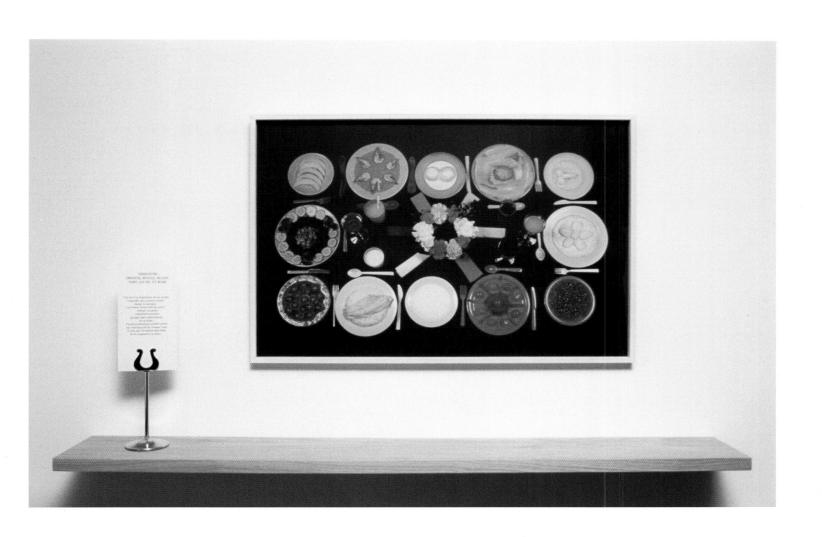

The Chromatic Diet 1997

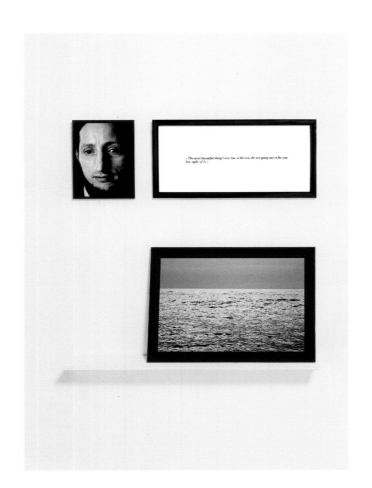

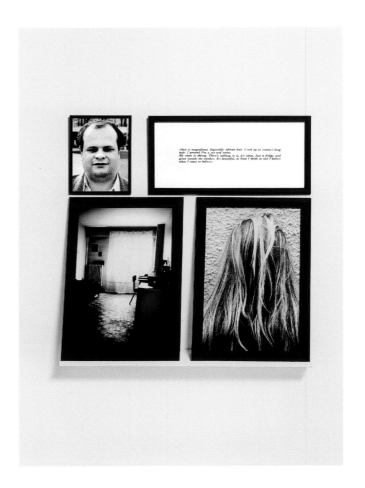

"I met people who were born blind.
Who had never seen.
I asked them what their image of beauty was."

The Blind 1986

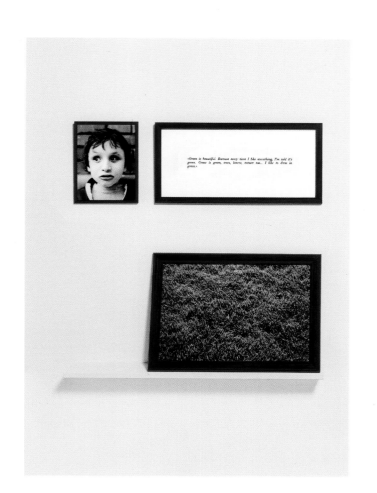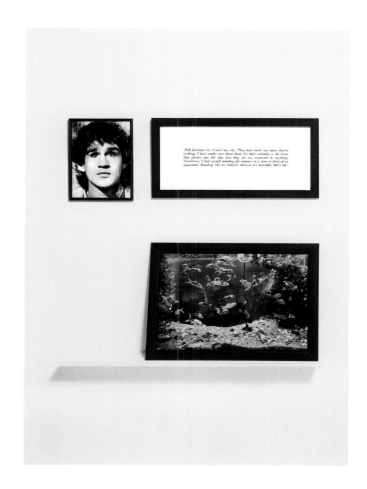

WILLIAM EGGLESTON

William Eggleston's brilliantly coloured photographic images are grounded in the Deep South community in which he has always lived, revealing a fascination for the mundane, the kitsch, the off-beat and the beautiful; all intimately observed. Colour has been an essential means to convey the reality of that which he observes and records through the lens of a camera. In the late 1960s photography was dominated by a black and white reportage style of image making and colour was disparagingly associated with its commercial use in advertising and magazine journalism. Eggleston's groundbreaking work was to change all that.

Early on in his career, Eggleston embraced the straight-forward frontal purity of the photographer Walker Evans, but under the influence of Henri Cartier-Bresson began to incorporate stark angles into his work. In 1965 and 1966 he momentously first experimented with colour photography, switching exclusively to colour negative film in 1967 and colour transparencies or Kodachrome in 1969. However, his most important innovation came as a result of discovering dye-transfer printing in 1973. The highly saturated colour effects he achieved this way gave his images an air of hyper-reality. The disparity between the richness of the dye-transfer medium and the banal subject matter Eggleston favours is key to appreciating his work.

His most well known image, *The Red Ceiling*, officially titled *Untitled (Greenwood Mississippi)*, 1973, is one of the first he produced using the dye-transfer technique. Taken from a characteristically awkward angle its apparent casualness is emblematic of Eggleston's work. The 'red room' belonged to Eggleston's very good friend, Dr Boring, a dentist in Memphis, who is also pictured naked in his grafitti covered bedroom in the earlier photograph *Untitled (Greenwood, Mississippi)*, c. 1970.

Eggleston has continued to chart an entire seam of anti-heroic subject matter and has brought to the photographic genre a unique, democratic way of looking. His dedication to showing the beauty, humour and horror found in the minutiae that surrounds us, has been enormously influential for successive generations of photographers and filmmakers alike.

The psychological intensity of Eggleston's domestic interiors are here contrasted with their absolute counterpoint, two images from his vast *Wedgwood Blue* series of 1979; the moment when Eggleston pointed his camera at the sky and shot.

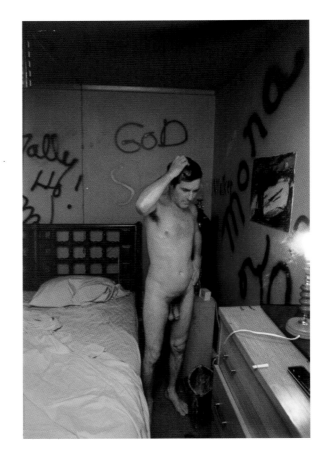

Untitled (Greenwood, Mississippi) c. 1970

Untitled (Greenwood, Mississippi) 1973

Wedgewood Blue 1979

COLOUR AFTER KLEIN

Wedgewood Blue 1979

Untitled (Poster in Hallway) Memphis, TN 1970

From the Seventies: Volume Two c. 1970

SPENCER FINCH

"There is always a paradox inherent in vision, an impossible desire to see yourself seeing. A lot of my work probes this tension; to want to see, but not being able to." [1]

In work that is whimsical and visually compelling, yet highly considered, Spencer Finch explores the realms of perception and memory. Working across a variety of media including photography, drawing, painting, light installations and stained glass, he focuses especially on colour and light to probe the truth of a given situation or context. Finch first came to prominence in the mid 1990s with works such as *Trying to Remember the Colour of Jackie Kennedy's Pillbox Hat*, 1995, which comprises over 100 combinations of pink, the artist's attempt to pinpoint the exact hue of the first lady's hat on the day John F Kennedy was assassinated. In so doing, Finch willingly taps into the collective activity of remembering. In a related work, 102 Rorschach notations constitute the process of remembering the colour of his nocturnal dreams.

Finch's practice is as much about not seeing as it is about seeing. A traveller of both space and time, interior and exterior spaces, Finch seeks to accurately represent the light and colour found at cultural landmarks and imagined mythological sites. Examples include the ceiling above Freud's couch; the sky over Roswell, the place of many UFO sitings in the United States, as well as the viewpoint that Icarus must have had when he fell from the sky into the Ikarian Sea. In a stained glass work installed at ArtPace, San Antonio, the sandblasted coloured glass diffuses the summer light of Texas at midday to transform it into the exact light of dusk in Paris on 8 January 2003.

In light installations such as *Blue (sky over Los Alamos, New Mexico, morning effect)*, and *Night Sky (Over the Painted Desert, Arizona, 11 January 04)*, Finch uses configurations of light bulbs to give carefully calculated representation to the atomic/molecular constituents of coloured pigment that in turn mirror the particulars of the colour of light in a given place. In this way Finch, mirroring Newton's prismatic experiment, "takes light apart and puts it together again". [2]

Finch's work is a rare blend of the conceptual and the aesthetic which serves to remind the viewer of how difficult it is to represent the light and colour we see and even more so, our memory of it.

1 Finch, Spencer, quoted in Rondeau James, *Matrix 133*, Hartford: Wadsworth Atheneum, 1997.

2 Finch, Spencer, in conversation with Jane Alison, 13 February 2005.

Sky (Over Roswell, New Mexico, 5/5/00, dusk) 2000

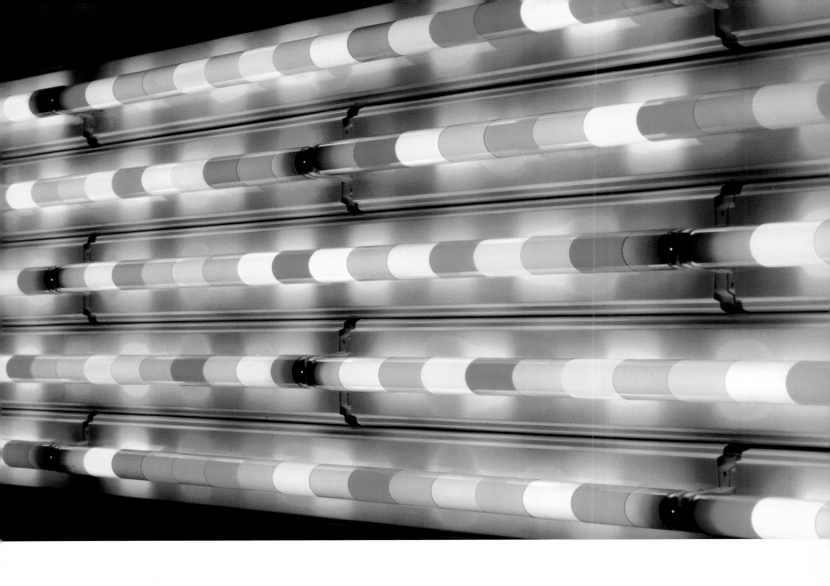

Sunset (South Texas 6/21/03) detail 2003

Overleaf: *102 Colours from my Dreams* 2000–2002

pp. 86–87: *Paris/Texas*
(France at dusk on January 8, 2003) 2003

DAN FLAVIN

"It's obvious that colour as material and colour as light are extremely different.... There isn't any difference between the light and the colour; it's one phenomenon."[1]

For more than three decades, Dan Flavin rigorously pursued the aesthetic applications of fluorescent light. Exclusively using commercially available fluorescent tubing, which he limited to ten colours and five different shapes (one circular and four straight fixtures of different lengths), Flavin succeeded in elevating this mundane material beyond its functional context and inserting it into the world of high art. Alongside Donald Judd, Sol LeWitt, Walter de Maria and Carl Andre, also known for their systematic use of forms and materials, Flavin is considered one of the primary exponents of Minimalism.

In the summer of 1961, while working as a guard at the American Museum of Natural History, New York, Flavin started to make sketches for sculptures in which electric lights were incorporated. Later that year, he made his first light sculptures that he called "icons", an ironic reference to religious objects; these icons consisted of eight painted boxes with fluorescent and incandescent light fixtures attached to the structures. As with much of his later work, Flavin dedicated these early pieces to a host of memorable figures from history as well as personal friends and acquaintances.

Flavin's earliest fluorescent works were conventionally installed on walls. However, he soon began to explore the possibilities of light within architectural spaces as well as those suggested by the margins and corners of rooms. In 1964, at Flavin's first solo exhibition at the Green Gallery in New York, the artist hung a primary picture, 1964, at the edge of the gallery wall, adjacent to a doorway. In occupying the edge, where wall meets empty space, Flavin abandoned the conventional space of art and allowed the art object to address the interior in a new way. With an ironic twist, Flavin constructed the fluorescent lights as a rectangle surrounding a void, mimicking the shape of a picture frame and mocking the rigid traditions of art.

the diagonal of May 25 1963

Flavin's breakthrough with fluorescent light was the diagonal of May 25, 1963 (to Constantin Brancusi). In this seminal work—the artist's first to use fluorescent light alone—Flavin eliminated the square box of the icons, and instead positioned a single, unadorned yellow fluorescent light at a 45 degree angle against a wall in his studio.

Because coloured light behaves differently than pigment, Flavin's works often defy the expectations of viewers, who are frequently surprised and amused by the discovery of the properties of light. For example, mixing colours across the spectrum in pigment renders paint black; blending the colours of the light spectrum results, instead, in white light. This effect is illustrated in untitled (to Mr and Mrs Giuseppe Agrati), 1964, where pink, daylight, green and yellow combine to produce an ambient white light. Primary colours also vary between pigment and light. For pigments the primaries are red, yellow, and blue, whereas for light they are red, blue, and green (green mixed with red makes yellow light). Flavin acknowledged this difference in greens crossing greens (to Piet Mondrian who lacked green), 1966, a work dedicated to Mondrian—the Dutch modernist famous for his primary colour palette. This work by Flavin also demonstrates another intriguing property of light: green is the most brilliant fluorescent light, and its intensity can be so strong that it almost appears white. In contrast, fluorescent red is subdued. Because no mixture of phosphors can make a true red, the inside of the tube must be tinted, which in turn blocks the amount of emitted light. Thus, while red pigment is bold, red light, such as that seen here in the diagonal of May 25, 1963, is muted. Flavin's fluorescent red suggests violence and bloodshed, yet the overall tone is subdued and elegiac rather than menacing.

1 Judd, Donald, in fluorescent light, etc. from Dan Flavin, Ottawa: National Gallery of Canada, October 1969, re-printed in Donald Judd, Complete Writings, 1959–1975, Halifax and New York: The Press of the Nova Scotia College of Art and Design and New York University Press, 1975, pp. 199–200.

untitled (to Mr and Mrs Giuseppe Agrati) 1964

COLOUR AFTER KLEIN

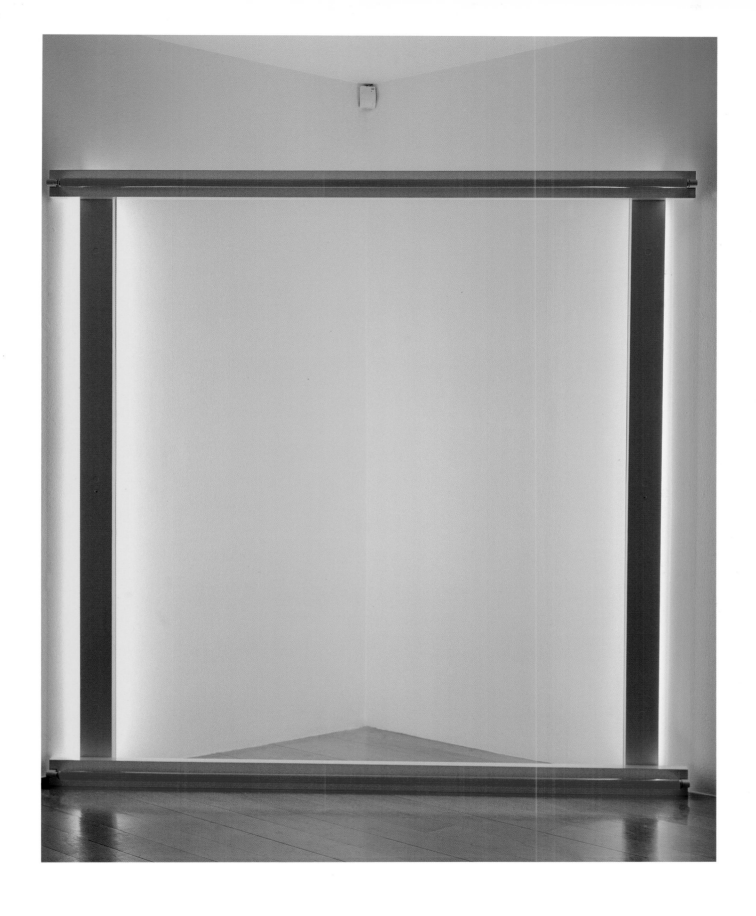

untitled (to Pat and Bob Rohm) 1969

FELIX GONZALEZ-TORRES

Felix Gonzalez-Torres created works that are relatively simple in construction yet rich in emotional content. His spare, elliptical work does not immediately declare its meaning but remains provocative, prompting the spectator to consider the pieces over an extended period, and producing multiple interpretations, all of which the artist considered valuable. This kind of open-ended exchange is characteristic of his refusal to conform to the stereotype of a political artist. He eschewed the role of a Latin American or queer artist or even an activist artist, while imbuing his work with subtle messages about his own perspective based on his particular experience as a Cuban-born, politically committed gay man.

Following the death of his partner from Aids, Gonzalez-Torres made a work to commemorate his birthday, comprising two bare light bulbs suspended from extension cords and entwined like a pair of lovers together in the dark as a metaphor for their relationship. This poignant work, sub-titled "5th March" and dating from 1991 was the forerunner of a number of so-called *Light-Strings* that followed. Installed in various permutations, the basic function of the *Light-String* is to enliven the environment as is traditional at dances, parties and celebrations in Cuba, and indeed the world over. In these apparently simple works, Gonzalez-Torres intended to give form to the inner light of humanity and illuminate the lives of his audience by stimulating their creativity.

A related strategy of interaction and interdependency between the artist, the work and the viewer also informed Gonzalez-Torres's *Candy Spills* begun in 1990. The *Spills* were conceived in differing colours and in all cases featured copious amounts of wrapped sweets, designed to be either heaped in corners or spread out like a carpet on the floor. The viewer may choose to take a sweet, remove or consume it, thereby partaking in the work and depleting and altering its form within the exhibition space. As such, the *Spills* have a formal sculptural quality as well as the potential for dematerialisation. When viewers remove a sweet, the physical manifestation of the work becomes disseminated; it exists in multitude, testing the boundaries of authenticity and ownership. The constant depletion and refreshment of the work is strongly suggestive of loss and renewal.

The *Candy Spills* come with a certificate that indicates the original format of the *Spill* but more importantly names and specifies the responsibilities attached to owning the work. The certificate also describes the original candies (sometimes a specific kind of sweet is integral to the piece, in others it is the colour of the sweet or wrapper). The owner, or any borrower, has the right to install the work as they wish.

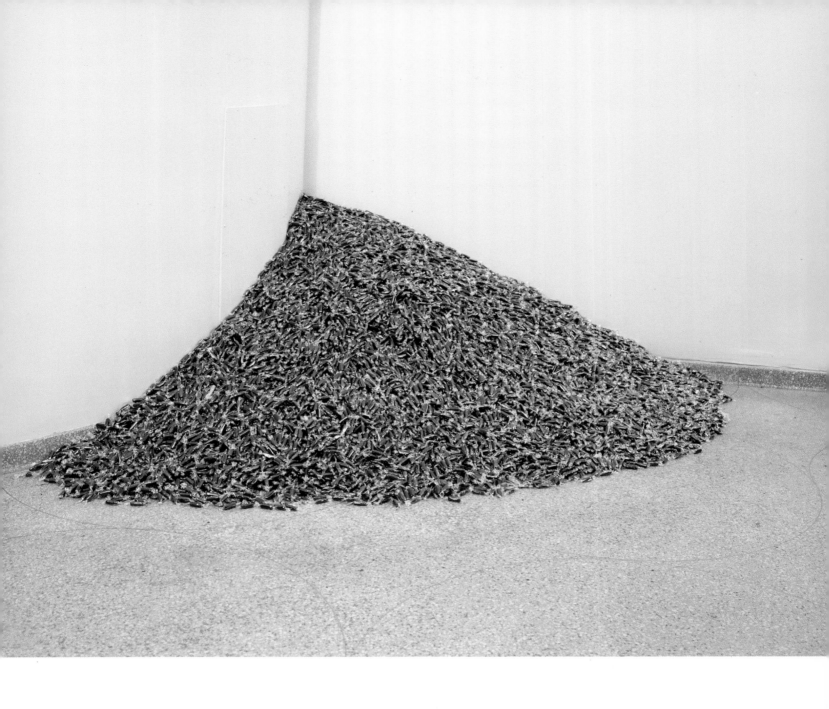

Untitled (Public Opinion) 1991

Overleaf: *Untitled (for Stockholm)*,
Kunstmuseum St Gallen, Switzerland 1997

MONA HATOUM

Making video, sculpture, large-scale installation, performance and actions, Mona Hatoum's diverse practice is characterised by a complex relationship between dialectical opposites: placement and displacement, boundaries and freedom of movement, activity and passivity, as well as the inscription of the corporeal into minimal forms. Hatoum demonstrates an acute sensitivity to the chromatic properties of materials, with black and steel grey predominating. Electric light and visceral colour is frequently used to punctuate her insistently dark oeuvre.

Hatoum became widely known in the mid 1980s for a series of intense performance and video work that centres on her own body. In early works such as *So Much I Want To Say*, 1983, and *Under Siege*, 1982, Hatoum set up a barrier between herself and the audience through devices such as plastic membranes, cages, veils, hoods and walls. Referencing ideas of imprisonment and physical duress through her actions, Hatoum was commenting upon the wider social forces at work in contemporary history, with specific reference to the volatile situation in the Middle East.

The Light at the End, of 1989, an installation created especially for The Showroom, a small gallery in London's East End, marked a turning point in Hatoum's aesthetic strategy. On entering the space the viewer is confronted by what appears to be a delicate group of six yellow lines etched in the darkness, which as they approach becomes a source of an uncomfortable heat that is also a barrier. Retinal pleasure is replaced by physical discomfort and psychological disturbance. Following on from this work Hatoum embarked on ever more dramatic large scale installations that aimed to engage the viewer in conflicting emotions of desire and revulsion, fear and fascination.

Many of Hatoum's more recent works have a strong graphic quality where horizontal and vertical lines repeatedly cut across the space, creating what the artist has called an "anatomised" space. *Quarters*, 1996, is immediately striking for its stark and barren appearance: four identical upright metal units of five levels each are squared off against one another. Characteristic of many of Hatoum's works, this installation sets up a coexistence of opposites—presence and absence, light and dark, motion and stillness. *Socle du Monde*, 1992-1993, an homage to Piero Manzoni, whose work of the same title was dedicated to Galileo, consists of a large black metal cube covered with metal filings which cling to magnets on the surface of the cube. The magnetic attraction and repulsion forces the filings into a convoluted, intestine-shaped pattern suggestive of a teeming organism.

The Light at the End 1989

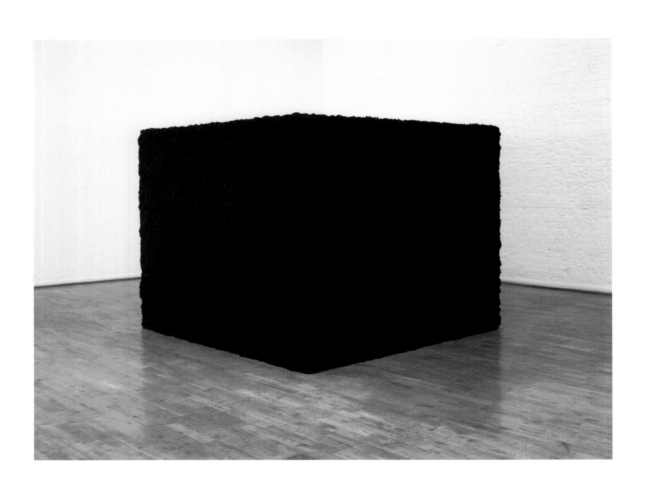

Socle du Monde 1992–1993

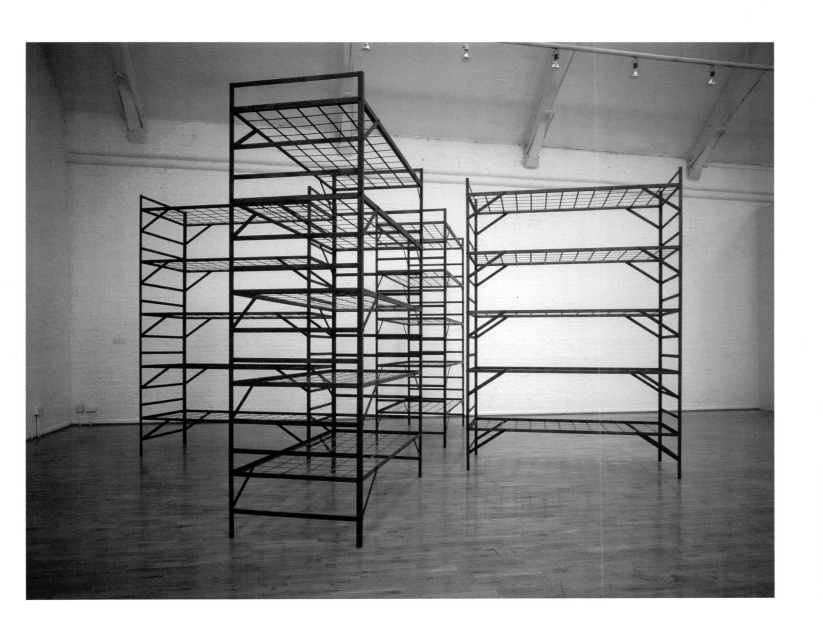

Quarters 1996

DONALD JUDD

"It's best to consider everything as colour."[1]

"My thought comes from painting even if I don't paint."[2]

In the early 1960s Donald Judd abandoned painting and the preoccupations of composition and illusionism associated with its European heritage in favour of creating symmetrical and insistently regular forms fabricated from industrial materials. He began by turning his paintings into three-dimensional reliefs, before moving to the realisation of free-standing structures that he named "specific objects" to denote their status as neither painting nor sculpture. Working at a time when American artists were actively resisting the commodification of art and were instead beginning to engage with unorthodox materials to expand the notions of sculpture and the art object, Judd became associated with the Minimalist tendency exemplified by the extreme reduction of forms to their geometric co-ordinates within a given space. For his part, Judd disliked the Minimalist tag, and his work, whilst incorporating the formal and conceptual rigour of Minimalism, extends it.

Despite having ceased painting in the conventional sense, Judd's interest in colour becomes ever more pronounced. He famously said that "material, space and colour are the main aspects of visual art".[3] Of these qualities, it is the field of colour which has tended until very recently to be overlooked in favour of the other two. As Dietmar Elgar concluded in his important exhibition *Donald Judd: Colourist* of 2000: "the way that colour primes objects with lyrical and atmospheric attributes, seemed hardly suitable for the rigorous formal language of Minimal Art, with the result that it was reduced by critics to no more than a means to distinguish different elements".[4] In fact, material, space and colour are each held in perfect balance within Judd's work and it was to colour, as well as space, that Judd turned to in his last essay, "Some Aspects of Colour in General and Red and Black in Particular" which was published on the occasion of his 1993 exhibition at the Stedelijk Museum. His friend and contemporary, Dan Flavin, recognised his achievement as a colourist from the start and made a beautiful fluorescent light work in dedication to this facet of his work; *untitled (to Don Judd, colourist)*, 1987.

Essentially, Judd believed that representation had hindered a full exploration of colour in art and his simple paired down forms were the ideal vehicle for seeing it anew. Like Joseph Beuys, Judd felt the chromatic resonance of materials too, especially corten steel with its dense, light absorbing brown surface, and copper with its lush, warm reflective surface. However, it is Judd's use of Plexiglas, a cast or extruded acrylic sheet, which the artist first discovered in 1964, that initially gave Judd both the chromatic range and subtle effects that he wanted. Plexiglas could be obtained in a massive variety of colours and could be transparent or opaque; and critically its colour was integral to it.

→

1 Judd, Donald, quoted by David Batchelor in *Donald Judd*, Nicholas Serota ed., London: Tate Gallery, 2004, p. 74.

2 Judd, Donald, quoted by Dietmar Elgar, "Introduction", *Donald Judd: Colourist*, Hannover: Sprengel Museum Hannover, 2000, p. 20.

3 Judd, Donald, "Some Aspects of Colour in General and Red and Black in Particular" [1993], on the occasion of Judd receiving the Sikkens Prize, awarded by Akzo, for the use of colour in art. Essay reprinted in full in *Donald Judd*, p. 157. Excerpt included here p. 168.

4 Elgar, "Introduction", *Donald Judd: Colourist*, p. 11.

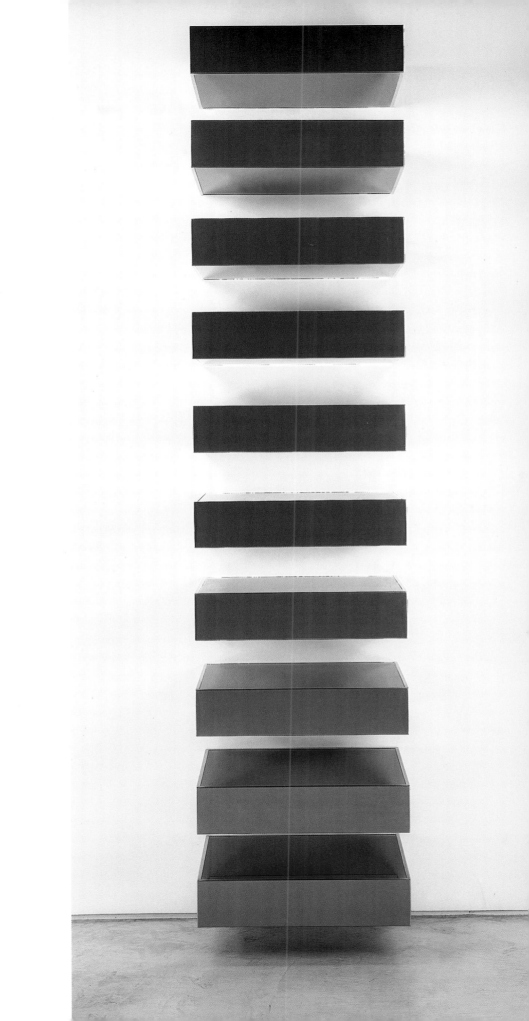

Untitled 1991

In 1963 the box, constructed of wood or metal, entered Judd's aesthetic vernacular and soon became his trademark. The open box was the ideal form for Judd as it was simultaneously a non-hierarchical enclosed and open structure. From the late 1960s onwards, he increasingly explored it, producing multiples and developing the internal structure of each, whilst also utilising alternative linings and internal divisions to explore the juxtaposition of materials and play of shadow and light on given surfaces. *Untitled* 1972, from the Tate Gallery collection, has a special place within Judd's oeuvre. The bottom of the box, painted with light cadmium red enamel, the colour that Judd most admired, is juxtaposed against the copper sides and exterior, the result of which is the creation of a mirage-like spectral haze that emanates from within the work as you approach it.

Four years after Warhol's exhibition of multiple repeat Campbell's Soup cans, working with his own simplified "objects", Judd introduced his so-called *Stacks* in 1966. Through these progressions or precise sequences of open and closed three-dimensional forms, Judd transferred the non-hierarchical formal properties of the rectangular box from the floor to the wall and significantly brought them into the eye line of the viewer. In the repetition of serial forms and spaces, these works literally incorporate space as one of its materials to create a play between positive and negative that coheres as a totality. Either as a regular system, or emphasising progressive change, these spatial arrangements produce a unified work, placing all the components in a harmonious and silent order that invites our consideration. In *Untitled*, 1991, a stainless steel and red Plexiglas *Stack*, the cool grey razor sharpness of stainless steel projections in space is off-set by the rich warm red glow that seeps from within each cut or division.

Paradoxically both simple and complex, Judd's oeuvre is characterised by an acute sensitivity to the physical properties of material, space and critically, light and colour, the latter which may in the end prove to be his finest legacy.

Untitled 1962
Judd Art © Judd Foundation. Licensed by VAGA,
New York/DACS, London 2005

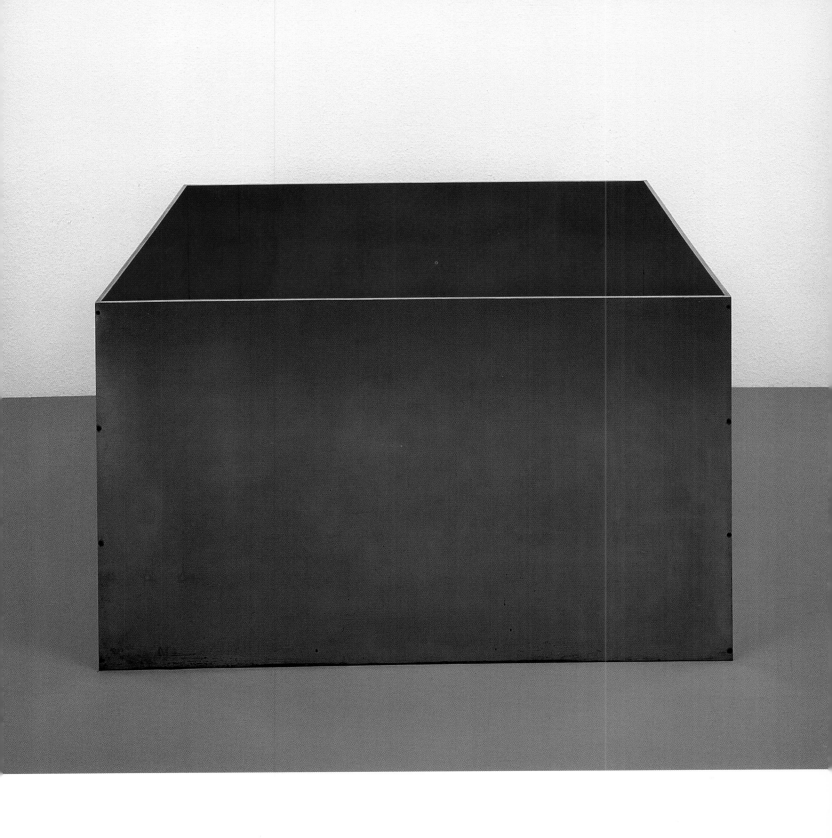

Untitled 1972

Untitled 1968

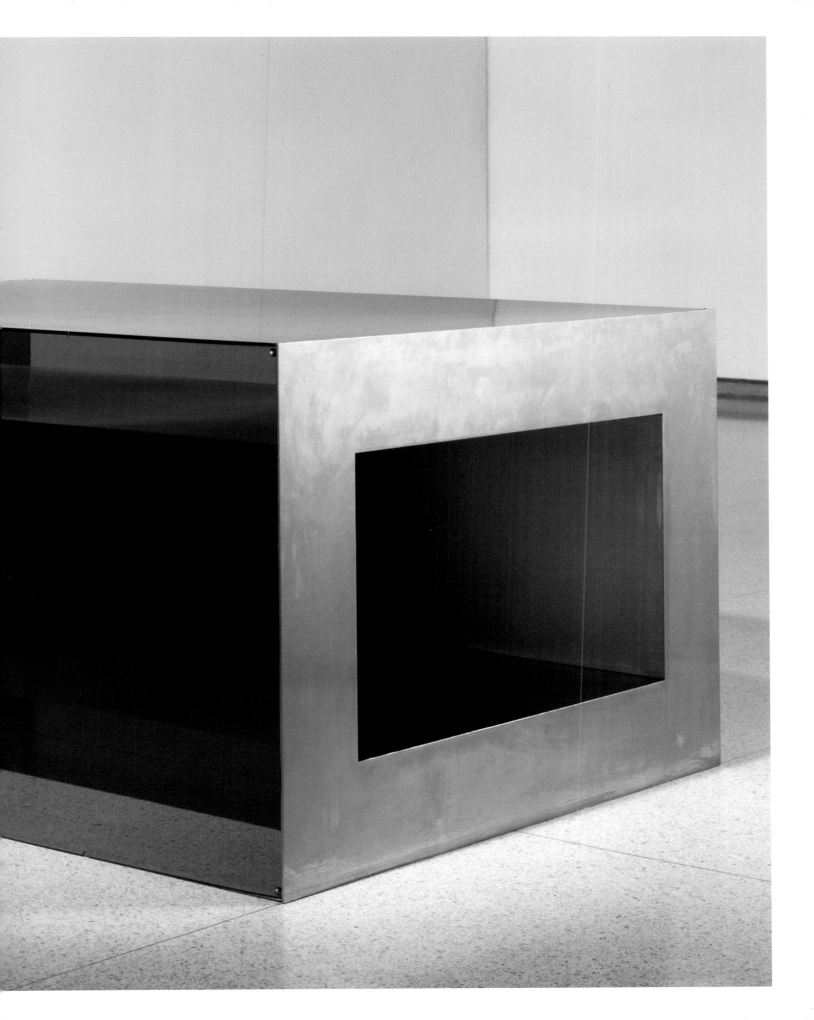

ANISH KAPOOR

"I think I am a painter who is a sculptor." [1]

Associated with a new wave of British sculpture that emerged in the early 1980s, Anish Kapoor gained international recognition with his early wall and floor based sculptures that blur the boundaries between sculpture and painting and are characterised by the use of pigment.

Over the past two decades, Kapoor has developed a multi-faceted body of work using such diverse materials as stone, marble, alabaster, stainless steel, aluminium, plaster, resins and glass. Kapoor's sculpture is constantly advanced through the regular practice of both drawing and painting. His sculptural investigation of material substances has been enriched by a powerfully evocative visual language dominated by archetypal forms, including the void, vessel, tower, pod, spiral and sphere. Through these simple universally resonant shapes, Kapoor's work explores such themes as presence and absence, weight and weightlessness, surface and space, the ocular and the aural, the solid and the intangible.

The conception of continuous space is central to Kapoor's practice. Early installations such as *Part of the Red*, 1981, and the larger *1000 Names* from 1980, unite the object with its architectural context; in part this is achieved through the signature spill of pigment that surrounds the objects themselves. The artist was interested in creating works that appeared as though still in a state of becoming, of growth; the limits of the forms hidden and unknown to the eye. This expanded field recalls the 'all-over' horizontal application of surface paint used by Jackson Pollock. Void space functions in Kapoor's work to engage and confound spatial perception. Polarities are suggested in the difference between outside and inside and light and darkness.

Kapoor's rich cultural heritage has had a formative effect on his work and he has acknowledged the influence on his art of both Western and Eastern culture. Ultimately, Kapoor's work relies on the viewer's individual associations to transform his spaces, enclosed and surrounding, and it is their experiences that bring the work to life. The interplay, between form, light, space, scale and colour evokes subliminal experiences, addressing physical and psychological primal states.

1 Kapoor, Anish, quoted in Douglas Maxwell, "Anish Kapoor",
 Art Monthly, May 1990.

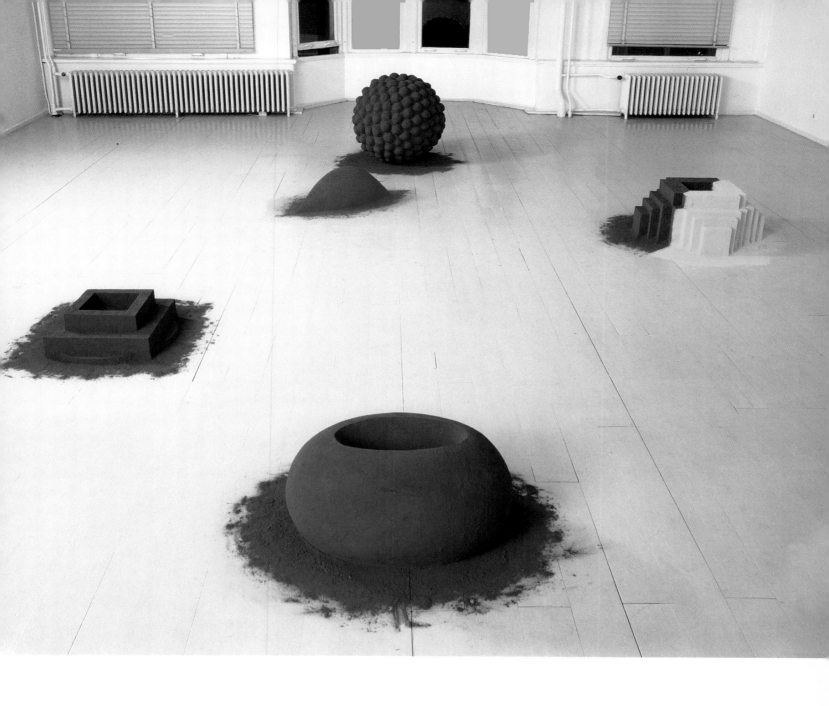

Part of the Red 1981

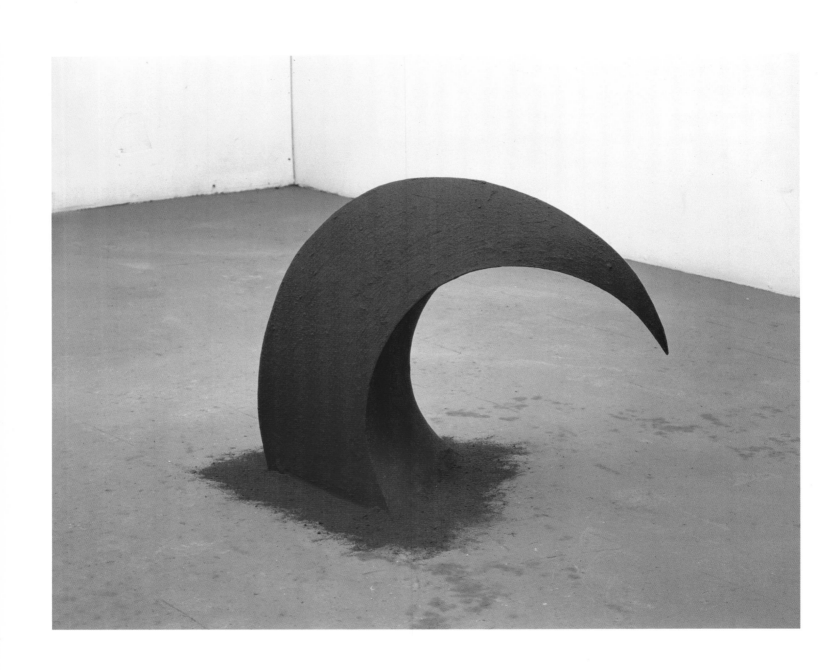

1000 Names 1979–1980

COLOUR AFTER KLEIN

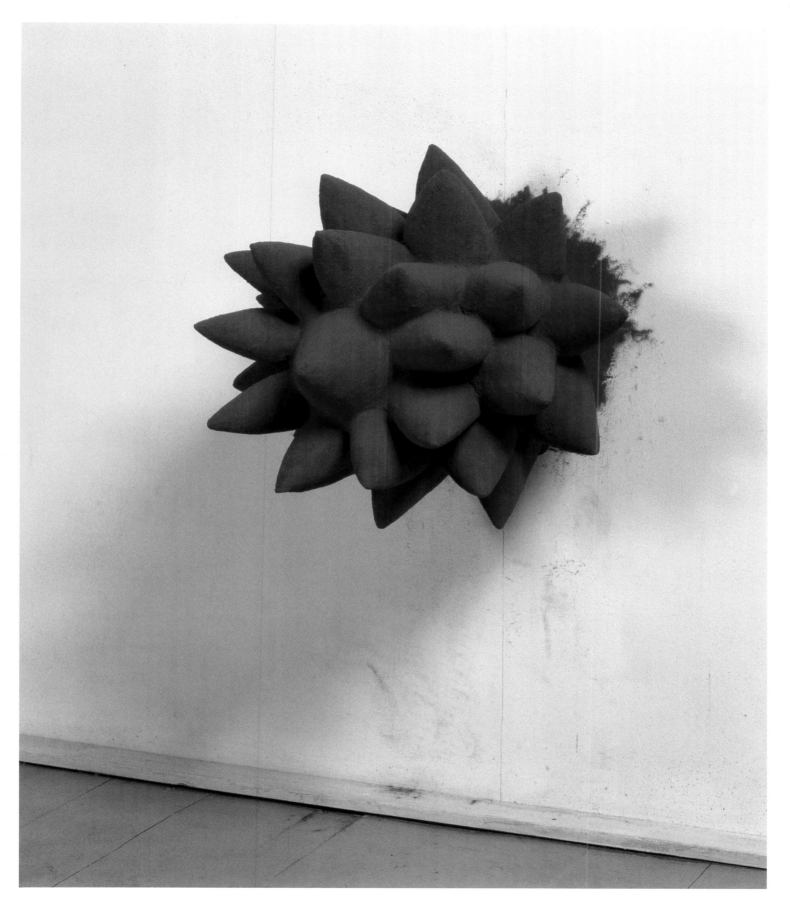

1000 Names (no. 30) 1982

Untitled 1990

COLOUR AFTER KLEIN

Untitled 1989

YVES KLEIN

Yves Klein was at the height of his success when he died of his third heart attack in 1962 aged only 34. In the space of 17 years preceding his untimely death, Klein had succeeded in irrevocably transforming the post war art scene in Europe as a result of a succession of conceptual innovations and his unique and spectacular utilisation of colour. In 1960 he succeeded in patenting a formula of ultramarine blue pigment and synthetic resin, which in a decidedly proto-pop gesture he branded International Klein Blue, or IKB for short.

Klein had been brought up a devout Roman Catholic and in 1947 was introduced to mystic Rosicrucianism which had a major impact on his work. The core principles for Klein's idiosyncratic but deeply held beliefs were as espoused by Max Heindel in *La Cosmogonie des Rose-Croix* (The Cosmogony of the Rosy Cross), a book that Klein obtained in late 1947. Thomas McEvilley, a long time commentator on Klein's work has written:

> **For Heindel, the dematerialisation of all finite figures into the infinite ground of the immaterial constituted the passage into the next age that occult tradition had long prophesied, the age which would no longer be characterised by figures with limits, but by pure space, the absence of figures, the lack of boundaries, the world of 'Colour', the passage into the infinite.** [1]

Nuit Banai, writing in this book, says that colour was Klein's "empire" and each of the innovations he enacts—whether installation, object or performance—are inflected by it. His entry onto the Paris art scene is marked by the production of his entirely fictitious catalogue of paintings, *Yves: Peintures*, of 1954 and the slab-like monochrome paintings in a range of sometimes kitsch colours that quickly followed. The catalogue, made up of readymade swatches of printed colour passed off as paintings was both a mischievous deception and an inspired opening gambit. Chroma emerges as a material presence in the early monochrome panels, which begin to exhibit the qualities of objects in space. Klein himself soon found the polychrome effect of them when exhibited together too decorative for his own liking.

Klein's next innovation was to opt for serial repetition and a uniformity of colour; a deep ultramarine blue chosen for its symbolism of the infinite. At the Galleria Apollinaire in Milan in January 1957, Klein exhibited 11 identically sized blue IKB monochromes together in one room. In another adjacent space, he showed differently coloured monochromes; a blue one was bought by Lucio Fontana, and a red one by the collector Count Panza de Biumo.

As Klein's fame grew, the gap between the nature of the work with its claims to "aesthetic silence" and "pure contemplation" and the character of Klein himself, "a champion of anguish" as the artist Jean Tinguely described him, becomes ever more apparent. [2] The control with which Klein presents himself and his work across his oeuvre is mirrored in his proficiency at Judo and epitomised by his somewhat disingenuous assertion: "It would never cross my mind to soil my hands with paint." [3]

→

1 McEvilley, Thomas, "Yves Klein and the Double-Edged Sublime" in *On the Sublime*, Berlin: Deutsche Guggenheim, 2001, pp. 71–72.

2 See Thomas McEvilley, "Conquistador of the Void", in *Yves Klein: A Retrospective*, Houston: Institute for the Arts, p. 43. The Pierre Restany quotes: "aesthetic silence" and "pure contemplation" are from the Preface to Klein's 1956 exhibition at Galerie Collete Allendy in Paris.

3 Klein, Yves, "The Chelsea Hotel Manifesto" [1961]. Re-printed in *Yves Klein: Long Live the Immaterial*, Nice: Musée d'Art Moderne et d'Art Contemporain, 2000, p. 87.

Blue Monochrome, Untitled (IKB 223) 1961

Red Monochrome, Untitled (M 38) 1955

Green Monochrome, Untitled (M 75) c. 1955–1956

Blue Monochrome, Untitled (IKB 46) 1955

Yellow Monochrome, Untitled (M 46) 1957

Pink Monochrome, Untitled (MP 8) 1956

Red Monochrome, Untitled (M 34) 1959 *Orange Monochrome, Untitled (M 6)* 1956

Expression of the Universe through the
Colour Orange Lead (M 60) 1955

COLOUR AFTER KLEIN

Pink Monochrome, Untitled (MP 30) 1955

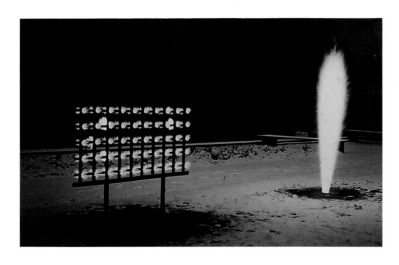

Arguably Klein's most influential achievement was his exhibition *Le Vide* (The Void) held at Galerie Iris Clert, Paris from 28 April–5 May 1958. In it, Klein presented a bare room with no discernible content apart from, critically, the artist and visitors themselves. The room was painted white and lit by a single fluorescent strip light. Originally entitled *The specialisation of sensibility in the state of primary matter stabilised by pictorial sensibility*, Klein's idea was that the spectator would feel "an intangible, sacred aura" of colour dematerialised in space.[4] At the opening, which was flooded with people, Klein served blue cocktails from La Coupole, that to his delight made the enthusiastic imbibers' urine turn blue. As part of the event, Klein had attempted to have the obelisk on the Place de la Concorde lit up in blue, a request that was turned down at the last minute.

The Void recalls Duchamp's *Paris Air* of 1919 and looks forward to Warhol's *Silver Clouds* installation of 1966 and other various void installations, such as Joseph Beuys's *Counting behind the bone/PAINROOM*, 1941–1983, originally at Galerie Konrad Fischer, Düsseldorf, and Bruce Nauman's *Room with my Soul Left Out, Room That Does Not Care* of 1984. The 1958 Iris Clert showing of *The Void* is just one, albeit the most famous, of three void spaces created by Klein during his career; the first was at Galerie Colette Allendy's in May 1957 and the third, an *Immaterial Room* within his first major museum show, *Monochrome and Fire* at the Museum Haus Lange in Krefeld, Germany in 1961.

Throughout 1958 and 1959, Klein had been planning and preparing a massive public art work in the entrance hall of the Gelsenkirchen Music Theatre in Germany. The work, which is still located at Gelsenkirchen comprises two 7 × 20 metre long blue reliefs with wave like surfaces and two further sponge reliefs measuring 5 × 10 metres. Also, in 1958, Klein made his first *Anthropométries*, works that are created by the impressions of naked bodies, usually women, smeared in paint who become, as Klein famously said, "living brushes". Dressed in a Tuxedo and before a crowd of invited guests on 9 March 1960, Klein directed his *Anthropométries de l'Epoque Bleue* (Anthropometries from the Blue Period) at the Galerie Internationale d'Art Contemporain, Paris. The show began with a small orchestra playing Klein's *Symphonie Monoton Silence*, a piece of minimal music composed by Klein and dating from 1949 comprising a single tone played for 20 minutes, followed by 20 minutes of silence. Thereafter three naked women enter and proceed to cover their bodies in paint to Klein's instructions before making impressions on paper laid on the floor in a manner reminiscent of a Jackson Pollock action painting.

Although blue predominates in Klein's work, he also favoured pink and gold in what amounts to a trinity of colours representative of the metaphysical realm. Fire encapsulated all three colours and epitomised their dematerialisation. Klein's only museum exhibition, *Monochrome and Fire*, marked the climax of his experiments with fire, an interest that first emerged in May 1957 with his action *Blue Fire Painting of a Minute* and which was in all likelihood influenced by a reading of Bachelard's *Psychoanalysis of Fire*, 1932. On the opening evening at Krefeld, as the sun began to set, Klein directed a spectacular display comprising three giant pillars of fire and a wall of 50 Bunsen burners, their flames resembling petals, illuminating the night sky. Klein had a professional filmmaker document the evening, and through this film, newly restored, it is possible to see how stunningly effective the work is. At one point the camera meditates on a writhing transparent phosphorus line of colour as it dissects the inky blue night sky in a moment of pure abstraction. Inside Klein exhibited 54 objects, a summation of his prolific career to date.

4 Banai, Nuit, "From the Myth of Objecthood to the Order of Space: Yves Klein's Adventure in the Void", in *Yves Klein*, Frankfurt: Schirn Kunsthalle, 2004, p. 22.

Fire fountain and fire wall (above), fire fountain (right) at the exhibition *Yves Klein: Monochrome and Fire*, **Museum Haus Lange, Krefeld, Germany** January 1961

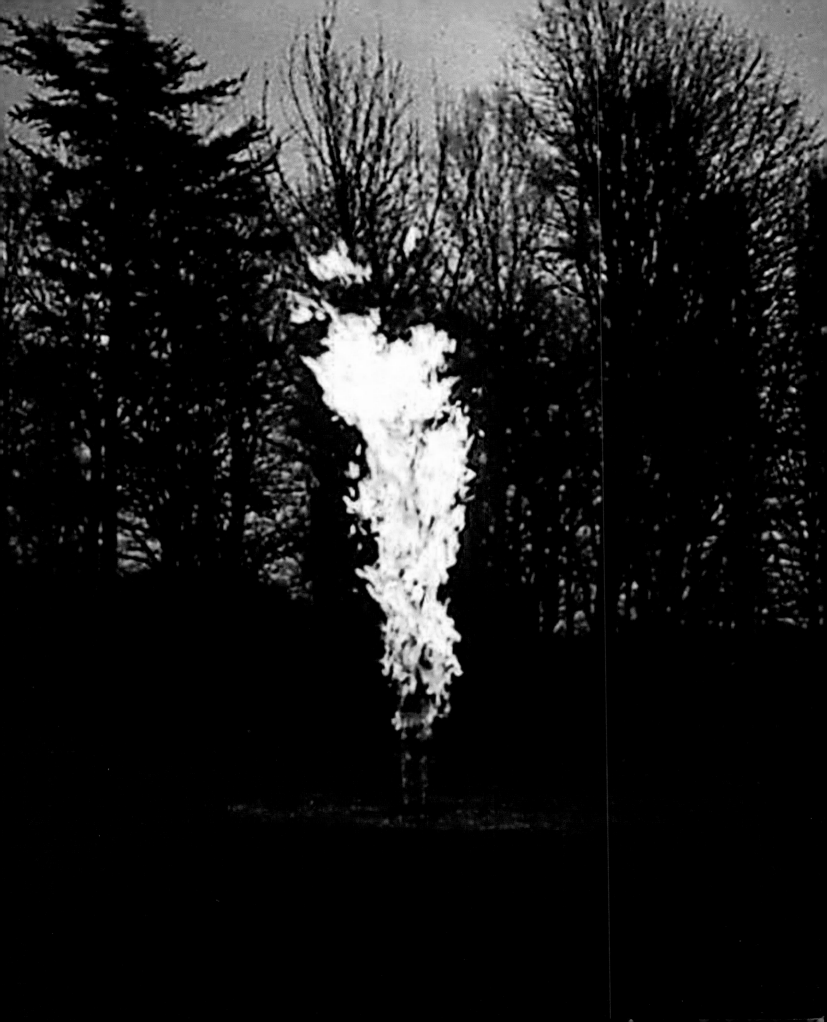

BRUCE NAUMAN

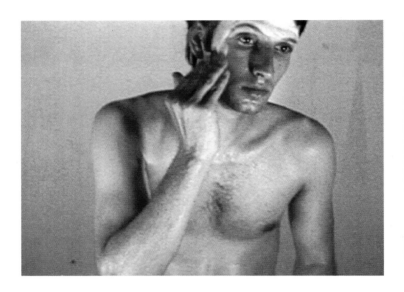

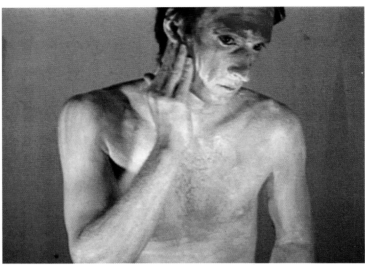

Bruce Nauman is one of the few American artists whose work has an existential dimension. Existential in this context means spanning life and death, perceived thematically, ritually, in word and sound.[1]

Bruce Nauman has come to be recognised as one of the most innovative and provocative of America's contemporary artists. Anger and frustration at social injustice and a finely tuned response to human vulnerability fuel his diverse oeuvre that includes drawings, films, holograms, installations, neons, photographs, prints, sculptures, sound recordings, videos and collaborative projects. His work, which has often been said feels more European than American, has been significantly informed by the Dada tradition of irony, paradox and political engagement, as well as a particular engagement with the works of the Irish playwright Samuel Beckett, the French writer Alain Robbe-Grillet and the philosophy of Ludwig Wittgenstein.

At the outset of his career in the mid 1960s, Nauman had the simple but profound realisation that "If I was an artist and I was in the studio, then whatever I was doing in the studio must be art. At this point art became more of an activity and less of a product."[2] Combined with an acute understanding for the cadences of contemporary dance and music, Nauman began to create a group of highly influential film documents that defy normal expectations of what a film should be, as they are without narrative, opening or closure. Although the actions are carefully choreographed, the films simply record what the artist chooses to do with his body in a given space at a given time. In one such work Nauman walks around the perimeter of a square in an exaggerated manner, in another he manipulates a single neon tube between his legs.

In *Art Make-Up* of 1967–1968, a four channel synchronised film installation, the artist covers the upper half of his body in different colours of paint; white, then pink, green and then finally black. While he masks himself literally, the title implies that in so doing he also creates himself, 'makes himself up'. Once the make up is fully applied the artist remains there motionless, suspended between illusion and reality, in a moment of both veiling and exposure.

1 Ammann, Jean-Christophe, "Wittgenstein and Nauman" in *Bruce Nauman*, London: Whitechapel Art Gallery, 1986, p. 21.

2 Nauman, Bruce, in Wallace and Keziere, "Nauman Interviewed", *Vanguard* 8, no. 1, February 1979, p. 18.
 Quoted in Kathy Halbreich and Neal Benezra, *Bruce Nauman*, Minneapolis, MN: Walker Art Center, 1994, p. 22.

→

Art Make-Up 1967–1968

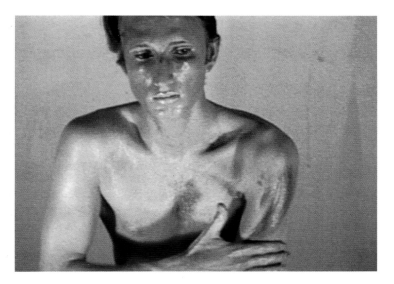 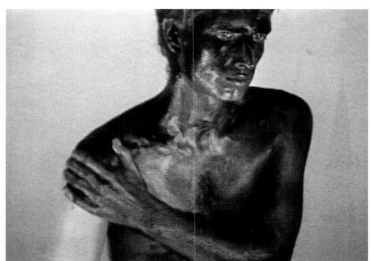

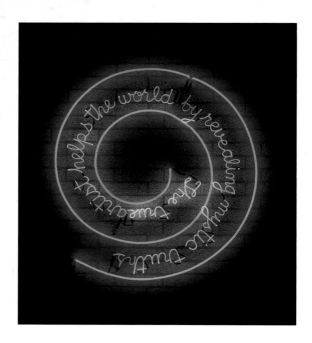

The most difficult thing about the whole piece for me was the statement. It was a kind of test, like when you say something out loud to see if you believe it. Once written down, I could see that the statement, 'the true artist helps the world by revealing mystic truths' was on the one hand a totally silly idea and yet, on the other hand, I believed it. It's true and it's not true at the same time. It depends on how you interpret it and how seriously you take yourself. For me it's still a very strong thought. [3]

A very early neon piece, *Neon Templates Of the Left Half Of My Body Taken At Ten Inch Intervals*, 1966, relates to the early film actions, but here Nauman maps the body rather than the body mapping space, whilst simultaneously introducing colour and light to maximum effect. This neon and others from the 1960s, such as *My Last Name Exaggerated Fourteen Times Vertically*, 1967, have a sensuality dictated by the play of line and colour that is rarely apparent in Nauman's oeuvre. The pale purple colour of the neon in *My Last Name Exaggerated...* is rarely used commercially due to its near illegibility, but this is exactly why Nauman chose it, to render the entire object barely perceptible. In later neons, colour is used in bold contrasting primaries, producing a chromatic assault on the cerebral and bodily receptors.

From the outset of his career, Nauman has looked to language as a way of exploring how human beings exist in the world: how they communicate or fail to communicate. Elaborate, descriptive and often humorous punning titles signal both a dissatisfaction with formalism and a need to imbue his work with cultural meaning. A circular sign from 1967 with the spiralling neon phrase *The True Artist Helps the World by Revealing Mystic Truths*, leaves the spectator uncertain of his seriousness. Not without irony, Nauman nonetheless wanted to test the hypothesis that it could indeed be possible.

Originally shown in the shop front window of his studio, the neon stood out among the plethora of market driven signs, a signal to the world that art is different, that art can be of consequence.

Neon, with its gaseous luminosity and chromatic brilliance, has consistently offered the artist a vehicle to express himself and has become a signature format; his messages intended to penetrate and upset our complacency. One such work is *White Anger, Red Danger, Yellow Peril, Black Death* from 1985, that along with neons such as *Raw War*, 1970 and *American Violence*, 1981–1982, signal Nauman's belief in the moral responsibility of the artist. Quite often Nauman's themes are realised in a variety of media, with *White Anger, Red Danger, Yellow Peril, Black Death* also being the title given to an ominous and monumental suspended sculpture of 1984.

3 Nauman, Bruce, in Brenda Richardson, *Bruce Nauman: Neons*, Baltimore, MD: The Baltimore Museum of Art, 1982, p. 20. Re-printed in Robert Storr, "Beyond Words", in *Bruce Nauman*, pp. 49–66.

Window or Wall Sign (The True Artist Helps the World by Revealing Mystic Truths) 1967

My Last Name Exaggerated Fourteen Times Vertically 1967

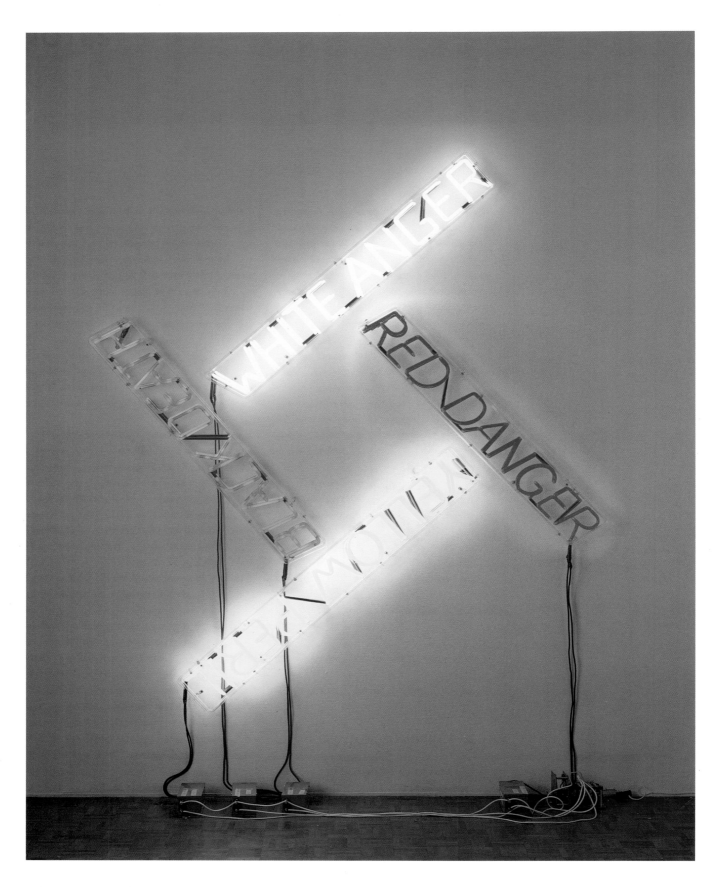

White Anger, Red Danger, Yellow Peril, Black Death 1985

COLOUR AFTER KLEIN

Raw War 1970

HÉLIO OITICICA

How clear it all is now: painting had to launch
itself into space, be complete, not in surface,
in appearance, but in its profound integrity.
Painting is characterised by colour as its principal
element; colour, then, begins to evolve with the
problem of structure, in space and in time, no
longer imparting fiction. Never has painting so
approached life, the feeling of life.[1]

A prime force in shaping Brazil's cultural scene in the 1960s
and 70s, Hélio Oiticica was a member of the Neoconcrete
movement, a group of artists and poets who recognised
that social transformation went hand in hand with cultural
change and strived to remove art from the canvas into the
realm of life. By the mid 60s, Oiticica had abandoned
traditional painting altogether, with the radical propositions
and developments that followed marking Oiticica out as an
artist of extraordinary accomplishment and originality. Although
his work was exhibited in London at the Whitechapel Art
Gallery in 1969, it is only in the last ten to 15 years that the
importance of his work has been fully recognised.

As early as 1960, at the very start of his career, Oiticica
wrote: "The experience of colour, specific element of
painting, has become the very axis of what I do, the starting
point of every work."[2] Colour no "longer tied to the rectangle"
will "incorporate" itself to become "the body of colour".[3]
Colour is indeed the axis of everything Oiticica achieved
thereafter. Mirroring the monochrome paradigm evident in
the post war period as evidenced in the work of the likes
of Ellsworth Kelly, Yves Klein, Robert Rauschenberg and Ad
Reinhardt, Oiticica developed a visual language based on
reduction to absolute essence. Indeed, his single monochromes
of the late 1950s are remarkably similar to those of Klein's
from the same period. And like Klein, Oiticica soon began to
envision colour as a spatial experience.

His first works to do that were his so-called *Nuclei*, simple
architectural constructions of intersecting monochrome planes
that the viewer could walk amongst at ease. Moving quickly
from one innovation to the next, Oiticica thereafter developed
what he called *Bolides*; containers which secreted and revealed
glowing masses of raw pigment, brightly coloured textiles
or other materials. In these works, colour had almost been set
free entirely from the historically and culturally determined
demands of representation, symbolism and narrative.

However, Oiticica had a vision for the total integration of
colour with life and in this respect his next developments were
the most radical. Oiticica's *Parangolés* were a cross between
a banner and a cape and were designed to be lived and
danced in. Sometimes they carried political or poetic messages,
whilst at other times they were just intended to be a way in
which a performer could immerse themselves in bright, bold
luminous colour, a reflection of Brazilian energy. In one final
move that would seal Oiticica's reputation, he began to create
environments that integrated colour, material and sound, a
total encapsulation of lived experience. The most famous of
these was *Tropicália*, 1967, a multi-dimensional tactile-
sensorial walk-in environment that combined a Neoconcretist
aesthetic with the colours, rhythms and patterns of Brazil.

In the 1970s, after moving to New York, Oiticica developed
the idea of his quasi-cinemas to investigate the moving
image and popular culture, including the effects resulting from
cocaine usage. In these participatory installations, slide
projections on walls, floors, and/or ceilings combine with
music and environmental components. Room sized
installations such as *cc1 Trashiscapes*, *cc3 Maileryn and
cc5 Hendrix-War* incorporate mattresses, emery boards,
sand dunes, balloons and hammocks to create alternative
viewing environments. These works seek to challenge the
traditionally passive relationship between the cinematic
image and the spectator and present a chaotic and fractured
world where pop culture, social issues, film and music are
merged into a complex installation experience.

1 Oiticica, Hélio, diary entry, 16 February 1961, re-printed in
 Hélio Oiticica, Minneapolis and Rotterdam: Walker Art Center
 and Witte de With, Centre for Contemporary Art, 1992, p. 42.
2 Oiticica, diary entry, 5 October 1960, re-printed in *Hélio Oiticica*, p. 33.
3 Oiticica, diary entry, 5 October 1960, p. 33.

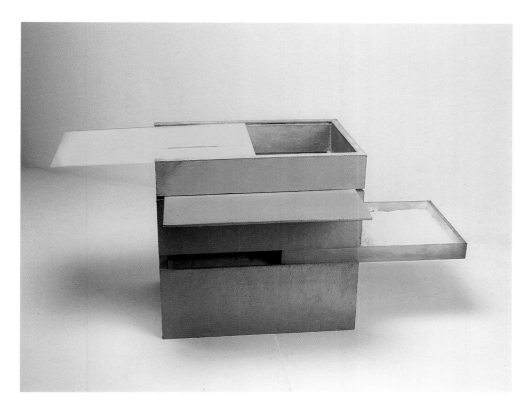

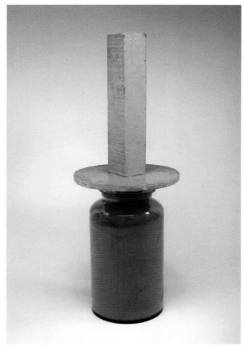

Glass Bolide 3 1964

Box Bolide 9 1964

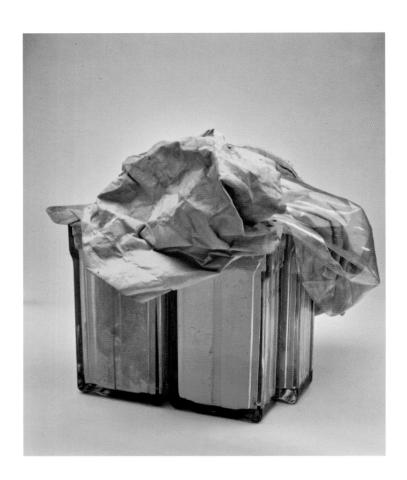

Glass Bolide 6 "Metamorphosis" 1965 Nildo of Manguiera with Parangolé P4 Cape 1 1964

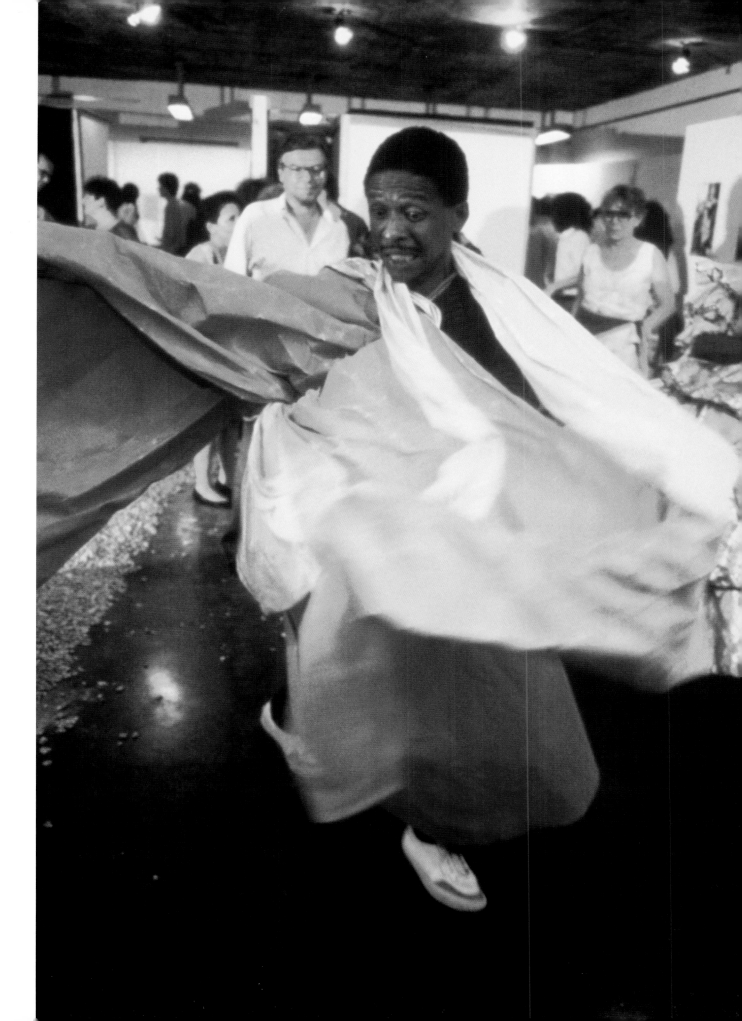

GERHARD RICHTER

Gerhard Richter is often considered a conceptual painter whose paintings are statements about paintings. It is a theory that is understandable given the eclectic nature of Richter's output, which is marked by a certain detachment and an acute intelligence. However, the artist himself has dismissed this idea, professing a belief in painting to tell some kind of truth. Richter mistrusts representation and yet feels compelled to convey reality. In his dexterity and accomplishment as a painter, fluctuating between abstraction and representation, the aesthetic and the conceptual, Richter has demonstrated painting's renewal rather than its obsolescence.

Photography has been central to Richter's work throughout his career. Faced with the mass of imagery available today, Richter asserts that all one can do is try to order it. *Atlas*, his massive repository of constantly expanding source material was begun in the early 1960s. It now comprises approximately 5,000 photographs, reproductions or cut-out details of photographs and illustrations, taken from the mass media as well as his own photographs, which he has also exhibited to reveal his sources.

Richter's earliest works are painted from photographs in a style that keeps something of the photograph's stasis and claim to truth. At the same time Richter blurs the images to differing degrees in order to assert the primacy and particularity of painting and to complicate any straightforward reading of the image, to create something else, a "third thing".[1] His subjects are wide ranging but nonetheless carefully selected, from the banal to the highly emotive. Subjects include toilet rolls, American bomber planes, a single chair, his Uncle Rudi the Nazi, pornographic images and society hostesses. These works, when seen alongside the monochromes that came in their wake, present a European parallel to Andy Warhol's *Disaster* paintings and serial repetitions of commodity products painted contemporaneously.

\longrightarrow

Mirror Painting (Grey) 1991

1 Richter, Gerhard, interview with Benjamin H D Buchloh,
 The Daily Practice of Painting: Writings 1962–1993,
 Hans-Ulrich Obrist ed., London: Anthony d'Offay Gallery,
 1995, p. 143.

1024 Colours (CR 350-3) 1973

COLOUR AFTER KLEIN

Richter's *Colour Chart* paintings dating from the mid 1960s and painted throughout the 1970s—representing a sustained exploration of spectral colour and its effects—are in stark contrast to his simultaneously painted 'photo-realist' themes and his subsequent devotion to the grey monochrome. The *Colour Charts* take their cue from patterns found in commercial paint swatches and employ random selection strategies for the configuration of colour, and are among his most conceptual works. They represent a denial of the kind of aesthetic reverence to colour and composition as found in the likes of Josef Albers and his followers. Ultimately, Richter has said that they resulted from the "desperation of not knowing how I could ever arrange colours meaningfully, and I tried to fabricate that, as beautifully and unequivocally as possible".[2]

In a further attempt to make paintings without illusion, Richter started to paint grey monochromes. By using grey, a colour as neutral as possible, Richter could focus on the application of the paint and the compositional structure of the work. The *Mirror Paintings* bring together Richter's entirely conceptual experiments with glass dating from the mid 1960s and the painterly monochromes, a "neither/nor" situation as Richter has described it.[3] The climax to Richter's painted mirror work is the monumental *Eight Grey* of 2002 for the Deutsche Guggenheim in Berlin.

The large body of abstract works that Richter has painted since the early 1980s reflect his ongoing commitment to exploring what painting is capable of. Always eloquent when grappling with his own internal processes, Richter has likened his daily practice to:

> [A]n almost blind desperate effort, like that of a person abandoned, helpless, in totally incomprehensible surroundings, like that of a person who possesses a set of given tools, materials and abilities and has the urgent desire to build something useful which is not allowed to be a house or a chair or anything else that has a name; who therefore hacks away in the vague hope that by working in a proper professional way he will ultimately turn out something proper and meaningful. [4]

2 Richter, interview with Jonas Storsve [1991], *The Daily Practice of Painting*, p. 226

3 Richter, interview with Storsve, *The Daily Practice of Painting*, p. 226.

4 Richter, note to himself, 25 March 1985, *The Daily Practice of Painting*, p. 121.

Eight Grey, Deutsche Guggenheim, Berlin 2002

PIPILOTTI RIST

"You can't overrate humour. And if I can manage to be entertaining without denying suffering, then my work is successful."[1]

Pipilotti Rist has established herself as one of the most successful international video artists, with works ranging from single screen projections to elaborate and innovative multi-screen installations. Her oeuvre is characterised by the evident pleasure Rist takes in combining image with sound, an irrepressible sense of humour, and a respect for collective practices of production.

Her first mature work, *I'm Not The Girl Who Misses Much*, 1986, condenses the lyrics of John Lennon's 1968 song "Happiness is a Warm Gun" through the repetitive use of the opening line. Significantly, Rist switches the pronoun from Lennon's 'She' to 'I' in order to undercut the masculine and place herself at the centre of the action. Her voice skids from shrill incomprehensibility to a monotone refrain while she repeatedly sings the line, changing from a frenetically fast almost satirical tempo to a lethargically slow lugubrious one. Exhausted, she eventually slumps to the floor in an apparent moment of breakdown, forcing the viewer out of the role of the passive consumer.

Rist's editing technique in this work and others include scrambled, jerky, zig-zag lines and overtly point to video editing as a form of suturing; her aesthetic, a declaration of disloyalty to high production values with smooth synch and natural colouration. In her 1993 video, *Blutclip* (Bloodclip), Rist employs graphic detail of menstruation combined with characteristic kaleidoscopic disruptions and distortions. In these two works and others, Rist attempts to subvert clichés of the feminine in the media and in so doing she draws on the legacy of artists such as Cindy Sherman, Adrian Piper, Mary Kelly and Carole Schneeman.

Exploiting the pace and seduction of a music video to produce lush, gorgeously coloured, yet often distorted and conspicuously marred images, Rist utilises and interrogates the genre to reveal and comment upon cultural attitudes and constructs of identity. In exploring the use of her own body as performer, Rist proposes a complex relationship between media and life.

1 Rist, Pipilotti, from an interview with Christoph Doswald, *Pipilotti Rist*, London: Phaidon, 2001.

I'm Not The Girl Who Misses Much 1986

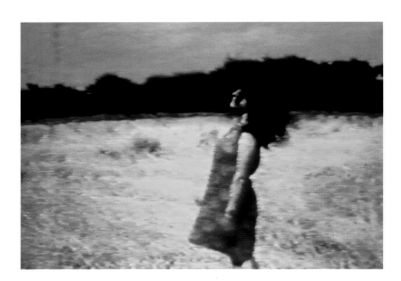

(Entlastungen) Pipilotti's Fehler
((Absolutions) Pipilotti's Mistakes) 1988

Blutclip (Bloodclip) 1993

COLOUR AFTER KLEIN

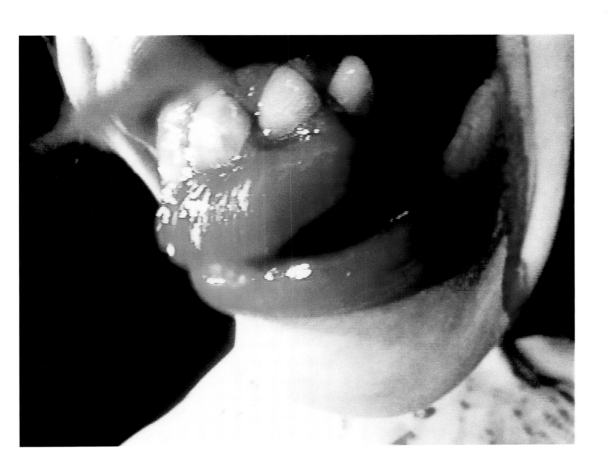

ANRI SALA

Anri Sala blends documentary, narrative and autobiographical strategies in his formally accomplished video, film and photography works. Emblematic of an emerging generation of artists who come from places in Europe once thought to exist outside the mainstream geographical, political, aesthetic and intellectual boundaries of contemporary European art, much of Sala's work can be related to his own personal history as well as the Balkan situation as a whole.

An early and much praised video, *Intervista* of 1998, explores the history of the Albanian revolution using found television footage of his mother's activities as a leader of the Communist youth alliance. The film consists of his efforts to comprehend his mother's interview, missing its original soundtrack and silenced. After lip readers succeed in restoring the dialogue, Sala's mother expresses disbelief in her own naïve recital of party jargon, ironically remarking, "we were living in a deaf and dumb system".

Dammi i Colori (Pass me the Colours), 2003, documents the charismatic artist-Mayor of Tirana, Edi Rama, as he articulates his vision to transform the degraded city environment with colour. Sala films the Mayor and interviews him as the pair tour the city by car. With the dramatic increase from 200,000 to 700,000 in the number of occupants since the fall of Communism the way people view the space they inhabit has changed. Neither the old Communist nor the new buildings and infrastructure set up to accommodate the expanding population were well planned, but the unifying use of colour on the exterior of the city's drab concrete buildings has succeeded in producing a formula through which the populace sees a bright democratic future. This utopian gesture has also heightened collective awareness of the lived environment, something Sala captures in his video and by extension expresses a hope for such a collective response from the extended art world audience.

A recent video work, *Làkkat*, is characteristic of the way Sala integrates the poetic and the conceptual. Filmed in Senegal in 2004, Sala focuses on the rhythmic patterns of sound as three Senegalese boys are instructed to repeat various words in ancient Wolof that express rich gradations of meaning between black and white. The term *Làkkat* is defined as one whose native tongue is different from the language of the place where he is. Sala explores the transformation of these words through a journey of cultural implications; in each country where the work is exhibited new translations have to be created, thereby testing the limits of language and the ability of a given culture to successfully address issues of race and colonialism.

Sala has opened up a space of contemplation in his work through the creation of increasingly abstract visual and aural means in which he exposes the spectator to the circumstances and events that take place in his work. He does this without projecting an authoritative opinion, but merely as an observer. Ultimately, the undercurrent is a fundamentally personal exploration of intimate, interwoven stories, embodying themes of globalisation, changing societies and the individual's navigation of such changes.

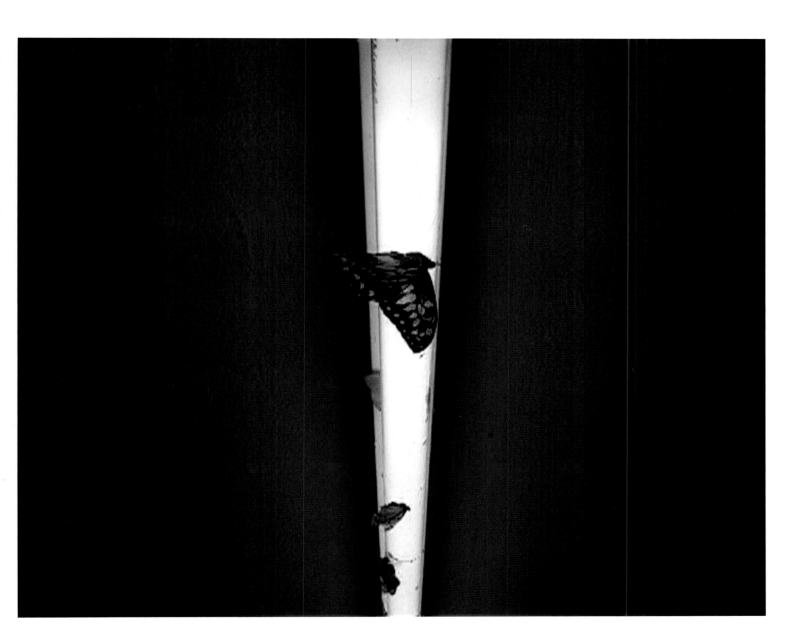

Làkkat 2004

Dammi i Colori (Pass me the Colours) 2003

COLOUR AFTER KLEIN

JAMES TURRELL

Regarded as one of the most influential artists of the late twentieth century, James Turrell has created a substantial body of work that centres on the sensitive manipulation of light, space and colour. Whether utilising a sunset or transforming the glow of a television set into a fluctuating portal, his art harnesses the manifest, physical presence of light, placing viewers in an infinite field of pure coloured light. Focusing on perception as his medium, with light and colour as his material, he has created ethereal experiences in sites that range from pristine gallery and museum installations to rugged outdoor topographies.

A member of the Light and Space movement, a loose group of Los Angeles-based artists working during the 60s, Turrell was intent in shifting the viewer's awareness away from autonomous works toward a systemic internal process of looking. Through the careful articulation of illusion and spatial disorientation, Turrell succeeds in drawing attention to the act of seeing and the body as a site of perception.

Among Turrell's most successful works are his earliest *Single Wall* and *Cross Corner Projections*. The first of these, *Afrum-Proto* of 1966, is characteristic of his approach: a single projection across the corner of a space that creates the illusion of a cube floating in space. His *Shallow Space Constructions*, dating from 1968 and 1969, rely on the placing of a partition wall with light emanating from behind, the effect is one in which—in contrast to the single projections— the aperture appears as though two-dimensional.

Alongside the light works, Turrell has also created a distinctive body of work that has as its subject the experience of sight within darkness. These works can be demanding of the viewer, but ultimately incredibly rewarding. Enveloped in silence and complete darkness, colour and light eventually emerge due to "a few passing photons, or to the least pressure exerted on the optic nerve, or simply due to the intensified desire not to be blind".[1]

In 1975 Turrell created his first *Skyspace* at the Villa Panza in Italy; an aperture cut into the roof acts as a simple but effective framing device in which to view the sky in all its changing moods and nuances of colour. His most famous and ambitious work has been created through subtle interventions in the crater of an extinct volcano situated near the Grand Canyon and Arizona's Painted Desert. Since he purchased the land in 1977, Turrell has been transforming the crater into a celestial observatory for the naked eye. Working with cosmological phenomena such as lunar and solar events and transits, *The Roden Crater Project* brings the heavens down to earth, palpably linking us with the movements of the galaxies.

1 Didi-Huberman, Georges, "The Fable of Place", *James Turrell: The Other Horizon*, Vienna: MAK, 2001, p. 49.

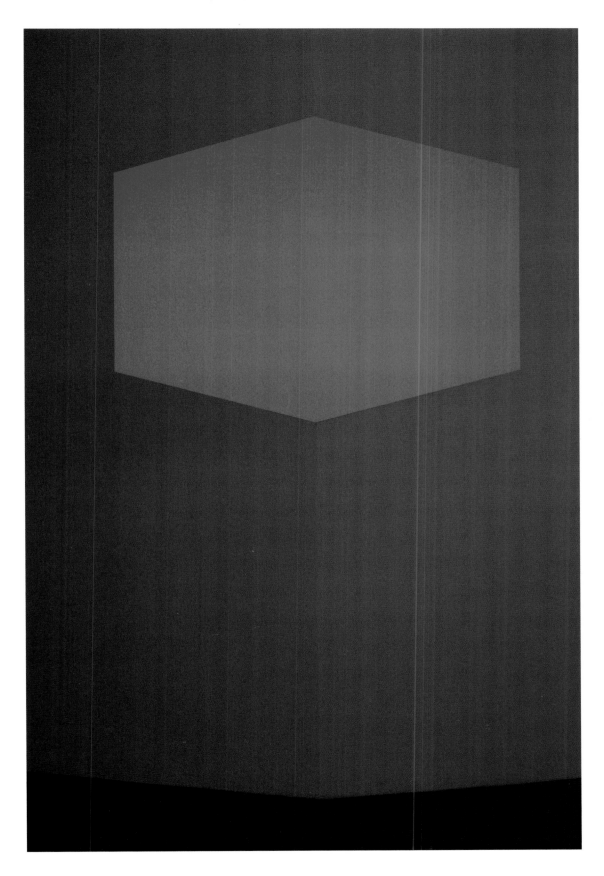

Afrum II 2002

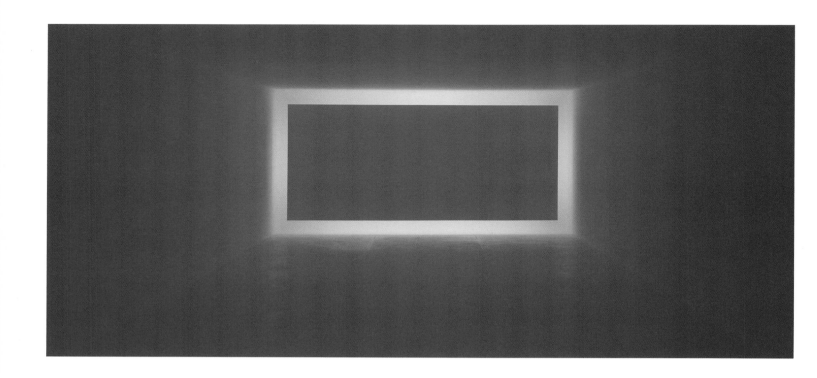

Rise 2002

COLOUR AFTER KLEIN

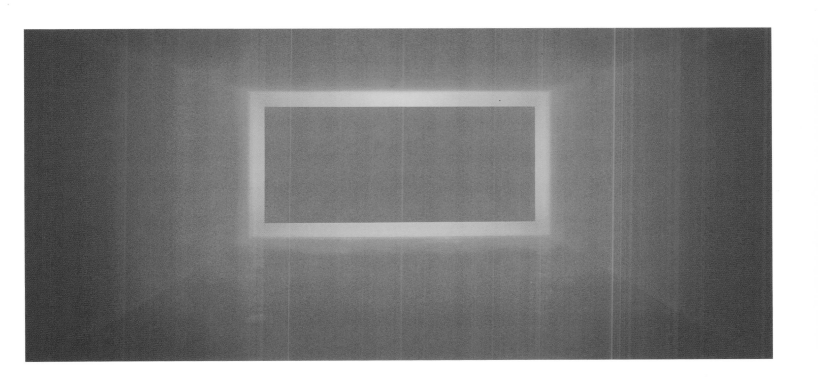

ANDY WARHOL

"If you want to know who I am, look at the surface of my pictures and my films. There is nothing behind." [1]

Warhol is indisputably one of the most important and innovative artists of the twentieth century. His commercial illustration from the 1950s announced his skill as a draughtsman and colourist, whilst his emergence on to the New York art scene in the 1960s ensured that he quickly became a cult figure. By the 1980s he was a legend. In Europe Yves Klein had created an aura of the spectacular, but Warhol championed the spectacle as never before, his practice embracing film, photography, TV, theatre, collaborations with musicians and magazine publishing, as well as painting, drawing, installations and happenings. The origin for many of his cultural interventions was the infamous and wildly productive Silver Factory—Warhol's studio, opened in 1964—that attracted style fiends, hangers-on and the genuinely talented. Warhol's fluency across such a wide range of cultural activities reflected a broader trend of cross-disciplinary, multi-media tendencies that emerged in tandem to the political and social upheavals of the 1960s, culminating in the summer of 1968. Warhol experienced his own crisis when he was shot on the afternoon of 3 June 1968 at The Factory by Valerie Solanas, on behalf of scum (the Society for Cutting Up Men), her one-person feminist movement.

With the adoption of his trademark photographic silkscreen process in 1962 Warhol began to alter his source material through the manipulation of scale, multiplicity and colour. His first major show occurred in 1962 at the Ferus Gallery in Los Angeles where he showed 32 identically sized canvases each with a Campbell's Soup can, the number of canvases being determined by the various flavours available from the company. In his hands, the celebrity portrait is just another commodity, ripe for packaging and seemingly endless replication in variant chromatic co-ordinates. He tapped into the reality of celebrity culture through his manipulation of media images, inscribing them onto his own surfaces washed with colour in the style of an advertisement hoarding. In one of his famous Marilyn paintings Warhol places the actress reverently in the middle of a much larger gilded field, recalling the religious symbolism of his Catholic faith.

→

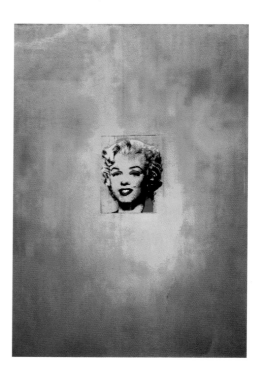

1 Warhol, Andy, quoted in Gretchen Berg, "Andy: My True Story", *Los Angeles Free Press*, March 1967. Re-printed in Mark Francis, "Horror Vacui: Andy Warhol's Installations", *Andy Warhol: The Late Work*, Mark Francis ed., Düsseldorf: Exhibition Museum Kunstpalast, 2004, p. 11.

Gold Marilyn Monroe 1962

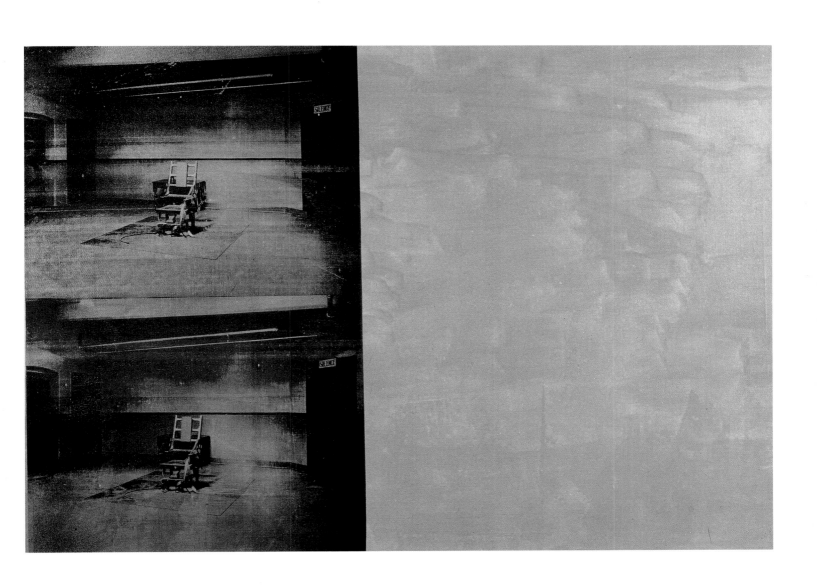

Silver Disaster 1963

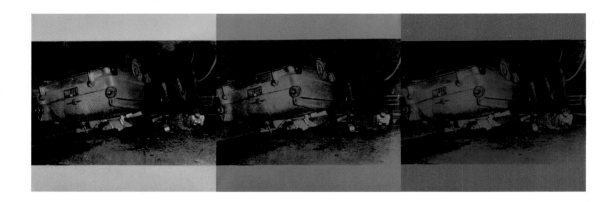

Warhol's devotion to chroma is apparent across his oeuvre, but is particularly evident in his photo silkscreened paintings from the 1960s. Colouristic effects are most noticeable in the *Death and Disaster* pictures, which are intentionally at odds with their extremely violent and disturbing subject matter. The title, *Five Deaths on Turquoise*, 1963, is suggestive of a fashion shoot rather than the grim aftermath of a car crash. The backgrounds were more often than not flat expanses of matt colour, but in *Red Race Riot*, 1963, a painterly nuanced surface is achieved. In Warhol's diptychs, one panel carries the representational silkscreen image, the other a monochrome of pure colour. In typically disparaging fashion and exhibiting a trademark humour, Warhol referred to these monochrome areas as "blanks".[2] They both reinforce the strategy of repetition and ironic comment that Warhol delighted in, but at the same time can also correctly be construed as 'monuments' to the dead and suffering of the disaster scenes. Frequently Warhol's "blanks" are considered to represent a vacuum within society and within Warhol himself.

Warhol's technique for painting and silkscreening the *Skull* series of 1976 is the same as for the *Death and Disaster* series from the 1960s. The canvas is divided up into four sections: loosely, foreground, background, skull and skull-shadow. Each area is painted in different colour combinations as can be seen in the six small *Skulls* seen here. Then Warhol would overlay the painted surface with the silkscreen image usually in black ink. It did not escape Warhol's attention that the shadow created by the skull looks like the rounded head of a foetus. In this way, the skull paintings took on even more gravitas as a representation of the passage of life from birth to death.

Although Warhol described his vast set of 102 *Shadow* paintings of 1978–1979 as "disco décor" they constitute the most monumental sequence of painting within his oeuvre and offer a summation of the life/death duality that underpins his work. The theme of death is further elaborated in the *Camouflage* and *Last Supper* paintings of the 1980s, as well as his haunting corpse-like, *Last Self-Portrait* of 1986.[3]

Five Deaths on Yellow (Yellow Disaster) 1963

Five Deaths on Turquoise (Turquoise Disaster) 1963

Five Deaths on Orange (Orange Disaster) 1963

2 Warhol said: "You see, for every large painting I do, I paint a blank canvas, the same background colour. The two are designed to hang together however the owner wants."
 As quoted and discussed in Benjamin H D Buchloh, "Andy Warhol's One Dimensional Art", *Neo-Avantgarde and Culture Industry*, Cambridge, MA: MIT Press, 2000, p. 490.

3 For an invaluable reading on death within Warhol's work see Trevor Fairbrother, "Skulls", *Andy Warhol: The Late Work*, pp. 66–79.

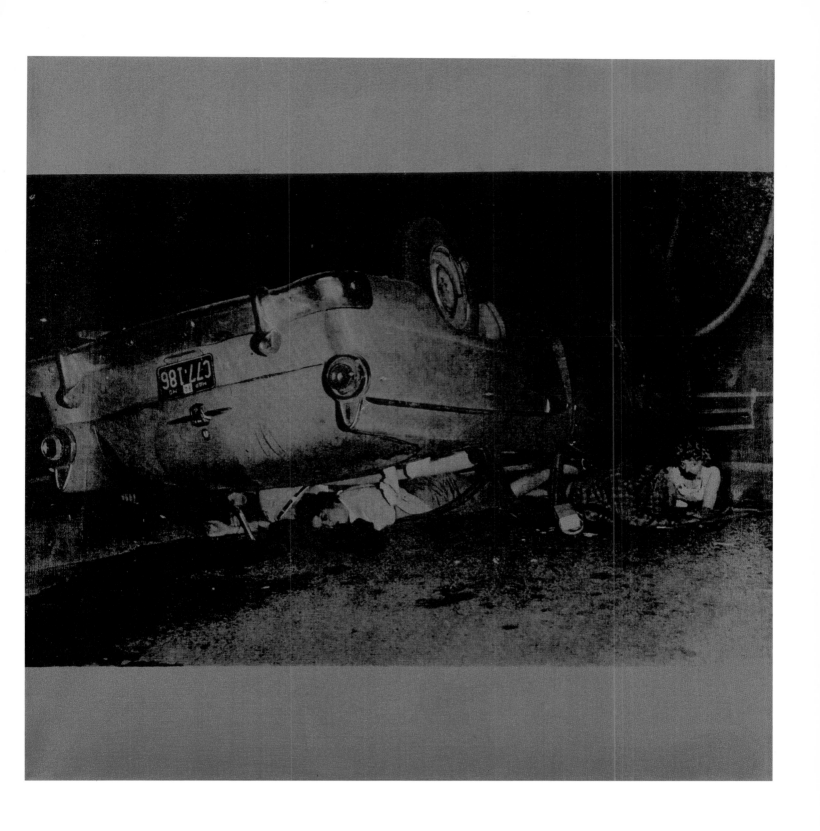

Five Deaths on Turquoise (Turquoise Disaster) 1963

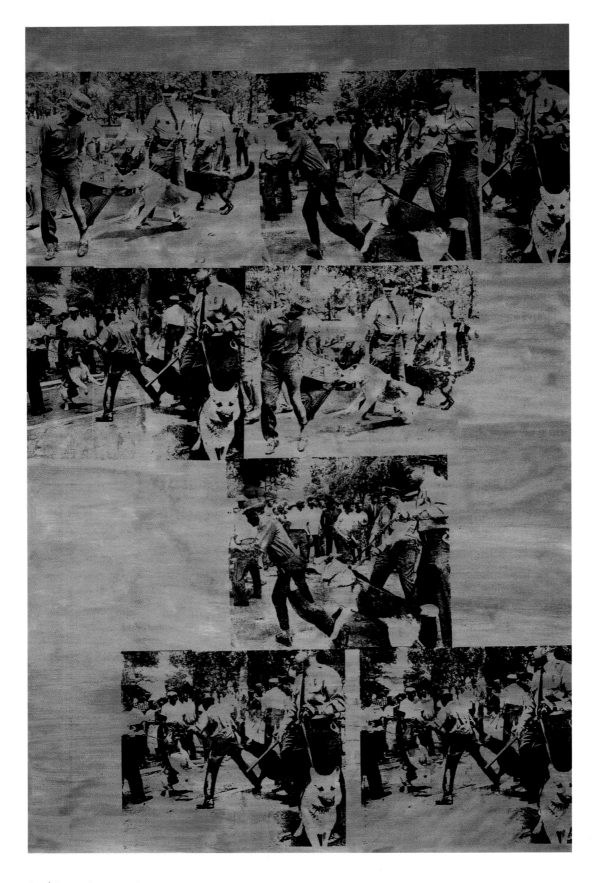

Red Race Riot 1963

COLOUR AFTER KLEIN

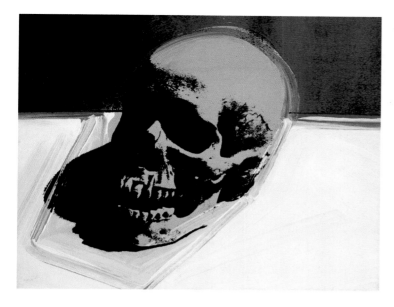
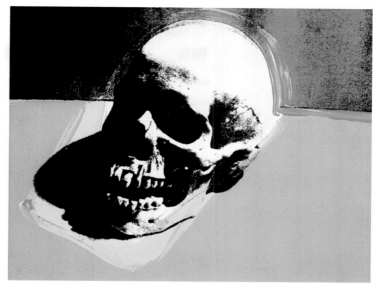
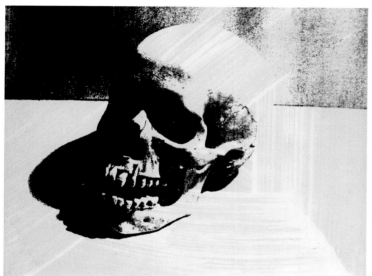
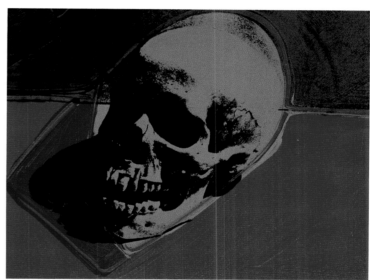
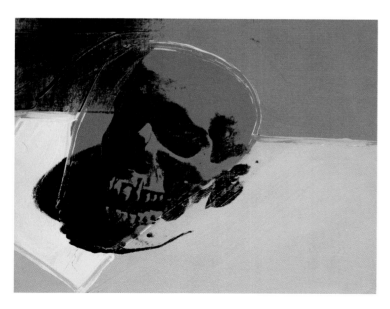
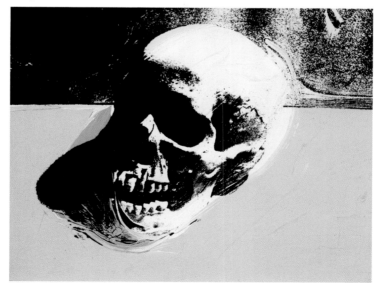

Skull 1976

TEXTS BY ARTISTS

THE WAR

Yves Klein

A brief personal mythology of monochromy, dating from 1954,
adaptable in film or in ballet

Originally published in French in Klein's *Dimanche,
le journal d'un seul jour*, November 27 1960

The War, dated 1954 but most probably written by Yves Klein
in 1957, recounts the long historic battle between line and
colour. While a number of French and German versions exist,
Klein originally published this particular text in Dimanche,
le journal d'un seul jour on the 27th November 1960.
Appearing on news stands throughout Paris, this one day,
self-created newspaper was, in Klein's words, "the ultimate
form of collective theatre". Taking the reader through a
mostly imaginary, multimedia and multi-sensory history of art
and civilisation, Klein recounts the subjugation of man by
the abstracting forces of line and his liberation through
colour's affective powers. While line might dominate man's
rational faculties, colour penetrates his sensibility, the source
of life itself. By inserting the aesthetic and cultural struggle
described in The War into the public sphere, Klein hoped
that art and life would be transformed. With Klein's guidance,
the Parisian public would collectively rediscover a reality
already contained within each individual. Empowered by this
knowledge, they would create a new form of realism, a mode
of aesthetic practice and social existence emerging from
colour's immaterial spaces of sensibility. This is the first time
the complete text has been published in English.
 —Nuit Banai

(Warning: I have determined to leave this text intact, as it
was written in 1954.[1] I certainly find it a bit naïve today and
without doubt would no longer employ the same terms.)

Two principle abstract characters; line and colour, which
combine, multiply themselves and then interpenetrate.
 For any décor an immense hemispheric screen (intended for
receiving the back projection of a film from backstage, or
from the front).

First painting: Projection of an intense and immaculate white
onto the screen for four seconds.

Second painting: Progressive passage from white to
gold (colour of refined gold 999.9) fixed for four seconds
with the opening of a continuous monotone sound
(wavelength of the gold).

Third painting: Progressive passage from gold to pink
(lacquered in madder pink, carmine pink). Progressive
passage of the continuous sound gold to the continuous
sound pink. Four seconds fixed of pink on the screen as well
as four seconds of monotone pink.

Fourth painting: Progressive passage from pink to blue
(IKB blue). Progressive passage of the continuous sound pink
to the continuous sound blue. Four blue seconds fixed on
the screen, accompanied by four seconds of monotone blue.

Fifth painting: Upon the image of uniform blue suddenly
appears a gigantic hand (prehistoric impression of a hand,
Castello, Spain, Abbé Breuil). A strong and dramatic jolt
in the continuous sound.

Commentary: Profiting from a need felt by the first man to
project his stamp beyond himself, line which since
the beginning of time has in fact been found nowhere in
immeasurable space, but which nevertheless is there,
and waits, succeeds in insinuating itself into the hitherto
inviolate kingdom of colour and of space.

Here begins the composition in concrete music.

Possibly the beginning of the ballet, too.

The dancers who, until now, have held themselves in prone positions on the stage, invisible, rise slowly in front of the screen and begin the dance along the contours of a gigantic hand projected on the screen. Slowly the hand begins to move upon the screen. The hand gradually disappears, three fingers, then only two, sketch linear traces in the discovered clay.... Then successively appear the prehistoric finger tracings brought to light by Abbé Breuil at Ornos de la Peña and Altamira in Spain.

In their movements the dancers follow the finger tracings on the screen.

At the same time a linear concrete piece of music follows the finger marks.

In this section of the ballet, man discovers all the forms of nature, the forms of the world and of tangible and sensual reality upon which he has just opened his eyes. He discovers the forms of woman in the same way as he discovers the forms of a rock, of a lion, of a plant, and at this point can be added a slightly suggestive, indeed even erotic dance: the mutual discovery of affective sensual emotion between man and woman.

Then comes the age of murder (Cain and Abel), the definitive transition from dream to reality.

FROM THIS MOMENT, IT IS FOR ANY CHOREOGRAPHER THERE MAY BE TO CUT WHAT IS GOING TO FOLLOW INTO TABLEAUX.

Rapidly mastered, pure colour, the universal soul in which bathes the soul of man in a state of terrestrial paradise, is imprisoned, compartmentalised, crippled, and reduced to slavery. Upon the screen the projection of lines encircled in red from Ornos de la Peña or from Pech-Merle in the Lot;

Australian line drawings by members of the Worora tribe, Port George, adorned also by feet.

The concrete music continues, adapted to the images projected on the screen.

In the joy and delirium of its triumph through trickery, line subjugates man and imprints upon him its simultaneously intellectual, material, and emotional abstract rhythm. Realism will soon appear.

The first moment of stupefaction past, prehistoric man realises that he has just lost vision.

He recovers in his discovery of the form called figurative.

Realism and abstraction combine in a horrible Machiavellian mixture that becomes human life on earth, and this is liveable death: "The horrible cage"... as will say Van Gogh several thousand years later.[2] Colour is subjugated to line that becomes writing....

On the screen, projection of stags in outline and of hunters from Nuestra Señora del Castillo, Almadén, Abbé Breuil, Hordes of warriors from Cueva del Val del Charco del Agua Amarga,[3] Teruel. Concrete music embellished with black African rhythms.

This inscription of a false reality that evolves in complexity, figurative physical reality, allows line to organise itself almost definitively already, in conquered terrain.

Its goal: to open the eyes of man onto the exterior world of matter that surrounds him and to open to him the way to realism. Man is drawn further and further away from his lost interior vision of colour, without however being able to divorce himself completely from this. Supplanting this interior vision is created a kind of void, atrocious for some, for others revolutionary and marvellously romantic, that become the interior life, the soul torn asunder by the reality of line.

Tarnished colour, humiliated, vanquished, will however develop in the prolonged course of centuries a return, an uprising that will prove stronger than everything. Upon the screen a projection of running figures from Bassonto in South Africa, Bison of Lascaux with large patches of red and green colour, Horses of Lascaux, then patches of colour independent of the drawing. Abstract drawings engraved on Neolithic artefacts, engraved bones, deer reduced to symbols, Southern Andalusia, brought to light by Abbé Breuil.

Musical accompaniment of the *Messe des pauvres* (Mass for the Poor) by Erik Satie.

Thus the history of the very long war between line and colour begins with the history of the world, of man, and of civilisation.

Heroic colour beckons to men whenever they feel the need to paint (the phenomenon of an attempt made by the affective body for liberation in space), which comes to him from very far in himself, from what lies beyond his soul.

Colour winks at man, enclosed in forms by drawing. Thousands of years will pass before man should understand these desperate cries and he suddenly, feverishly launches into action to liberate colour and himself as well. Paradise is lost, the entangling web of lines becomes like the bars of a veritable prison that is moreover, more and more, psychological human life. The drama of inevitable death of "mortals", into which they are dragged by the stormy coexistence of line and colour at war, provokes the birth of art.

This struggle for eternal, and above all immortal, creation, in order to achieve the transmutation—in objects, in forms, in sound, and in images—through the fashioning of this universal soul of colour that is the conquest of life itself, invaded, bullied by line, magical power of evil and dark shadows, terrible, because it kills.

From the situation of figurative forms and from the enchantment that man feels in separating drawing from colour, which leaves him always with a vague impression of remorse when he has not done it, is born writing. On the screen, a parade of masterpieces illustrating always the first symptoms of the birth of writing; the true and unique mission worthy of line and of drawing, Hieroglyphs. Comforted colour breathes and again becomes pure although still prudently compartmentalised in Ancient Egypt. Each cast has its colours (ritual of colours). America: Aztec, Toltec, and Mayan civilisations.

In China, colour seems to free itself by means of an intermediary, a ruse (rather again, here, of the ritual quality of colour which the ideogram tends to substitute).

Colour insinuates itself into the images, the surfaces, with delicacy, and drawing seems to be submitted to it for a time; but it is not by deceptions that colour seeks to free itself; this colour clearly feels.

It is, in effect, in the monochrome that the Chinese painter has excelled, notably during the "Song" period. The artist sometimes adds a tiny point of ink to the flat tones, which allows the achievement of plays of light. The most ancient monochrome paintings are severe in style: one example is the famous roll of silk preserved in the British Museum in London (a work of the painter Koukaï-tché, fourth century). It is only in the thirteenth century that violent tones, reds and purples, make their appearance. But nevertheless, colour recognises itself that this clear-obscurity, this delicate painting of atmosphere, those clouds, of tone and half-tone blending without violence one into the other, although very little scored by drawing, this is not a true victory! It is merely an armistice and what is more a compromise. Colour does not desire a false liberation. It wants a true victory beyond all infection.

Soon, thanks to such attempts at coexistence, line manages to make itself appealing, or at least respectable, to colour (reign of the concept form + colour, logical categories of vision as of understanding. Colour and drawing adapt to each other and a life that is morbid but liveable establishes itself, and takes form. Before the mere appearance of peace

reigning between the two antagonists civilisations devoted themselves to the pictorial arts (the great myths are born), colour, like line, is more or less valued according to the period. On the screen, observations on colours and lines in each of these civilisations. A procession of masterpieces showing, at one time the superiority of line, at another that of colour (psychological deductions). Line and colour confront each other in all the following civilisations.

Observation and imagery compared on the screen:

India, the Etruscans, Japan, the civilisation of Asia Minor, the Middle East, Greece, Rome. Religion, which often forbids figurative representation in art, colour among the Negroes; clearly show the "ritual".

The pictorial Christian world: oriental and occidental.

The abstract Irish manuscript illuminations, the Middle Ages in Europe.

The Italian primitives, the Renaissance, reaching to our own day, that is to say first through the precursors of Impressionism.

Last outburst and attempt to defend line in the Ingres-Delacroix debate: "Colour", said Ingres, "adds ornaments to painting (he meant to drawing and composition), but it is only its wardrobe mistress...".[4]

But Delacroix copied out in his journal some observations that had struck him: "Colours are the music of the eyes.... Certain harmonies of colours produce feelings that music itself cannot achieve."[5]

Very important, the concept of lyricism recovered.

Opposition between the essentially affective ritual power of colour and the rationalising symbolism of graphic art.

The history of art is the soul of the history of peoples. Contented peoples have no history: therefore contented peoples are those among whom peace reigns. That there should exist a history of art, just as history of peoples, simply requires that there should be a war! War is necessary, and is necessarily followed by peace, and peace by war again, and war again by peace—Duality—Duel—Contrast— Opposition— Progression and evolution by comparison and analogy.

It is for this that one can reproach art, with some exceptions, it is precisely having been until our own time only a history of art, a kind of constant witness of the period. Certainly, many geniuses have lived all the same as true artists, which is to say that they have been more or less unconsciously transported by the art well beyond, to the margins of their own times, sometimes in advance by several centuries, often reaching as far back into the past.

But it is this invisible link, this glue, that binds the entire universe across time and that is eternal, which ought to be perceived and transmuted in the creation of art. True artists ought to be like prophets of peace, deep and violently intense, stronger than destructive war. Today line is pursued until even in its most solid entrenchments by this imperative to retrieve the absolute. The very rapid evolution of these past years in Japanese calligraphy is the proof of this; line disappears, transforms itself rather into forms stripped or almost stripped of contours and filling the entire surface in an almost uniform manner.

Line, jealous of colour, the authentic inhabitant of space, attempts to free itself from its condition as a visitor in space: line dissolves and invades the pictorial surface. This is the discovery of the all-powerful dominant to reveal to broad day; evolution allows this initiation that leads everything back into order. Everyone, everywhere, desires true peace, not this word full of falsehood and dishonesty: "The Peace of Nations", but that inexpressible peace in nature and in man before the intrusion of line into colour.

Today Japanese calligraphy would almost be able to fill with its qualitative spatial presence, in an equal and unified manner, a given surface; the result would be a dominant

everywhere impregnated by itself through its choice and its creative quality. There would be no more linear psychological prison bars. In front of a colour surface, one would find oneself directly before the matter of the soul.

Drawing is writing in a painting. One draws a tree, but this amounts to the same thing as painting a colour and writing on the side: tree. At root, the true painter of the future will be a mute poet who will write nothing but who will tell the story, without articulation and in silence, of an immense and limitless painting.

Among the Egyptians, line felt the danger of continuous revolt of conquered colour and preoccupied with colour, line attempts to win a psychological victory in imitating nature, "all sensibility", of colour, it will then lead to the false illumination of pleasure, pleasure that is almost always sensual, of the sense of the eye in particular. Artists will then be aesthetes, abstract or realist; in passing through an entire range of styles of figuration. Colour agonises and then recollects itself. There are pacts and treaties between the two adversaries with the rising of this or that civilisation. Often it happens that colour succeeds in dominating without ever being able to completely defeat line.

It always appears, throughout the long history of art, that it is incomprehensible and beyond all possibility, and yet true, that artists have always chosen what is ephemeral and unreal as their emotive theme.

Nevertheless, the power of the image is such that one sees entire civilisations by turns ban at some times representation and at others abstraction.

Arriving at the low point of materialism in the twentieth century, the veil of the temple of art is finally rent, the initiation is for everyone and each will be able to appreciate and deeply understand art, formerly reserved to the privileged few. In the first chapters of his treatise, Leonardo da Vinci, does his utmost to demonstrate the superiority of painting over poetry, music and sculpture.

Painting and art in all their forms disturb the masses. One recognises in the image the possibilities of exploration of the unconscious. Investigations either conscious or unconscious undertake to recover something forgotten, but which everyone senses.

The knowledge of the real furnished by our senses is the foundation of experiences of space; analogous will be the notion that intelligence makes of it. Bergson affirmed this:

> **Physical collection, just as that of words or of clear ideas, fails when one departs from what defines itself by a form to what makes itself felt by its intensity or by its quality alone. Clear or distinct ideas only exist through analogy with the separations of space. Pure sensibility is confused; it is only duration; hence communicability.**

The child has gone to bed. The room is dark. He closes his eyes; he presses two fingers held together against his eyelids. And he sees great flames. He sees them and yet they are there where his eyes are, even more deeply in his head. But there is nothing more either within or without, no more objects, no more eyes. Quite simply, the child sees intense colour. He now takes his hands away from his eyes and there appears a marvellous assemblage of coupled diamonds, as fluidly mobile as water, as soft as almost liquid velvet, which would radiate a phosphorescent light like the flowers of shrubs in the night.

But this astonishing light is neither day nor night. It is immutable and yet trembles softly. It has been there in his head forever. Will it remain there forever? And the colour is more beautiful than all the colours on earth, as sumptuous as the intense colour of garden pansies, but without that aspect of mildewed ancient fabric one knows not where. The child calls to his mother and asks her: "What is it we see when we close our eyes?" But his mother does not at first understand; he explains and his mother answers him: "You mustn't do that... you'll go blind!"

Delacroix and romantic realism. On February 20, 1824, although determined to imitate thus to say nature, he cried out, "Ah! Cursed realism, would you wish by chance to produce an illusion for me such as I imagine that I observe in reality at the spectacle that you claim to offer to me? It is the cruel reality of objects that I flee when I take refuge in the sphere of artistic creation."[6]

"Cursed be the painting that reveals nothing beyond the finite. The merit of the painting is indefinable; it is precisely that which defies exactitude." What then is it? "It is what the soul has added to the colours and the lines to reach the soul."[7] Delacroix was seeking the complete expression of himself in and by colour.

But in this he was mistaken and where there is confusion in the meaning of the word soul is when he adds, "The soul tells a story in drawing a part of its essential being." It is no longer a matter of the soul when one speaks of drawing and in this the twentieth century will find its place. It is a matter of the subconscious, which is altogether different. And when he says, "It is within yourself that you must look and not around yourself," he is exactly right, but note that in ourselves there is an essential part that is the sole true life and even vitality that we possess, it is the soul, the rest is merely realism, which everyone understands as such and which is merely ephemeral. The subconscious, the intellect, sensuality, etc., etc..

It is immediately after the period named "realism" that occurred the pictorial revolution that will ultimately lead to the great rending of the veil of the temple of art. And this is a matter of impressionism.

Impressionism will be a technical revolution. There is no need to exaggerate at the outset, as has been done, the importance of the theories of a Hood and of a Chevreul on colour in vision. For the most part the Impressionists were highly incapable of adhering to these theories.... But it does remain that these painters were struck by the resources that were opened to them by the prismatic decomposition of light into the elementary colours of the spectrum. They understood that two juxtaposed colours could blend into each other in the eye in reciprocally exalting each other, while their mixture yielded a heavy, earthy look. They advocated from then the use of pure and generally light colour. Some among them even claimed to have altogether excluded black and all its gradations of grey, which, besides, do not exist at all in nature.

Thus it is that is hatched the vast plan for the liberation of colour in the nineteenth century, Manet, Renoir, Monet, Degas.

Interior light is entirely colour.

If it is true that the physical world is the reflection or even the direct projection of the spiritual world, then, in this case, we are well liberated from these two aspects or states. But, in any case, for all time, the decadent periods in all the great civilisations have been those in which sensibility—essentially the emotional and exclusively human domain—has been brought to its heights of refinement and exactitude.

What more delicious today for the New World, which is experiencing its powerful, active, dominating glacial period, than to observe Old Europe, which is dying immensely rich in sensibility, ridden of all materiality and spirituality.

What an immense human body it represents. Europe is fully pure "flesh", engorged with the blood of past civilisations and silenced interior joy. We shall quickly become cannibals.

"The painter of the future is a colourist such as has never yet been...".[8] That will come in a future generation. Van Gogh foresaw monochromatic art.

In the work of Van Gogh, colour has plastic value that reveals a new vision of space. One knows that this same colour was for the Dutch genius the direct language and symbol of his sensibility.

Standing before any painting that lives and speaks, certainly, I have felt a sensation of being imprisoned, of seeing, behind the bars constituted by the drawing, the lines, in the painting, the life of a world of colour, free and true.

It is, I do believe, in this sense that Van Gogh wished to be freed "from I know not what horrible cage" by the alchemy of painting.[9] What I can sustain in my human physical state is to live in a house with unbarred windows, then and thus is life bearable.

All that will inspire hilarity in those, too numerous, who believe that the solution is to be found in balance. Balance is a tour de force that demands constant vigilance to avoid falling at the slightest error. It is a false and horrible solution that keeps men blind for, while they commit themselves, with endless precautions, to carefully weighing the pros and cons of everything, they see nothing and pass alongside true life.

And so it is that a new flood will soon again devastate the human species in search of balance that it will never find because it is not to be found: the destiny of man is his flesh, his life.

It is to be noted in art that whenever times darken there is always an invasion of lines in painting. The difficult years in the life of whatever civilisation, or even yet simply on the scale of collective and individual human life, are immediately scored and obscured by lines in their pictorial art. To return to the subject of balance, it is a worthless position; it is in its element, in one's race, in oneself, and in the dominant that one must seek life and peace: the human dominant is colour, an entire and immense evolution throughout the ages is proof of this and tends toward the discovery of the mystery of colour.

Van Gogh 1885: "Colour, by itself, expresses something that one cannot disregard; one must make use of it: what is beautiful, truly beautiful, is equally true."[10] It is an organic tendency arising from the deepest part of ourselves that today urges us all to rediscover in colour our life.

Drawing in painting is writing around a condition of the soul! This writing explains and describes the absurdities and the superficial and valueless ephemera around the burning heart of being.

Van Gogh to Theo (letter 459): "Painters have their own lives that arise entirely from the soul of the painter. In short, a painter is a man who, consciously or not, tears open his own soul in rooting out, with or without pain, or with joy, for each painting, scraps to transform them through the alchemy of painting (creative genius) into the matter of the ephemeral, perishable, and physical soul."[11]

Like Christ, the painter says mass in painting and gives the body of his soul as nourishment to other men; he realises on a miniature scale the miracle of the Holy Communion in each painting.

John.vi.53: "Truly, truly, I say to you, if you do not eat of the flesh of the Son of man or if you do not drink of his blood, you will have nothing of life in yourselves."[12]

Throughout the entire ballet... possible contribution of great gusts of wind, hot, cold, or temperate—odours.

NOTES

1 Contrary to what Yves Klein affirms, he has not "left the text intact" (see the explanations of Pierre Restany on the different adjustments in *Anthologie du cinéma invisible* (Anthology of invisible cinema), p. 334. The Yves Klein Archives preserves a German version of this text, and several variants. On one among them Klein noted the name and address of the dancer Jean Babilée.

2 Van Gogh, *Lettres de Vincent Van Gogh à son frère Théo* (Vincent Van Gogh's Letters to his Brother Théo), Georges Philippart ed., Paris: Editions Bernard Grasset, 1937, p. 43.

3 The "Warrior hordes" belongs to the art of the Levant, a style of eastern Spain whose monochrome paintings are distinct from franco-cantabric art. Certain of these were published in 1951 by the scholar of prehistory Beltràn, in Valence the head of the service for the research of prehistory, in particular three paintings of women in the cueva Saltadora at Valtorta, entitled "Women merchants" whose form singularly evokes that of the figures of the *Anthropométries*. As Pierre Restany wrote for the formal invitation of the International Gallery of Contemporary Art in March: "The blue gesture is going to trigger Yves Klein run through 40,000 years of modern art to rejoin, as sufficient as necessary, that dawning of our universe, the anonymous trace that at Lascaux or at Altamira, signifies the awakening of man into consciousness of himself and of the world." Restany, *Yves Klein*, Paris: Le Chêne/Hachette, 1982, p. 116. René Huyghe first published "Warrior horde" and "Running figures" in *Dialogue avec le visible* (Dialogue with the visible), Paris: Flammarion, 1955, p. 183. In *L'art et l'homme* (Art and Man) (see René Huyghe, Paris: Larousse, 1957, p. 29), he adds to these illustrations figures of women, entitled "Femmes coiffées de plumes" (Women in plumed headdress). René Huyghe has,

it appears, influenced Yves Klein not only through his books, in the choice of images and citations) but also in his method. One recalls the enthusiasm of Yves Klein in the reading of theses of the latter in the article by Jacques Tournier in 1955. One can note that René Huyghe is also the author, with Daisaku Ikeda, president of Soka Gakkai, of *La nuit appelle l'aurore, dialogue Orient – Occident sur la crise contemporaine* (The night calls forth the aurora, dialogue of East and West on the contemporary crisis), Paris: Flammarion, 1980. In his speech upon admission into the French Academy in 1998, his successor Georges Vedel renders homage to the historian of art but also to the Buddhist.

4 "Of colour, tone, and effect", in Ingres, *Ecrits sur l'art* (Writings on Art), Paris: La Bibliothèque des arts, collection Pergamine, p. 51.

5 Delacroix, Eugene, *Journal 1822 – 1863*, Paris: Plon (1931 – 1932), 1982, p. 844. Delacroix in reality is citing Alphonse Karr.

6 The citation does not correspond to the diary entry indicated.

7 Delacroix, *Journal 1822 – 1863*, p. 850.

8 Van Gogh, *Lettres de Vincent Van Gogh*, p. 183.

9 Van Gogh, *Lettres de Vincent Van Gogh*, p. 43.

10 The citation does not correspond to the entry indicated.

11 Van Gogh, *Lettres de Vincent Van Gogh*, p. 43.

12 Gospel according to St John, chapter vi, 54.

COLOUR, TIME AND STRUCTURE

Hélio Oiticica

21 November 1960
Jornal do brasil, Rio de Janeiro, 26 November 1960

With the sense of colour-time, the transformation of structure became essential. Already, it was no longer possible to use the plane, that old-fashioned element of representation, even when virtualised, because its 'a priori' connotation of a surface to be painted. Structure rotates, then, in space, becoming itself also temporal: 'structure time'. Structure and colour are inseparable here, as are time and space, and the fusion of these four elements, which I consider dimensions of a single phenomenon, come about in the work.

DIMENSIONS: COLOUR, STRUCTURE, SPACE, TIME

It is not an 'interlocking' of these elements which takes place here, but a fusion, which exists already from the first creative moment; fusion, not juxtaposition. 'Fusion' is organic, whereas juxtaposition implies a profoundly analytical dispersal of elements.

COLOUR

To pigment-based colour, material and opaque by itself, I attempt to give the sense of light. The sense of light can be given to every primary colour, and other colours derived from them, as well as to white and to grey; however, for this experience one must give pre-eminence to those colours most open to light: colour-light: white, yellow, orange, red-light.

White is the ideal colour-light, the synthesis-light of all colours. It is the most static, favouring silent, dense metaphysical duration. The meeting of the two different whites occurs in a muffled way, one having more whiteness, and the other, naturally, more opaqueness, tending to greyish tone. Grey is, therefore, little used, because it is already born from this unevenness of luminosity between one white and another. White, however, does not lose its sense in this unevenness and, for this reason, there remains from grey a role in another sense, which I will speak of when I come to this colour. The whites which confront each other are pure, without mixture, hence also their difference from a grey neutrality.

Yellow, contrary to white, is the least synthetic, possessing a strong optical pulsation and tending towards real space, detaching itself from the material structure, and expanding itself. Its tendency is towards the sign, in a deeper sense, and towards the optical signal, in a superficial sense. It is necessary to note that the meaning of the signal does not matter here, since coloured structures function organically, in a fusion of elements, and are a separate organism from the physical world, from the surrounding space-world. The meaning of the signal would be that of a return to he real world, being, thus, a trivial experience, consisting only of the signalising and virtualising of real space. The meaning of the signal, here, is one of internal direction, for the structure and in relation to its elements, the sign being its profound non-optical, temporal expression. Contrary to white, yellow also resembles a more physical light, more closely related to earthly light. The important thing here is the temporal light sense of colour; otherwise it would still be a representation of light.

Orange is a median colour par excellence, not only in relation to yellow and red, but in the spectrum of colours: its spectrum is grey. It possesses its own characteristics which distinguish it from dark-yolk-yellow and red-light. Its possibilities still remain to be explored within this experiment. Red-light distinguishes itself from blood-red, which is darker, and possesses special characteristics within this experiment. It is neither light-red nor sanguineous vibrant-red, but a more purified red, luminous without arriving at orange since it possesses qualities of red. For this very reason, in the spectrum, it is found in the category of dark colours; but pigmentarily it is hot and open to light. It possesses a grave, cavernous sense of dense light.

The other derivative and primary colours: blue, green, violet, purple and grey, can be intensified towards light, but are by nature opaque colours, closed to light, except grey, which is characterised by its neutrality in relation to light. I will not deal with these colours now, since they harbour more complex relations, yet to be explored. Up to now, we have only looked at the relation between colours of the same quality, in the sense of light. The colour-light of various

fig. 1 fig. 2

qualities has not been jointly explored, since this will depend on a slow development of colour and structure.

STRUCTURE

The development of structure occurs to the extent to which colour, transformed into colour-light and having found its own time, reveals structure in its interior, leaving it bare. Since colour is colour-time, it would be consistent for structure to be equivalent, to become 'structure time'. Space is indispensable as a dimension of the work, but, by the fact of already existing in itself, it does not pose a problem; the problem, here, is the inclusion of time in the structural genesis of the work. The secular surface of the plane, upon which a space of representation was built, is shorn of all representational reference by the fact that the colour planes enter from the outside until they meet at a certain line (fig. 1). Thus, the plane is broken virtually, but continues to exist as an 'a priori' support. Afterwards, the rectangle is broken, since the planes which before adjoined one another now begin to slide organically (fig. 2). The wall does not serve here as background, but as extraneous, unlimited space, though necessary to the vision of the work. The work is closed within itself as an organic whole, instead of sliding over the wall, or superimposing itself upon it. Structure is then carried into space, rotating 180 degrees about itself, this being the definitive step towards the meeting of its temporality with that of colour; here the spectator does not see only one side, in static contemplation, but tends towards action going around, completing its orbit, in a pluridimensional perception of the work. From then on, development occurs in the direction of appreciating all positions of vision and the research into the dimensions of the work: colour, structure, space and time.

TIME

Colour and structure having arrived at purity, at the primary creative—state static par excellence—of non-representation, it was necessary for them to become independent possessing their own laws. Then the concept of time emerges as the primordial factor of the work. But time, here, is an active element: duration. In representational painting, the sense of space was contemplative, and that of time, mechanical. Space was of a kind which represented fictional space on the canvas, the canvas worked as a window, a field of representation of real space. Time, then, was simply mechanical: the time interval between one figure and another, or of the relation between the figure and perspectival space; in any case, it was the time of figures in a three-dimensional space, which was made two-dimensional on the canvas. Well, from the moment that the plane of the canvas began to function actively, the sense of time necessarily entered as the principal new factor of non-representation.

There then emerges the concept of the 'non-object'—a term invented and theorised by Ferreira Gullar,[1] a more appropriate term than 'picture'—since the structure is no longer one-sided like a picture, but pluridimensional. In the work of art, however, time takes on a special meaning, different from the meanings which it has in other branches of knowledge; it has close ties with philosophy and the laws of perception, but what characterises time in the work of art is its symbolic signification of man's inner relation to the world, an existential relation.

Faced with the non-object, man no longer meditates through static contemplation, but finds his living time as he becomes involved, in a univocal relationship, with the time of the work. Here he is, even closer to 'pure vitality' than Mondrian envisaged. Man lives the polarities of his own cosmic destiny. He is not only metaphysical, but rather, cosmic, the beginning and the end.

SPACE

As we already saw, the concept of space also changes with the development of painting, and it would be tedious to trace this development here. Let us start here with Mondrian, for whom space was static; not symmetrically static, but static relative to representational space. In opposition to the 'dynamism' of futurism, which was an 'inside the canvas' dynamism, Mondrian's static-dynamic is the immobilisation of

this inside-the-canvas and the virtual dynamisation of its horizontal-vertical structure. Mondrian does not conceive time; his space is still that of representation. The concretists still conceive time as mechanical and in this sense—Ferreira Gullar put it well—they take a step backwards. In their intellectual and analytic conception, space cannot take on a temporal vitality and retains residues of representation. However, it is not my intention to conduct a historical overview of concrete art, but to show the difference between the 'non-object' and a typical 'concrete' work. While the first is dynamic, temporal, the other is static, analytical. To these four elements which I call dimensions: colour, time, structure, and space, I would add one more which, without being a fundamental dimension, is a global expression, born of the unity of the work and of its significance: infinite dimension, not in the sense that the work could dissolve to infinitude, but in the sense of unlimitedness, of 'non-particularity', which exists in the relation between full and empty, different colour levels, spatial direction, temporal duration, etc.. At present, I am pondering on two parallel directions, which are taken in the work and which compliment each other: one, of an architectural kind, and the other of a musical kind, and the relations between them. The architectural sense appears most accentuated in the 'maquettes' and in the 'large paintings'. The musical sense, in the *Equali* or in the *Nuclei*. The first *Equali* is composed of five pieces in space (equal squares), but their relationship is not 'sculptural' because of the fact of being in space; it is more like an architectural relationship. But where this truly manifests itself is in the 'large paintings' and in the 'maquettes'. The predominant relationship in the *Equali* is musical, not because the pieces generate counterpoint or eurythmics, akin to music, or have relations of this kind with it: musicality is not 'lent' to the work, but rather is born from its essence. In reality, it is very close to the essence of music. In the *Grand Nucleus*, the parts are not equal and the relationship is more complex, in fact unforeseen. Since the idea occurs in three-dimensional space, it is tempting to associate it with sculpture, but this association is, upon further analysis, superficial, and can only trivialise the experience. It would be more accurate, though still superficial, to speak of

'painting in space'. In the 'large paintings' and 'maquettes', the architectural relation shows itself as predominant and evident, by virtue of the appearance here of the 'human scale'. The 'large paintings' stand on the floor and are 1.70 metres high, enough to envelop us in their life-experience, and the 'maquettes' are true pieces of architecture, some in a labyrinthine sense, others with rotating panels. What matters, in these 'maquettes', is the 'simultaneity' (musical element) of the colours between themselves, as the spectator goes around and becomes involved in its structure. It is then noticeable that, ever since the first 'non-object' launched into space, a tendency already showed itself towards a 'life-experience of colour', neither totally contemplative, nor totally organic, but cosmic. What matters is not the mathematical or rhythmical relationship of colour, or one measured by physical processes, but colour's value. A pure orange is orange, but if placed in relation to other colours, it will be a light-red or dark-yellow, or another shade of orange; its sense changes according to the structure which contains it, and its value, born of the intuitive dialogue of the artist with the work, in its genesis, varies intimately from work to work. Colour is, therefore, value, as are the other elements of the work; vehicle for 'life-experiences, of all kinds (life-experience, here, in all-encompassing, not vitalist, sense of the work). The genesis of the work of art is to such a degree connected to and experienced by the artist, that it is no longer possible to separate matter from spirit, because, as Merleau Ponty points out, matter and spirit are dialectics of a single phenomenon. The artist's guiding and creative element is intuition; as Klee once said, "in the final analysis the work of art is intuition, and intuition cannot be surpassed".

1 Ferreira Gullar, Brazilian poet, art critic, and author of the *Manifesto Neoconcreto*, 1959.

YVES KLEIN

Donald Judd

1963 *Arts Magazine* review of
Yves Klein exhibition at Alexandre Iolas Gallery,
New York, 5–24 November 1962

Copious publicity and Klein's own shenanigans proclaimed
him the best, the newest of the younger European artists.
It seems to have been true. But although the biggest frog,
he was the biggest in a rather stagnant pond. He was
not as good as several of the best younger American artists;
but he was a good second. Klein died last June at 34.
The sequence of his art, according to Pierre Restany, was:
*la proposition monochrome (conçue dès 1946), l'époque
bleue (1957), l'époque pneumatique (1958), les
Anthropométries (1960), l'Or Frémissant et l'Immatériel
(1960), les Cosmogonies, les peintures et les sculptures de
feu (1961)*. This exhibit has a couple of scorched
canvases, a couple done with nudes in paint, such as
Anthropométrie, a touching imprint of a neat butt, a couple
of pink monochromes and perhaps a dozen blue paintings
of various sizes. The blue paintings are the interesting
ones; the others, despite their flamboyant means, are not
unusual. In three respects Klein's blue paintings are
related to certain American work. They are simple and
broadly scaled, they tend to become objects and,
consequently, they have a new intensity. Barring simplicity,
Bontecou's work, as an example, has these aspects, and
to a greater degree. The quality that is intense is, however,
extremely foreign. Klein's paintings have an unmitigated,
pure but very sensuous beauty. Ingre's *Angélique, Le Bain
Turc* or some of Correggio's paintings occur as parallels.
There is nothing which objectifies or mitigates the pungent
beauty but its difficult strength. A very large painting is
simply a panel of blue paint, which is rolled on so as to
produce a dense texture. The corners of the panel, as in
every painting, are rounded, which accords with the
sensation that the panel is an erotic blue object. Another
blue painting, one of the best, has sponges attached, some
which overhang the edges. The irregular sponges and
format and the encrusted, absorbed blue upon the sponges
are especially voluptuous.

EXTRACTS FROM "SOME ASPECTS OF COLOUR IN GENERAL AND RED AND BLACK IN PARTICULAR"

Donald Judd, 1993

Material, space, and colour are the main aspects of visual art. Everyone knows that there is material that can be picked up and sold, but no one sees space and colour. Two of the main aspects of art are invisible; the basic nature of art is invisible. The integrity of visual art is not seen. The unseen nature and integrity of art, the development of its aspects, the irreducibility of thought, can be replaced by falsifications, and by verbiage about the material, itself in reality unseen. The discussion of science is scientific; the discussion of art is superstitious. There is no history.

...

The discussion of colour is greater than the discussion of space, and unlike the missing particularities of space, it describes to redundancy the particularities of colour. Primarily this has been because with the creation of science in the seventeenth century the study of colour has been part of science. And like astronomy it has been cursed with its own astrology. The discussion of colour has not been leisurely, like that of space. Instead of millennia, the speed has been in generations. There is a history of colour, first in philosophy and then in science. Aristotle said that there was in the category of substance an entity that might have an aspect of the category of quality: material was primary, colour was secondary. He also said, to quote Copleston, that "matter is at once the principle of individuation and unknowable in itself". There is a history of colour in art. Every other generation has a new idea of colour. However, this is a generation without ideas. At the present space and colour have in common complete neglect. Despite the primary importance of colour for more than a hundred years there are now no theories. The last philosophy of colour, which is what it was, as well as being factual, and the mixture may be unavoidable, at least in art, was that of Josef Albers in *The Interaction of Colour* of 1963. In Part I, Albers begins:

> If one says "Red" (the name of a colour) and there are 50 people listening, it can be expected that there will be 50 reds in their minds.
> And one can be sure that all these reds will be very different.

That is a philosophy and it does not agree with what Albers was taught in the Bauhaus.

I knew as a child that certain colours were supposed to produce certain feelings. I didn't understand why a bull should be mad at red. Johannes Itten and Kandinsky taught in their important colour courses at the Bauhaus that colours always produce the same emotions, and also that colours always correspond to certain shapes, the two together agreeing on the emotion. The idea that I like best is Kandinsky's that a pentagon combines a square, which is red, with triangles, which are yellow, to make orange. The idea should be sent to Washington so that the newly painted Pentagon could be the first to use colour in war. The square is death; the triangle is vehemence. The circle is blue and is infinite and peaceful. As with God and patriotism, I didn't take the attributions of colour seriously enough to contemplate. I don't remember such ideas being discussed in the 50s or after. In contrast, the terms 'warm' and 'cool' are still used as description, but also as thermometers of feeling. The more vague an idea, the longer it lasts; in decay it becomes even more vague and lasting.

...

The last real picture of real objects in a real world was painted by Courbet. After that no one was so sure about the real world, so that when it came to keeping a colour or an undescriptive shape at the cost of accurate representation, the latter lost. From Manet onward the concerns of painting itself developed quickly. This is the conventional history of recent painting. Nothing like this happened in sculpture, since being in space there was no conflict, and there was no colour. It was conservative and was not bothered by the problem of how the world is known. The trouble and cost of its making had to have been a factor. The history of the increasing emphasis on the means of painting is very large and detailed. More than the so-called form, or the shapes, colour is the most powerful force. In retrospect, and only so, the expansion of colour is logical until the 1960s, concluding with the painting of Pollock, Newman, Still, and Rothko. The need for colour, the meaning of that need, more than

anything, destroyed the earlier representational painting, whether in Europe or Asia. In the work of all of the well-known painters, colour is amplified beyond anything seen for centuries, even in the work of Munch, whose work is not considered abstract. In the work of most—Matisse, Mondrian, Malevich, Leger, the four just mentioned—colour is the dominant aspect, as black and white photographs show. Colour is an immediate sensation, a phenomenon, and in that leads to the work of Flavin, Bell, and Irwin.

All experience is knowledge: subjective experience is knowledge; objective experience, which is science, is obviously knowledge. Colour is knowledge. As Albers says, it is very subjective, even hard to remember. Colour is also objective. In Part VIII Albers says to paste a red circle and a white circle on a black sheet of paper and then stare at the red circle. Then, look at the white circle: it is green or blue-green, the complementary of red. Allowing for everything human being subjective, this is absolutely objective. Colour as knowledge is very durable. I find it difficult, maybe impossible, to forget. A considerable effort in the painted sheet, aluminum work that I made was to forget the colours and their combinations that I had liked and used in my first paintings, those in turn sometimes derived from Mondrian, Leger, or Matisse, or earlier European painters. Newman of course faced this definition and durability when he painted the three paintings he called *Who's Afraid of Red, Yellow and Blue*. He didn't go so far as to challenge red, yellow, blue, and white. Mondrian's colours are one of the facts and wonders of the world; there aren't seven anymore. Perhaps if the four colours were equal in extent they would no longer belong to Mondrian. The preponderance of white to the bright colours is of course the determining ratio.

...

Itten wrote in 1916: "Form is also colour. Without colour there is no form. Form and colour are one." It never occurred to me to make three-dimensional work without colour. I took Itten's premise, which I had not read, for granted. Sculpture itself was a distant idea to me, that it be only white or grey

was a notion of the academy. This is why so much of this essay is about space. Colour and space occur together. I consider black, grey, and white to be colour, as Leonardo did, despite, as he says, philosophers, and despite Mondrian and van Doesburg. Aside from the scientific view of light as colour and its absence as the absence of colour, which is true of course, it is also true that the whole range from white through the colours to black can be seen in light. Colour as the spectrum and colour as material, so to speak, are not the same. Black can be seen in the light. And also, again, all materials, grey and tan, are coloured.

...

Colour will always be interpreted in a new way, so that I hardly think my use is final, in fact I think it is a beginning. Infinite change may be its constant nature. Colour is opposite to the projection of feeling described to Goethe, Hoelzel and Itten. The idealism of Mondrian is very different. The attitude of Albers is different again. No immediate feeling can be attributed to colour. Nothing can be identified. If it seems otherwise, usually the association is cultural, for example, the light blue and white, supposedly the colours of peace, of the cops and the United Nations. If there were an identifiable feeling to red or to red and black together they would not be usable to me.

Colour is like material. It is one way or another, but it obdurately exists. Its existence as it is is the main fact and not what it might mean, which may be nothing. Or rather, colour does not connect alone to any of the several states of the mind. I mention the word 'epistemology' and stop. Colour, like material, is what art is made from. It alone is not art. Itten confused the components with the whole. Other that the spectrum, there is no pure colour. It always occurs on a surface which has no texture or which has a texture or which is beneath a transparent surface.

ARTIST BIOGRAPHIES

BAS JAN ADER

(1942–1975), Winschoten, The Netherlands

From 1963 until his early death in 1975, Ader lived and worked predominantly in California. The 36 works that make up the artist's entire oeuvre are listed in Paul Andriesse's monograph published in 1988 to coincide with a retrospective exhibition at the Stedelijk Museum in Amsterdam. The artist's estate is administered by Patrick Painter Inc.

Key Exhibitions:

2004	*Bas Jan Ader*, Museo Tamayo Arte Contemporaneo
2000	*Bas Jan Ader*, Bonner Kunstverein, Bonn
1999	*Bas Jan Ader*, The Art Gallery, University of California, Irvine, CA
1988	*Bas Jan Ader*, Stedelijk Museum, Amsterdam
1974	*In search of the Miraculous*, Kabinett für Aktuelle Kunst, Bremerhaven
1963	*Bas Jan Ader*, Robin Metze Gallery, Pasadena, CA
1961	*Bas Jan Ader: Paintings and Drawings*, Realite, Washington DC

Essential Reading:

Crow, Thomas, *Bas Jan Ader: A Bridge Too Far*, Irvine, CA: University of California Press, 1999.

Heiser, Jörg, "Emotional Rescue", *Frieze*, no. 71, November/December 2002.

Roberts, James, "Bas Jan Ader: the artist who fell from grace with the sea", *Frieze*, no. 17, Summer 1994.

Verwoert, Jan See, "Bas Jan Ader: The Conceptuality of the Grand Emotions", *Camera Austria International*, no. 71, June 2000.

JOSEPH BEUYS

(1921–1986), Krefeld, Germany

From 1947 to 1951 Joseph Beuys trained at the Kunstakademie Düsseldorf, studying sculpture. He became a Professor of Monumental Sculpture there in 1961 and continued teaching until 1972 when he was dismissed following numerous controversies concerning his pedagogic style and his refusal to limit the number of students in his class.

Key Exhibitions:

2005	*Joseph Beuys: Actions, Vitrines, Environments*, organised by the Menil Collection, Houston, in collaboration with Tate Modern, London
1997	*Joseph Beuys: Multiples*, Walker Art Center, Minneapolis, MN
1993	*Thinking is Form: The Drawings of Joseph Beuys*, Museum of Modern Art, New York
	Joseph Beuys, Kunsthaus Zurich, Museo Nacional Centro de Arte Reina Sofia, Madrid and The Pompidou Centre, Paris
1979	*Joseph Beuys: Retrospective*, Guggenheim Museum, New York
1974	*I like America and America likes me*, Rene Block Gallery, New York
1972	Beuys debates with the public for 100 days, *Documenta V*, Kassel

Essential Reading:

Adriani, Götz, Winfried Konnertz, et al, *Joseph Beuys: Life and Works*, Patricia Lech, trans., New York: Barron's Educational Series Inc., 1979.

Buchloh, Benjamin H D, "Twilight of the Idol. Preliminary Notes for a Critique", *Artforum*, January 1980.

Cooke, Lynne and Karen Kelly, eds., *Joseph Beuys Arena: Where would I have got if I had been intelligent*, New York: Dia Centre of Arts, 1994.

Kuoni, Carin, ed., *Energy Plan for the Western Man: Joseph Beuys in America*, New York: Four Walls, Eight Windows,1990.

Ray, Gene, ed., *Joseph Beuys: Mapping the Legacy*, Sarasota: The John and Mabel Ringling Museum of Art, 2001.

Seymour, Anne, *Joseph Beuys: Drawings*, London: Victoria and Albert Museum, 1983.

Temkin, Ann, "Joseph Beuys: Life Drawing", *Thinking Is Form: The Drawings of Joseph Beuys*, New York: Museum of Modern Art, 1993.

Thistlewood, David, ed., *Joseph Beuys: Diverging Critiques*, Critical Forum series, vol. 2, Liverpool: Liverpool University Press and Tate Gallery, 1995.

Tisdall, Caroline, *Joseph Beuys*, New York: Guggenheim Museum, 1979.

LOUISE BOURGEOIS

(b. 1911), Paris, France

Louise Bourgeois studied art at various schools in Paris, including the École du Louvre, Académie des Beaux-Arts, Académie Julian, and Atelier Fernand Léger. In 1938 she married the American art historian Robert Goldwater and moved to New York, where she studied with Vaclav Vytlacil at the Art Students League. Since then she has lived and worked in New York, becoming a US citizen in 1951.

Key Exhibitions:

2001	*Louise Bourgeois*, Guggenheim Museum, Bilbao
1998	*Louise Bourgeois*, The Serpentine Gallery, London
1996	*São Paulo Biennale*, São Paulo
1993	Louise Bourgeois represented the United States at the *Venice Biennale*
1992	*Documenta 9*, Kassel
1989	*Louise Bourgeois: A Retrospective Exhibition* (first travelling European retrospective), Frankfurter Kunstverein, Frankfurt, and Stadtische Galerie, Munich
1982	*Louise Bourgeois: A Retrospective*, Museum of Modern Art, New York
1966	*Eccentric Abstraction*, curated by Lucy Lippard, Fishback Gallery, New York
1945	*Louise Bourgeois* (first solo exhibition), Bertha Schaefer Gallery, New York

Essential Reading:

Cooke, Lynne, Alain Cueff, et al, *Louise Bourgeois: Sculptures, environnements, dessins 1938-1995*, Paris: Musée d'art moderne de la ville de Paris, 1995.

Ekman, Joanna, ed., *Louise Bourgeois: The Locus of Memory, works 1982-1993*, New York: The Brooklyn Museum, 1994.

Gorovoy, Jerry and Pandora Tabatabai Asbaghi, ed., *Louise Bourgeois: Blue Days and Pink Days*, Milan: Fondazione Prada, 1997.

Krauss, Rosalind, "Portrait of the Artist as Fillette" in *Louise Bourgeois*, Frankfurt: Frankfurter Kunstverein, 1991.

Morgan, Stuart, *Louise Bourgeois*, London: Serpentine Gallery, 1985.

Morris, Frances and Marina Warner, *Louise Bourgeois (The Unilever Series)*, London: Tate Publishing, 2000.

Storr, Robert, Paulo Herkenhoff, et al, *Louise Bourgeois*, London: Phaidon, 2003.

Wye, Deborah, ed., *Louise Bourgeois*, New York: The Museum of Modern Art, 1982.

JAMES LEE BYARS

(1932-1997), Detroit, Michigan, USA

From 1948 to 1956 James Lee Byars studied art and philosophy at the Wayne State University and the Merill Palmer School of Psychology. Byars travelled to Japan in 1957 where he stayed for ten years, mainly living in Kyoto and teaching English, making numerous trips back to the United States and Europe. The artist's estate is administered by Michael Werner, New York and Cologne.

Key Exhibitions:

2004	*James Lee Byars: Life, Love and Death*, Schirn Kunsthalle, Frankfurt
1994/ 1995	*The Perfect Moment*, IVAM, Valencia
1986	*Venice Biennale*, Venice
1980	*Venice Biennale*, Venice
1982	*Documenta 7*, Kassel
1977	*Documenta 6*, Kassel
1972	*Documenta 5*, Kassel
1971	*The Black Book*, Galerie Michael Werner, Cologne
1970	*The Gold Curb*, The Metropolitan Museum of Art, New York
1962	*The Performable Square*, National Museum of Modern Art, Kyoto
1961	*James Lee Byars* (first solo exhibition) Marion Willard Gallery, New York

Essential Reading:

Byars, James Lee with IVAM Centre del Carme, *The Perfect Moment*, Generalitat Valenciana: Conselleria de Cultura, 1994.

Elliott, James, *The Perfect Thought: Works by James Lee Byars*, Berkeley, CA: University of California, 1990.

Haenlein, Carl, *James Lee Byars—The Epitaph of Con. Art is which Questions have disappeared?*, Hannover: Kestner Gesellschaft, 1999.

Junker, Howard, "James Lee Byars: Performance as Protective Coloration" in *Art in America*, November/December 1978.

McEvilley, Thomas and Kevin Power, *James Lee Byars: The Palace of Perfect*, Porto: Fundacao de Serralves, 1997.

McEvilley, Thomas, "James Lee Byars: More Golden than Gold", *Artforum*, November 1985.

Ottmann, Klauss, *James Lee Byars: Life, Love and Death*, Frankfurt: Schirn Kunsthalle, 2004.

SOPHIE CALLE

(b.1953), Paris, France

After leaving school, Calle travelled the world for seven years, during which she worked as a barmaid, dancer and dog trainer, amongst other things. She returned to Paris in 1979. Calle now lives and works in both Paris and New York.

Key Exhibitions:

2003	*Sophie Calle: m'as-tu vue*, Pompidou Centre, Paris
	The Distance between Me and You, Lisson Gallery, London
1999	*Sophie Calle: Double Game*, Camden Arts Centre, London
1997	*Suite Vénitienne*, White Cube, London
1994	*L'Absence*, Museum Boijmans van Beuningen, Rotterdam
1993	*Blind Colour*, Leo Castelli, New York

Essential Reading:

Baudrillard, Jean and Sophie Calle, *Suite Vénitienne/Please Follow Me*, Seattle: Bay Press, 1988.

Bois, Yves-Alain, Christine Macel, et al, *Sophie Calle: Did you See Me?*, London: Prestel, 2004.

Grigely, Joseph, "Postcards to Sophie Calle from Joseph Grigely", *Parkett*, no. 36, 1993.

Imis, Deborah, *Sophie Calle: A Survey*, Santa Monica, CA: Fred Hoffman Gallery, 1989.

Pincus, Robert, "Sophie Calle: The Prying Eye", *Art in America*, October 1989.

WILLIAM EGGLESTON

(b. 1939), Memphis, Tennessee, USA

William Eggleston was raised in the Mississippi Delta. He studied at Vanderbilt University, Delta State College and the University of Mississippi. He lives and works in Memphis.

Key Exhibitions:

2002	*William Eggleston*, Fondation Cartier pour l'art Contemporain, Paris and Hayward Gallery, London
1999	*William Eggleston and the Color Tradition*, J Paul Getty Museum, Los Angeles, CA
1998	*William Eggleston: 1998 Hasselblad Award Winner*, Hasselblad Center, Gothenburg
1992	*William Eggleston: Ancient and Modern*, Barbican Art Gallery, London
1990	*The Democratic Forest*, Corcoran Gallery, Washington, DC
1984	*Graceland*, Middendorf Gallery, Washington, DC
1976	*William Eggleston's Guide*, Museum of Modern Art, New York

Essential Reading:

Eggleston, William, Ute Eskildsen, et al, *The Hasselblad Award 1998: William Eggleston*, Gothenburg: Hasselblad Center, 1999.

Holborn, Mark, "Colour codes", *Aperture*, no. 96, 1984.

Holborn, Mark, *William Eggleston*, London: Barbican Art Gallery, 1992.

Holborn, Mark, "William Eggleston: Democracy and Chaos", *Artforum*, Summer 1988.

Kozloff, Max, "How to Mystify Color Photography", *Artforum*, November 1976.

Szarkowski, John, *William Eggleston's Guide*, New York: The Museum of Modern Art, 1976.

Welty, Eudora, *The Democratic Forest*, New York: Doubleday, 1989.

SPENCER FINCH

(b.1962), New Haven, Connecticut, USA

Spencer Finch studied at the Doshisha University, Kyoto and at Hamilton College in Clinton, New York. He then went on to study sculpture at the Rhode Island School of Design, Providence, in 1989. Spencer Finch lives and works in New York, where he is represented by Postmasters Gallery.

Key Exhibitions:

2004	*As much of noon as I can take between my finite eyes*, Postmasters Gallery, New York
2003	*Mars Black*, Portikus, Frankfurt
2003	*Paris, Texas*, ArtPace, San Antonio, TX
2002	*From things you can't remember to things you can't forget*, Postmasters, New York
1997	*Spencer Finch*, Matrix Gallery, Wadsworth Athenaeum, Hartford, CT
1992	*Spencer Finch* (first solo exhibition), Tomoko Liguori Gallery, New York

Essential Reading:

LaBelle, Charles, "Eclipse: Spencer Finch", *Frieze*, no. 75, May 2003.

Levin, Kim, *Waterworks: US Akvarell*, Skärhamn: The Nordic Watercolor Museum, 2001.

Godfrey, Mark, "Spencer Finch", *Frieze*, May 2001.

Mehta, Nina, "The Curiously Dissociative Work of Spencer Finch", *Multimedia Visions Magazine*, October 2004.

Saul, Anton, "Color Commentary: The Art of Spencer Finch", *Artforum*, April 2001.

DAN FLAVIN

(1933–1996), New York, USA

Dan Flavin studied art history at the New School for Social Research, and Columbia University, both in New York and exhibited internationally from 1963 onward. He lived and worked for most of the last 20 years of his life in Bridgehampton and Wainscott, Long Island.

Key Exhibitions:

2004	*Dan Flavin: A Retrospective*, National Gallery of Art, Washington, DC
1992	Large scale installation to commemorate the re-opening of the Guggenheim Museum, New York
1969	*Florescent Light etc.*, from Dan Flavin, National Gallery of Canada, Ottowa
1967	*Dan Flavin: Pink and Gold*, Museum of Contemporary Art, Chicago, IL
1964	*Icons*, Kaymar Gallery, New York
1961	*Dan Flavin* (first solo exhibition), Judson Gallery, New York

Essential Reading:

Bell, Tiffany, Michael Govan, et al, *Dan Flavin: The complete lights 1961–1996*, New York: Dia Art Foundation, 2004.

Govan, Michael, *Dan Flavin: A Retrospective*, New York: Dia Art Foundation, 2004.

Feldman, Paula and Karsten Schubert, eds, *It is What it is: Writings on Dan Flavin*, London: Thames and Hudson, 2004.

Flavin, Dan, *Dan Flavin: Drawings, Diagrams and Prints 1972–1975*, Lake George: Fort Worth Museum, 1977.

Flavin, Dan and Fiona Rageb, *Dan Flavin: The Architecture of Light*, New York: Guggenheim Museum, 1999.

Flavin, Dan, *Dan Flavin*, London: Waddington Galleries, 1990.

FELIX GONZALEZ-TORRES
(1957–1996), Guaimaro, Cuba

Felix Gonzalez-Torres was born in Cuba but moved to Puerto Rico in 1970. In 1976 he graduated from Colegio San Jorge after studying art at the Universidad de Puerto Rico, San Juan. He moved to Brooklyn, New York in 1979, and studied photography, gaining a BFA in 1983 from Pratt Institute and an MFA in 1987 from the International Center of Photography, New York University. His estate is administered by the Felix Gonzalez-Torres Foundation in New York.

Key Exhibitions:

2000	*Felix Gonzalez-Torres*, Serpentine Gallery, London
2000	*Le Temps, Vite*, Pompidou Centre, Paris
1997	*Felix Gonzalez-Torres*, The Sprengel Museum, Hannover, Germany
1995	*Felix Gonzalez-Torres Retrospective*, Guggenheim Museum, New York
1990	*Felix Gonzalez-Torres*, Andrea Rosen Gallery, New York

Essential Reading:

Corrin, Lisa, *Felix Gonzalez-Torres*, London: Serpentine Gallery, 2000.

Farrow, Clare, ed., *Symptoms of Interference, Conditions of Possibility: Ad Reinhardt, Joseph Kosuth, Felix Gonzales-Torres*, London: Camden Arts Centre, 1994.

Gonzalez-Torres, Felix, Amanda Cruz, et al, *Felix Gonzalez-Torres*, Los Angeles: Museum of Contemporary Art, 1994.

Gonzalez-Torres, Felix, *Felix Gonzalez-Torres: Catalogue Raisonne*, Ostfildern: Hatje Cantz Verlag, 1997.

Spector, Nancy, *Felix Gonzalez-Torres*, New York: Guggenheim Museum, 1995.

Spector, Nancy, Robert Storr, et al,"Collaborations: Felix Gonzalez-Torres", *Parkett*, no. 39, 1994.

Storr, Robert, "Setting Traps for the Mind and Heart", *Art in America*, January 1996.

MONA HATOUM

(b.1952), Beirut, Lebanon

Born into a Palestinian family in Beirut in 1952, Mona Hatoum originally came to visit England in 1975 but ended up staying in the country when civil war broke out in Lebanon. She studied at the Byam Shaw School of Art in 1979 and the Slade School of Art in 1981. The artist lives and works in London and is represented by White Cube Gallery, London.

Key Exhibitions:

2003	*Mona Hatoum: Here is Elsewhere*, Museum of Modern Art, New York.
2002	*Mona Hatoum*, Centro de Arte de Salamanca, Salamanca, and the Centro Galego de Arte Contemporanea, Galicia
2000	*Domestic Disturbance*, Site Santa Fe and Museum of Contemporary Art, Santa Fe, NM
2000	*The Entire World as a Foreign Land*, Tate Britain, London
1997	*Mona Hatoum*, New Museum of Contemporary Art, New York
1994	*Mona Hatoum*, Pompidou Centre, Paris

Essential Reading:

Archer, Michael, Guy Brett, et al, *Mona Hatoum*, London: Phaidon, 1997.

Garb, Tamar, "Mona Hatoum", *Art Monthly*, May 1998.

Garb, Tamar, Jo Glencross, et al, *Mona Hatoum*, Galicia: Centro de Arte de Salamanca (CASA), 2002.

Said, Edward, *Mona Hatoum: The Entire World as Foreign Land*, London: Tate Gallery, 2000.

DONALD JUDD

(1928–1994), Excelsior Springs, Missouri, USA

Donald Judd studied philosophy and then art history at Columbia University in New York, and worked as an art critic for *ArtNews*, *Arts Magazine*, *Art Digest* and *The New York Times* among others between 1959 and 1965. In 1986 a permanent installation of his work opened at Chinati Foundation, Marfa, TX.

Key Exhibitions:

2004	*Donald Judd*, Tate Gallery, London
1988	*Donald Judd*, travelling retrospective organised by The Whitney Museum of American Art, New York
1982	*Documenta 7*, Kassel
1980	*Venice Biennale*, Venice
1968	*Donald Judd*, The Whitney Museum of American Art, New York
1966	*Donald Judd*, Leo Castelli Gallery, New York
1963	*Donald Judd*, Green Gallery, New York
1957	*Donald Judd* (first solo exhibition), Panoras Gallery, New York

Essential Reading:

Batchelor, David, "A small kind of order", *Artscribe*, no. 78, November/December 1989.

Dietmar, Elger, ed., *Donald Judd Colorist*, Hannover: Sprengel Museum Hannover, 2000.

Judd, Donald, *Complete Writings 1959–1975*, Halifax: The Press of the Nova Scotia College of Art and Design, 1975.

Serota, Nicholas, ed., *Donald Judd*, London: Tate Publishing, 2004.

ANISH KAPOOR

(b.1954), Bombay, India

Anish Kapoor came to the UK in the early 1970s where he studied at the Hornsey College of Art, London, before graduating from the Chelsea School of Art in 1978. Kapoor was awarded the Turner Prize in 1991. He lives and works in London and is represented by the Lisson Gallery, London.

Key Exhibitions:

2002	*Anish Kapoor: The Unilever Series*, Tate Modern, London
1998	*Anish Kapoor*, Hayward Gallery, London
1998	*Anish Kapoor: At the Edge of the World*, CGAC, Centro Galego de Arte Contmporanea and Santiago de Compostela, Galicia
1991	*Anish Kapoor*, Palacio de Velazquez, Centro de Arte Reina Sofia, Madrid
1990	Anish Kapoor represented Britain at the *Venice Biennale*
1984	*An International Survey of Recent Paintings and Sculpture*, Museum of Modern Art, New York

Essential Reading:

Balmond, C, and Donna De Salvo, *Anish Kapoor: Marsyas*, London: Tate Publishing, 2003.

Celant, Germano ed., *Anish Kapoor*, Milan: Charta, 1995.

Dorment, Richard, "Vexed questions of colour", *Daily Telegraph*, 9 December 1989.

Kapoor, Anish, *Anish Kapoor: British Pavilion, XLIV Venice Biennale*, London: British Council, 1990.

Lewison, Jeremy, *Anish Kapoor: Drawings*,
London: Tate Publishing, 1990.

Warner, Marina, "The Perforate Self or Nought is
not Naught", *Parkett*, no. 69, 2003.

YVES KLEIN

(1928–1962), Nice, France

Yves Klein studied at the École National de la
Marine Marchande and the École Nationale
des Langues Orientales. Between 1948 and
1952, he travelled to Italy, Great Britain, Spain,
and Japan. Klein settled permanently in Paris
in 1956.

Key Exhibitions:

2005	*Yves Klein*, Guggenheim Museum, Bilbao
2004	*Yves Klein: A Retrospective*, Schirn Kunsthalle, Frankfurt
2000	*'La vie' la vie elle-même qui est l'art absolu*, Musée d'art moderne et d'art contemporain, Nice, France
1985	*Yves Klein*, Museum of Modern Art, New York
1962	*Antagonismes 2: L'Objet*, Musée des Arts Décoratifs, Paris
1961	*The Anthropometrics*, The Galerie Internationale d'Art Contemporain, Paris
1961	*Yves Klein* (first solo exhibition in the USA), Leo Castelli Gallery, New York

Essential Reading:

Bashkoff, Tracey, ed., *On the Sublime:
Mark Rothko, Yves Klein and James Turrell*,
New York: Guggenheim Foundation, 2001.

Berggruen, Olivier, Max Hollein, et al,
Yves Klein, Frankfurt: Schirn Kunsthalle, 2005.

Bourriaud, Nicolas, Alain Buisine, et al,
Yves Klein: Long Live the Immaterial!, New York:
Delano Greenidge Editions, 2000.

Bozo, Dominique, Dominique de Menil, et al,
Yves Klein: A Retrospective, Houston: Institute for
the Arts, 1982.

Klein, Yves, *Tinguely's Favourites: Yves Klein*,
Basel: Museum Jean Tinguely, 1999.
Noever, Peter and Francois Perrin, eds, *Air
Architecture: Yves Klein*, Ostfildern: Hatje Cantz
Verlag, 2004.

Seymour, Anne, *Beuys, Klein and Rothko:
Transformation and Prophecy*, London: Anthony
d'Offay Gallery, 1987.

Sichère, Marie-Anne and Didier Semin eds.,
*Le depassement de la problématique de l'art et
autres écrits*, Paris: École Nationale Supérieure
des Beaux Arts, 2003

Stich, Sidra, *Yves Klein*, London: Hayward
Gallery, 1995.

BRUCE NAUMAN
(b.1941), Fort Wayne, Indiana, USA

Bruce Nauman studied mathematics, physics, art and music at the University of Wisconson, Madison and gained an MFA at the University of California, Davis. He now lives and works in New Mexico. He is represented by Sperone Westwater in New York.

Key Exhibitions:
2004/ 2005	The Unilever Series: Bruce Nauman Tate Modern, London
1999	Nauman won the Golden Lion Prize at the Venice Biennale, Venice
1994	Bruce Nauman, The Walker Art Center, Minneapolis, MN
1981	Bruce Nauman: 1972–81, Rijksmuseum Kröller-Müller, Otterlo, and the Staatliche Kunsthalle Baden, Baden
1972	Bruce Nauman: Works from 1965–1972, The Whitney Museum of American Art, New York (travelled around the US and Europe)
1968	Documenta, Kassel
1966	Bruce Nauman (first solo exhibition), Nicholas Wilder Gallery, Los Angeles

Essential Reading:
Dercon, Chris, Patrick Frey, et al, "Collaborations: Bruce Nauman", Parkett, no. 10, 1986.

Livingston, Jane and Marcia Tucker, Bruce Nauman: Work from 1965 to 1972, Los Angeles: Los Angeles County Museum of Art, 1972.

Nauman, Bruce, Bruce Nauman, London: Whitechapel Art Gallery, 1986.

Nauman, Bruce, Bruce Nauman: Image/Text, 1966–1996, London: Hayward Gallery, 1998.

Richardson, Brenda, Bruce Nauman: Neons, Baltimore: The Baltimore Museum of Art, 1983.

Simon, Joan, ed., Bruce Nauman, Minneapolis, MN: Walker Art Center, 1994.

HÉLIO OITICICA
(1937–1980), Rio de Janeiro, Brasil

Hélio Oiticica graduated in 1954 from the Escola do Museu do Arte Moderna in Rio de Janeiro under Ivan Serpa. He developed an interest in Constructivism and became a member of the Grupo Frente, and the Neconcretists. His estate is administered by Projeto Hélio Oiticica in Brazil.

Key Exhibitions:
2002	Hélio Oiticica: Quasi-Cinemas, Whitechapel Art Gallery, London
1992	Hélio Oiticica, Witte de With, Centre for Contemporary Art, Rotterdam
1992	Hélio Oiticica, Musee de Jeu de Paume, Paris
1987	Hélio Oiticica, Museu de arte Contemporanea da Universidade de São Paulo
1986	Lygia Clarke Hélio Oiticica, Paco Imperial, Rio de Janeiro
1969	Hélio Oiticica, Whitechapel Art Gallery, London

Essential Reading:
Basualdo, Carlos, Hélio Oiticica: Quasi-Cinemas, Columbus: Köinischer Kunstverein, 2001.

Brett, Guy, and Catherine David, Hélio Oiticica, Rotterdam: Witte de With, Centre for Contemporary Art, 1992.

Doctors, Marcio, Hélio Oiticica, Rio de Janeiro: Museu do Açude, 2000.

Salzstein, Sonia, "Hélio Oiticica: Autonomy and the limits of subjectivity", Third Text, Autumn/Winter 1994.

GERHARD RICHTER

(b. 1932), Dresden, Germany

Richter studied art at the Kunstakademie in Dresden between 1952 and 1957 before moving to Düsseldorf in 1961 where he took up a place at the influential Staatliche Kunstakademie. Richter became a Professor at the Kunstakademie in 1971 and moved to Cologne in 1983 where he still lives.

Key Exhibitions:

2005 *Gerhard Richter—Image after Image*, Louisiana Museum of Modern Art, Humlebaek, Denmark

2005 *Gerhard Richter*, K20 Kunstsammlung Nordrhein-Westfalen, Düsseldorf, and tour.

2004 *Gerhard Richter*, Albertinum Galerie Neuer Meister, Dresden, Germany

2002 *Gerhard Richter: Forty Years of Painting*, Museum of Modern Art, New York

1995 *Atlas*, Dia Center for the Arts, New York

1991 *Gerhard Richter Retrospective*, Tate Gallery, London
Mirrors, Anthony d'Offay Gallery, London

1988 *Gerhard Richter: Paintings* (first North American retrospective), the Art Gallery of Ontario, Toronto, and the Museum of Contemporary Art, Chicago, IL
The London Paintings, Anthony d'Offay Gallery, London

1987 *Documenta 8*, Kassel

1978 *Abstract Painting*, Stedelijk Van Abbemuseum, Eindhoven (a major exhibition, which travelled to the Whitechapel Gallery in 1978)

1977 *Documenta 6*, Kassel

1976 *Gerhard Richter* (first retrospective), Kunsthalle, Bremen

1972 Gerhard Richter represented Germany at the *Venice Biennale*, Venice
Documenta 5, Kassel

1963 *Gerhard Richter* (first solo exhibition), Mobelhaus Berges, Düsseldorf

Essential Reading:

Ascherson, Neal, Stephen Germer, et al, *Gerhard Richter*, London: Tate Gallery, 1991.

Buchloh, Benjamin H D, *Eight Grey*, Berlin: Deutsche Guggenheim Museum, 2002.

Criqui, Jean-Pierre, Dave Hickey, et al, "Collaborations: Gerhard Richter", *Parkett*, no. 35, 1993.

Green, David, "From History Painting to the history of painting and back again: reflections on the work of Gerhard Richter", *History Painting Reassessed: the Representation of History in Contemporary Art*, David Green and Peter Seddon, eds, Manchester: Manchester University Press, 2000.

Nasgaard, Roald, Benjamin H D Buchloh, et al. *Gerhard Richter: Paintings*, Chicago, IL: Museum of Contemporary Art, 1988.

Richter, Gerhard, *The Daily Practice of Painting: Writings 1962–1993*, Hans-Ulrich Obrist, ed., London: Anthony d'Offay Gallery, 1995.

Storr, Robert, *Gerhard Richter: October 18, 1977*, New York: The Museum of Modern Art, 2000.

Storr, Robert, *Gerhard Richter: Forty Years of Painting*, New York: The Museum of Modern Art, 2002.

PIPILOTTI RIST

(b. 1962), Rheintal, Switzerland

Rist studied commercial art, illustration and photography at the Institute of Applied Arts in Vienna, Austria, in 1986 before graduating in Audio Visual Communication from the Basel School of Design in 1988. Between 1988 and 1994, Rist was a member of the music band Les Reines Prochaines. Rist lives and works in Zurich and is represented by Hauser and Wirth, Zurich/London.

Key Exhibitions:

2006 *Pipilotti*, Contemporary Arts Museum Houston, Houston, TX

2005 *Pipilotti Rist*, Hauser and Wirth, London
Pipilotti Rist, Venice Biennale, Venice

2004 *Pipilotti Rist: Stir Heart, Rinse Heart*, San Francisco Museum of Modern Art, San Francisco, CA

2004 *The State of Play*, The Serpentine Gallery, London

2001 *Apricots Along the Street*, Museo Nacional de Arte Reina Sofia, Madrid

2000 *Open My Glade*, Times Square, New York
Pipilotti Rist (first solo exhibition), Luhring Augustine Gallery, New York

Essential Reading:

Phelan, Peggy, Hans Ulrich Obrist et al, *Pipilotti Rist*, London: Phaidon, 2001.

Rist, Pipilotti, *Himalaya (50 Kg)*, Cologne: Oktagon, 1998.

Rist, Pipilotti, *Apricots Along the Street: Pipilotti Rist*, Zurich: Scalo Publishers, 2001.

Rist, Pipilotti, *Remake of the Weekend*, Cologne: Oktagon, 1998.

ANRI SALA

(b. 1974), Tirana, Albania

Anri Sala studied at the National Academy of Arts in Tirana followed by the École Nationale Supérieure des Arts Décoratifs in Paris. In 2000 he graduated from Le Fresnoy, Studio National des Arts Contemporains, Tourcoing, France. Sala is currently based in Berlin and is represented by Galerie Chantal Crousel, Paris and Hauser and Wirth, London and Zurich.

Key Exhibitions:

2005 *Anri Sala: Artist in Focus*, Museum Boijmans Van Beuningen, in cooperation with the 34th International Film Festival, Rotterdam

2004 *Anri Sala: Entre chien et loup*, Musee d'Art Moderne de la Ville de Paris, Paris

2004 *Now I See*, The Art Institute of Chicago, Chicago, IL

2003 *Anri Sala*, Kunsthalle Wien, Vienna

2002 *Anri Sala*, Ikon Gallery, Birmingham

2002 *Missing Landscape and Promises*, Trans-area, New York

1999 *After the Wall*, The Stockholm Modern Museum, Stockholm

Essential Reading:

Gioni, Massimiliano and Michele Robecchi, "Anri Sala: Unfinished Histories. An Interview with Anri Sala", *Flash Art*, no. 219, July–September 2001.

Grammel, Simon, "Finding the words", *Afterall*, issue 5, 2002.

Kremer, Mark, "Getting Lost in the Essence: Anri Sala's Cinematic parables", *Afterall*, issue 5, 2002.

Muka, Edi, "Nocturnes by Anri Sala", *Manifesta 3 Borderline syndrome / Energies of Defence*, Ljubljana: Manifesta, 2000.

Pagé, Suzanne, *Anri Sala: Entre chien et loup*, Paris: Musee d'Art Moderne de la Ville de Paris, 2004.

Verwoert, Jan, "Mother Country", *Frieze*, no. 67, May 2002.

JAMES TURRELL

(b.1943), Los Angeles, California, USA

James Turrell learned to fly aged 16. He studied psychology, mathematics and art history at Pomona College, Claremont, California, concluding his fine art studies at the University of California in 1965. The artist lives and works in Flagstaff, Arizona.

Key Exhibitions:

2004 *James Turrell*, IVAM: Institut Valencia d'Art Modern, Valencia

1998 *James Turrell: Spirit and Light*, Contemporary Arts Museum, Houston

1985 *James Turrell: Retrospective*, Museum of Contemporary Art, Los Angles, CA

1980 *James Turrell: Retrospective*, The Whitney Museum of American Art, New York

1976 *James Turrell*, Stedelijk Museum, Amsterdam

1967 *James Turrell* (first solo exhibition), Pasadena Art Museum, Los Angeles

Essential Reading:

Adcock, Craig, "Light and Space at the Mendota Hotel: The Early Work of James Turrell", *Arts Magazine*, March 1987.

Bright, Richard, *James Turrell Eclipse*, London: Michael Hue-Williams Fine Art/Hatje Cantz, 1999.

Coplans, John, "James Turrell: Projected Light Images", *Artforum*, October 1967.

Didi-Huberman, Georges, *The Fable of Place*, Vienna: MAK, 2001.

Holborn, Mark, *James Turrell: Air Mass*, London: Hayward Gallery, 1993.

ANDY WARHOL

(1928–1987), McKeesport, Pennsylvania, USA

Andy Warhol attended the Carnegie Institute of Technology (now Carnegie Mellon University), where he graduated in pictorial design. He moved to New York in the summer of 1949 and in 1963 set up the legendary multi-disciplinary studio, The Factory.

Key Exhibitions:

2002 *Warhol*, Tate Modern, London
1994 The Andy Warhol Museum opened in Pittsburgh, PA
1989 *Andy Warhol: Retrospective*, Museum of Modern Art, New York
1979 *Shadows*, Heiner Friedrich Gallery, New York
1970 *Andy Warhol: Retrospective*, Pasadena Art Museum, Los Angeles, CA, later travelled around the US and abroad
1969 *Raid the Icebox I with Andy Warhol*, Rice University, Houston, TX
1966 *Silver Clouds*, Leo Castelli Gallery, New York
1965 *Andy Warhol: Flowers*, Ileana Sonnabend Gallery, Paris
1964 *Warhol*, Stable Gallery, New York
1962 *The New Realists*, Sydney Janis Gallery, New York
1962 *Andy Warhol: Campbell's soup cans*, Ferus Gallery, Los Angeles, CA
1952 *Andy Warhol* (first solo exhibition), The Hugo Gallery, New York

Essential Reading:

Becker, Robert, Remo Guidieri, et al, "Collaborations: Andy Warhol", *Parkett*, no. 12, 1987.

Bourdon, David, *Warhol*, New York: Harry N Abrams, 1989.

Crone, Rainer, *Andy Warhol: A Picture Show by the Artist*, New York: Rizzoli, 1987.

Filler, Martin, "Andy Warhol 1928–1987. A collage of appreciations from artists, colleagues, critics and friends", *Art in America*, May 1987.

Francis, Mark, ed., *Andy Warhol: The Late Work*, Düsseldorf: Exhibition Museum Kunstpalast / Prestel, 2004.

Kozloff, Max, "Andy Warhol and Ad Reinhardt: The Greatest Accepter of the Great Demurrer", *Studio 181*, March 1971.

McShine, Kynaston, ed., *Andy Warhol: A Retrospective*, New York: Museum of Modern Art, 1989.

Michelson, Annette, ed., *Andy Warhol, October Files 2*, Cambridge, MA: MIT Press, 2001.

FURTHER READING ON COLOUR

Albers, Josef, *Interaction of Colour*, New Haven:
Yale University Press, 1963.

Batchelor, David, *Chromophobia*, London:
Reaktion Books, 2000.

Berger, John and John Christie,
*I send you this Cadmium Red: A correspondence
between John Berger and John Christie*,
Barcelona: Actar and MALM, 2000.

Birren, Faber, *The Elements of Color,
a treatise on the Color system of Johannes Itten
based on his book the Art of Color*,
Canada: John Wiley and Sons Inc., 1970.

Dennison, Lisa and Nancy Spector,
*Singular Forms (Sometimes Repeated):
Art from 1951 to the present*, New York:
The Guggenheim Museum, 2004.

Fer, Briony, *On Abstract Art*, New Haven:
Yale University Press, 2000.

Finlay, Victoria, *Colour*, London:
Hodder and Stoughton, 2002.

Fioretos, Aris, ed., *Re: The Rainbow*,
Lund: Propexus, 2004.

Fisher, Philip, *Wonder, the Rainbow,
and the Aesthetics of Rare Experiences*,
Cambridge, MA:
Harvard University Press, 1998.

Gage, John, *Colour and Culture:
Practice and Meaning from Antiquity to
Abstraction*, London:
Thames and Hudson, 1995.

Gage, John, *Colour and Meaning: Art,
Science and Symbolism*, London: Thames and
Hudson, 1999.

Gass, William, *On Being Blue: A Philosophical
Inquiry*, Manchester: Carcanet New Press, 1976.

Goethe, Johann Wolfgang von,
Theory of Colours, Charles Lock Eastlake trans.,
Cambridge, MA: MIT Press, 1970.

Jarman, Derek, *Chroma: A book of Colour—
June '93*, London: Vintage, 1994.

Kristeva, Julia, "Giotto's Joy", *Desire in
Language: A Semiotic Approach to Literature and
Art*, Leon S. Roudiez ed. and trans.,
New York: Columbia University Press, 1980.

O'Doherty, Brian, *Inside the White Cube:
The Ideology of the Gallery Space*,
Berkeley: University of California, 1999.

Sacks, Oliver, *The Island of The Colorblind*,
New York: Vintage, 1998.

Steiner, Rudolf, *Colour*, London:
Rudolf Steiner Press, 1971.

Wittgenstein, Ludwig, *Remarks on Colour*,
Berkeley, CA: University of California Press,
1978.

LIST OF ILLUSTRATIONS
AND PICTURE CREDITS

Captions in **bold** refer to works in the exhibition

BAS JAN ADER

Farewell to Faraway Friends, 1971
C-print, 28.2 x 35.5 cm
illus. p. 51

Primary Time, 1974
U-matic tape transferred to DVD, colour, silent
25:47 min
illus. pp. 52–53

Broken Fall (Organic), 1974
Black and white photograph
46 x 63.5 cm
illus. p. 13

Courtesy of Bas Jan Ader Estate and Patrick
Painter Editions.

JOSEPH BEUYS

Felt Action, 1963
Oil (*Braunkreuz*) on paper with felt
65 x 43.8 cm
illus. p. 59

For Brown Environment, 1964
Oil (*Braunkreuz*) on card, 4 parts in 2 frames
Left, overall dimensions: 79.2 x 86.6 cm
Right, overall dimensions: 79.2 x 68.9 cm
illus. pp. 56–57

Houses of the Shaman, 1965
Oil (*Braunkreuz*) and pencil on paper, 2 parts
35.4 x 52.4 cm
illus. p. 17

Schmela, 1966
Oil (*Braunkreuz*) on paper
40 x 56.5 cm
illus. p. 58

Anthony d'Offay, London

Capri-Battery, 1985
Lightbulb with plug socket, lemon, screenprinted
wooden box, offset lithograph on paper
Courtesy of Alfred and Marie Greisinger
Collection, Walker Art Center, T B Walker
Acquisition Fund, 1992
illus. p. 55

© DACS, London 2005, unless otherwise stated.

LOUISE BOURGEOIS

Red Night, 1946–1948
Oil on linen
76.2 x 152.4 cm
Daros Collection, Switzerland
Photo: Zindman Fremont
illus. p. 61

The Red Room (Child), 1994 (detail)
Wood, metal, thread, glass
211 x 348 x 295 cm
Collection Musée d'art contemporain
de Montréal
Photo: Richard-Max Tremblay
illus. pp. 23, 62–63

The Red Room (Parents), 1994 (detail)
Mixed media
247.6 x 426.7 x 424.1 cm
Collection Hauser and Wirth, Switzerland
Photo: Peter Bellamy
illus. pp. 64–65

The Colour Red, 1994
Ink and white out on brown paper envelope
26 x 33 cm
Collection Jerry Gorovoy, New York
Courtesy Cheim & Read, New York
Photo: Christopher Burke
illus. p. 61

Topiary IV, 1999
Steel, fabric, beads and wood
68.5 x 53.3 x 43.1 cm
Collection Jerry Gorovoy, New York
Courtesy Cheim & Read, New York
Photo: Christopher Burke
illus. p. 60

All images © Louise Bourgeois/VAGA, New
York/DACS, London 2005.

JAMES LEE BYARS

The Black German Flag, 1974
Black silk
250 x 470 cm
illus. p. 68

The Rose Table of Perfect, 1989
3,333 red roses, Styrofoam ball
100 cm diameter
Collection IVAM, Instituto Valenciana de
Arte Moderno, Generalitat Valenciana
illus. p. 67

Eros, 1992
Thassos marble, 2 parts
Each: 68 x 170 x 34 cm
Michael Werner Gallery, New York
and Cologne
illus. p. 70

The Red Angel of Marseille, 1993
100 red glass spheres
1100 x 900 x 11 cm
Fonds National d'Art Contemporain, France
illus. p. 71

All images are courtesy of Michael Werner
Gallery, New York and Cologne, © The Estate of
James Lee Byars, unless otherwise stated.

SOPHIE CALLE

The Blind, 1986
Series of 23 sets of photographs and text
approximately 120 x 150 cm each
Collection of Stuart and Judy Spence, LA
illus. pp. 29, 74–75

The Chromatic Diet, 1997
Set of 6 framed colour photographs,
30 x 30 cm each
One framed colour photograph,
49 x 73.5 cm
7 menus in holders
illus. p. 73

Courtesy of Galerie Emmanuel Perrotin ©
ADAGP, Paris and DACS, London 2005.

WILLIAM EGGLESTON

Untitled (Poster in Hallway) Memphis, TN,
1970
Dye-transfer print
40.6 x 50.8 cm
Edition 8/15
Collection Cheim & Read, New York
illus. p. 80

From the Seventies: Volume Two, c. 1970
Portfolio of ten dye-transfer prints
40.6 x 50.8 cm
Edition 1/15
Collection Cheim & Read, New York
illus. p. 81

Untitled (Greenwood, Mississippi), c. 1970
Dye-transfer print
61 x 50.8 cm
Edition 6/15
Collection John Eric Cheim
illus. p. 76

Untitled (Greenwood, Mississippi), 1973
Vintage dye-transfer print
38.7 x 52.7 cm
Edition 11/12
Collection Cheim & Read, New York
illus. p. 77

Wedgewood Blue, 1979
Book of 15 C-prints
27.9 x 33 cm
Edition 10/20
Collection Elizabeth Ford Hohenberg
illus. pp. 14, 78, 79

All images are courtesy of Cheim & Read, New
York, © Eggleston Artistic Trust 2005.

SPENCER FINCH

Ceiling (above Freud's couch, 19 Berggasse,
2/18/94—morning effect), 1995
Fresco on wood panel
112 x 160 cm
Private collection, New York
illus. p. 24

Sky (Over Roswell, New Mexico, 5/5/00,
dusk), 2000
Rhinestones and acrylic on aluminium panel
121.9 x 182.9 cm
Collection of Martha and Sam Peterson,
Connecticut, MA
illus. p. 82

102 Colours From My Dreams, 2000–2002
102 drawings, ink on paper
25.4 x 25.4 cm each
Cartin Collection, US
illus. pp. 84–85

Rainbow (Brooklyn), 2001
Two black and white photographs with text
Each 40.7 x 30.5 cm
Collection Igor D'Acosta, New York
illus. pp. 1, 192

Paris/Texas (France at dusk on January 8, 2003),
2003
Sandblasted stained glass; installation at ArtPace,
San Antonio, Texas; the stained glass filters the
summer light of Texas at midday to recreate the
exact light of Paris
3.65 x 8.53 m
illus. pp. 86–87

Sunset (South Texas, 6/21/03) (detail), 2003
Fluorescent lights, filters
4.8 x 12 m
Private collection, New York
illus. p. 83

All images are courtesy of Postmasters Gallery,
New York, © Spencer Finch.

DAN FLAVIN

the diagonal of May 25, 1963
Red fluorescent light
244 cm
Private collection
Photo: Rury Fischelt
illus. p. 89

untitled (to Mr and Mrs Giuseppe Agrati), 1964
Fluorescent lights (4 fluorescent tubes: pink,
daylight, green and yellow)
244 cm
Private collection
Photo: Rury Fischelt
illus. p. 90

untitled (to Bob and Pat Rohm), 1969
Red, green and yellow fluorescent light
244 cm
Private collection
Photo: Rury Fischelt
illus. p. 91

All images are courtesy of Haunch of Venison,
© Stephen Flavin/ARS, NY and DACS,
London 2005.

FELIX GONZALEZ-TORRES

Untitled (Public Opinion), 1991
Black rod liquorice candy, individually
wrapped in cellophane (endless supply);
Ideal weight: 700 lbs
Dimensions variable
Courtesy of Solomon R Guggenheim Museum,
New York. Purchased with funds contributed
by the Louis and Bessie Adler Foundation,
Inc., and the National Endowment for the Arts
Museum Purchase Program, 1991
Photo: David Heald © The Solomon R
Guggenheim Foundation, New York
illus. p. 93

Untitled (For Stockholm), installation at
Kunstuseum St. Gallen, Switzerland, 1997
15 watt lightbulbs, porcelain light sockets and
extension cords
Dimensions variable
Courtesy of Andrea Rosen Gallery, New York
Photo: Stefan Rohner
© The Felix Gonzalez-Torres Foundation
illus. pp. 94–95

MONA HATOUM

The Light at the End, 1989
Angle iron metal frame and 6 electronic
elements
Frame size 165 x 112.5 cm
Arts Council Collection, Hayward Gallery,
London
illus. p. 97

Socle du Monde, 1992–1993
Wooden structure, steel plates, magnets
and iron fillings
164 x 200 x 200 cm
illus. p. 98

Quarters, 1996
Mild steel
275 x 517 x 517 cm
illus. p. 99

All images are courtesy of Jay Jopling/White
Cube, London, © Mona Hatoum.

JEAN-AUGUSTE-DOMINIQUE INGRES

Le Bain Turc, 1862
Oil on canvas
Collection Musée du Louvre, Paris
© Photo RMN © Gerard Blot
illus. p. 20

DONALD JUDD

Untitled, 1962
Cadmium red light detail and Liquitex and sand
on masonite with copper
122 x 122 cm
Collection of Judd Foundation
illus. p. 102

Untitled, 1962
Light cadmium red oil on liquitex and sand on
masonite with yellow Plexiglass
122 x 243.8 x 7 cm
San Francisco Museum of Modern Art, Bequest
of Phyllis Wattis
illus. p. 15

Untitled, 1968
Stainless steel, plexiglass
Collection Walker Art Center, Minneapolis; Art
Center Acquisition Fund, 1969
illus. pp. 104–105

Untitled, 1972
Copper and light cadmium red enamel on
aluminium
91.6 x 155.5 x 178.2 cm
Courtesy of Tate, presented by the American
Fund for the Tate Gallery, 1993 © Tate, London
2004
illus. p. 103

Untitled, 1991
Stainless steel with red plexiglass
Ten units, each 23.2 x 101.9 x 78.7 cm
Private collection; courtesy of
PaceWildenstein, New York
Photo: Ellen Page Wilson
illus. p. 101

All images are courtesy of Judd Art, © The Judd
Foundation. Licensed by VAGA, New York/
DACS, London 2005, unless otherwise stated.

ANISH KAPOOR

1000 Names, 1979–1980
Wood, gesso and pigment
63.5 x 51 x 30.5 cm
Collection Celine and Heiner Bastian, Berlin
Photo: Prudence Cuming, London
illus. p. 108

Part of the Red, 1981
Bonded earth, resin, pigment
Dimensions variable
Collection of Rijksmuseum Kröller-Müller,
Otterlo, The Netherlands
illus. p. 107

1000 Names, 1982 (no. 30)
Mixed media and pigment
45.2 x 45.2 x 30 cm
Private collection, Paris
Photo: Dave Morgan
illus. p. 109

Untitled, 1989
Gouache on paper
49.8 x 53 cm
Collection Edwin Cohen, New York
Photo: Gareth Winters, London
illus. p. 111

Untitled, 1990
Earth, PVA and gouache on paper
56 x 76 cm
Collection of the artist
Photo: Gareth Winters, London
illus. p. 110

Untitled, 2001
Fibreglass and paint
244 x 365.7 x 127 cm
Private collection, courtesy Barbara
Gladstone Gallery, New York
illus. p. 19

All images are courtesy of Lisson Gallery, London
© the artist, unless otherwise stated.

YVES KLEIN

Yves: Peintures, 1954
Booklet with foreword
10 loose folios with affixed paper sheets in
different colours and dimensions
Each: 24.5 x 19.5 cm
Private collection
illus. pp. 40–41

Blue Monochrome, Untitled (IKB 46), 1955
Pure pigment and synthetic resin on gauze on
wood
66 x 46 x 2 cm
Private collection
illus. p. 114

*Expression of the Universe through the Colour
Orange Lead (M 60)*, 1955
Dry pigment and synthetic resin on paper
95 x 226 x 5 cm
Private collection
illus. p. 116

Red Monochrome, Untitled (M 38), 1955
Pure pigment and synthetic resin on canvas
on wood
50 x 50 cm
Private collection
illus. p. 114

Pink Monochrome, Untitled, (MP 30), 1955
Dry pigment and synthetic resin on canvas
on wood
100.3 x 64.4 x 2 cm
Private collection
illus. p. 117

Green Monochrome, Untitled (M 75),
c. 1955–1956
Dry pigment and synthetic resin on board
59 x 101.5 x 3 cm
Private collection
illus. p. 114

Pink Monochrome, Untitled, (MP 8), 1956
Pure pigment and synthetic resin on gauze on
wood
100 x 25 cm
Private collection
illus. p. 115

Orange Monochrome, Untitled (M 6), 1956
Dry pigment and synthetic resin on canvas on
wood
57 x 37 cm
Private collection
illus. p. 115

Yellow Monochrome, Untitled (M 8), 1957
Dry pigment and synthetic resin on canvas
on wood
65.5 x 50 cm
Private collection
illus. p. 4

Yellow Monochrome, Untitled (M 46), 1957
Dry pigment and synthetic resin on canvas
on wood
100 x 100 x 8cm
Private collection
illus. p. 114

Green Monochrome, Untitled (M 51), c. 1957
Dry pigment and synthetic resin on canvas
on wood
13 x 5 cm
Private collection
illus. p. 37

*The specialisation of sensibility in the state
of primary matter stabilised by pictorial sensibility.
The Void.* Interior view of the exhibition, Galerie
Iris Clert, Paris , April 28–May 5, 1958
illus. p. 43

Red Monochrome, Untitled (M 34), 1959
Dry pigment and synthetic resin on gauze
mounted on panel
77 x 56 x 3.5cm
Private collection
illus. p. 115

Yves Klein's reliefs in the entrance hall of the
Gelsenkirchen Music Theatre, 1959
illus. p. 45

Do-Do-Do, (RE 16), 1960
Dry pigment and synthetic resin, natural sponges
and pebbles on panel
199 x 165 x 18 cm
Private collection
illus. p. 21

*Leap into the Void, 5, rue Gentil-Bernard,
Fontenay-aux-Roses,* October 1960
The title of this work follows
Yves Klein's newspaper, *Dimanche*,
27 novembre 1970: "Un homme dans l'espace!
Le peintre de l'espace se jette dans le vide!"
Gelatin silver print
25.9 x 20 cm
Photo: © Harry Shunk
illus. p. 12

Yves Klein applying blue paint to an
Anthropometry model, Paris, 1960
illus. p. 20

Blue Monochrome, Untitled (IKB 223), 1961
Pure pigment and synthetic resin on gauze on
wood
195 x 140 x 2.5 cm
Private collection
illus. p. 113

Fire fountain and fire wall at the exhibition
Yves Klein: Monochrome and Fire, Museum
Haus Lange, Krefeld, Germany, January 1961
illus. pp.118, 119

BRUCE NAUMAN
*Window or Wall Sign (The True Artist helps the
World by Revealing Mystic Truths)*, 1967
Neon
150 x 140cm
Collection Kröller-Müller Museum, Otterlo, The
Netherlands
illus. p. 122

*My Last Name Exaggerated Fourteen Times
Vertically*, 1967
Pale purple neon tubing
160 x 83.8 x 5 cm
Panza Collection, Lugano
Photo: Giorgio Colombo, Milano 1977
illus. p. 123

Art Make-Up, 1967–1968
16 mm film, colour, silent
10 min
Courtesy of Electronic Arts Intermix (EAI),
New York
illus. pp. 120–121

Raw War, 1970
Red and orange glass tubing, with clear glass
suspension frame, transformer and flashing
mechanism
16.5 x 43.5 x 6 cm
The Baltimore Museum of Art: Gift of Leo Castelli,
New York
illus. p. 125

Green Light Corridor, 1970–1971
Wallboard and green fluorescent light fixtures
Dimensions vary with installation
Courtesy of Solomon R Guggenheim Museum,
New York, Panza Collection 1992
Photo by David Heald © The Solomon R
Guggenheim Foundation, New York
illus. p. 16

*White Anger, Red Danger, Yellow Peril,
Black Death*, 1985
Neon and glass tubing
203 x 220 cm
Marieluise Hessel Collection on permanent
loan to the Center for Curatorial Studies, Bard
College, Annandale-on-Hudson, New York
illus. p. 124

HÉLIO OITICICA

Glass Bolide 3, 1964
Glass, pigment, painted wood
72 x 27.7 x 27.7 cm
illus. p. 127

Box Bolide 9, 1964
Painted wood, painted glass, pigment
50 x 50 x 34 cm
illus. p. 127

Nildo of Manguiera with Parangolé P4 Cape 1,
1964
Tissue, plastic, cotton, nylon mesh and cord
Dimensions variable
illus. p. 129

Glass Bolide 6 "Metamorphosis", 1965
Glass, pigments, painted nylon mesh, plastics
and painted fabric
30.5 x 28.8 x 22.3 cm
illus. p. 128

Basin Bolide 1, 1966
Plastic basin, earth, plastic bag, rubber gloves
15 x 62.8 x 40.2 cm
illus. p. 18

Courtesy of Projeto Hélio Oiticica.

GERHARD RICHTER

1024 Colours (CR 350-3), 1973
Lacquer on canvas
Collection Centre Georges Pompidou, © Photo
CNAC/MNAM Dist. RMN / © Jacques Faujour
illus. pp. 132–133

Betty, 1988
Oil on canvas
102.2 x 72.4 cm
Saint Louis Art Museum, funds given by Mr and
Mrs R Crosby Kemper Jr, through the Crosby
Kemper Foundation, The Arthur and Helen Baer
Charitable Foundation, Mr and Mrs Van-Lear
Black III, Anabeth Calkins and John Weil,
Mr and Mrs Gary Wolff, the Honorable and
Mrs Thomas F Eagleton; Museum Purchase,
Dr and Mrs Harold J Joseph, and Mrs Edward
Mallinckrodt, by exchange.
© Saint Louis Art Museum
illus. p. 28

Mirror Painting (Grey), 1991
Pigment on glass
280 x 165 cm
Anthony d'Offay, London
Photo: Mathias Schorman
illus. p. 131

Eight Grey (installation shot), 2002
Pigment on glass
© Deutsche Guggenheim Berlin
Photo: Mathias Schorman
illus. p. 135

All images are © Gerhard Richter unless
otherwise stated.

PIPILOTTI RIST

I'm Not The Girl Who Misses Much, 1986
Video, colour, 7:46 min
illus. pp. 136–137

*(Entlastungen) Pipilotti's Fehler
((Absolutions) Pipilotti's Mistakes)*, 1988
Video, colour, 11 min
illus. pp. 138–139

Blutclip (Blood Clip), 1993
Video, colour, 2:25 min
illus. pp. 140–141

All images are courtesy of Hauser and Wirth,
Zurich London, © Pipilotti Rist.

ANRI SALA

Làkkat, 2004
Transferred video on DVD, colour, sound
9:44 min
illus. pp. 24, 143

Dammi i Colori (Pass me the Colours), 2003
Transferred video on DVD, colour, sound
15:24 min
illus. pp. 31, 144, 145

All images are courtesy of Galerie Chantal
Crousel, © Anri Sala.

JAMES TURRELL

Night Passage, 1987
Rectangular cut in partition wall, fluorescent and
tungsten lamps and fixtures
Dimensions vary with installation
Solomon R Guggenheim Museum, New York
Panza Collection, Gift, 1991, © The Solomon
R Guggenheim Foundation, New York
illus. cover

Rise, 2002
As installed in the exhibition James Turrell:
Into the Light at the Mattress Factory,
Pittsburgh, PA
Collection Michael and Ali Hue-Williams,
London
Photo: Florian Holzherr
illus. pp. 148, 149

Afrum II, 2002
As installed in the exhibition *James Turrell: Into the Light at the Mattress Factory*, Pittsburgh, PA
Photo: Florian Holzherr
illus. p. 147

All images are courtesy the Mattress Factory, Pittsburgh, PA, © James Turrell, unless otherwise stated.

ANDY WARHOL
Gold Marilyn Monroe, 1962
Synthetic polymer paint, silkscreen, and detail on canvas
211.4 x 144.7 cm
Museum of Modern Art (MoMA), © Photo SCALA, Florence, Museum of Modern Art, New York, 2005
illus. p. 150

Orange Car Crash Fourteen Times, 1963
Synthetic polymer paint and silkscreen on canvas, two panels
268.9 x 416.9 cm
Museum of Modern Art (MoMA) © 2005, Digital Image, The Museum of Modern Art, New York/ Scala, Florence. Gift of Philip Johnson
illus. p. 27

Silver Disaster, 1963
Silkscreen on canvas
107 x 152 cm
illus. p. 151

Five Deaths on Yellow (Yellow Disaster), 1963
Silkscreen on canvas
77 x 77 cm
illus. p. 152

Five Deaths on Turquoise (Turquoise Disaster), 1963
Silkscreen on canvas
77 x 77 cm
illus. pp. 152, 153

Five Deaths on Orange (Orange Disaster), 1963
Silkscreen on canvas
77 x 77 cm
illus. p. 152

Red Race Riot, 1963
Silkscreen on canvas
350 x 210 cm
Museum Ludwig Cologne
Photo: Rheinisches Bildarchiv Cologne
illus. p. 154

Skull, 1976
Synthetic polymer paint and silkscreen ink on canvas, in 6 parts
38.1 x 47.6 cm each
Anthony d'Offay, London
illus. p. 155

Shadows, 1978–1979, installation view at Dia: Beacon, New York
Synthetic polymer paint and silkscreen on canvas
Dimensions variable
Collection: Dia Art Foundation
Photo: Bill Jacobson
illus. p. 11

Courtesy of Sonnabend Collection, New York, © The Andy Warhol Foundation for the Visual Arts, inc. / ARS, NY and DACS, London 2005, unless otherwise stated.

Yves Klein, "The War: A brief personal mythology of monochromy, dating from 1954, adaptable in film or in ballet", originally published in French in Klein's *Dimanche, le journal d'un seul jour*, 27 November 1960, © Yves Klein, ADAGP, Paris and DACS, London, 2005. All rights reserved.

Donald Judd, "In the Galleries: *Arts Magazine*, January 1963–Yves Klein", *Donald Judd Complete Writings: 1959-1975*, Halifax and New York: The Press of the Nova Scotia College of Art and Design and New York University Press, 1975, pp. 69–70, © Judd Foundation 2005.

Donald Judd, Excerpts from "Some Aspects of Colour in General and Red and Black in Particular", 1993, © Judd Foundation 2005.

Hélio Oiticica, "Colour, Time and Structure", 21 November 1960, from *Jornal do Brasil*, 26 November 1960, © Projecto Hélio Oiticica 2005.

COLOPHON

© 2005 Barbican Centre, Corporation of London, the artists and authors. All rights reserved

First published on the occasion of the Barbican Art Gallery's exhibition 'Colour after Klein' 26 May –11 September 2005

The Barbican is owned, funded and managed by the Corporation of London

www.barbican.org.uk

Curator: Jane Alison
Assistant Curator: Alona Pardo
Exhibition Assistant: Clementine Hampshire

Published by:
Black Dog Publishing Limited
Unit 4.4 Tea Building
56 Shoreditch High Street
London E1 6JJ

Tel: +44 (0)20 7613 1922
Fax: +44 (0)20 7613 1944
Email: info@bdp.demon.co.uk
www.bdpworld.com

Produced by Catherine Grant,
Black Dog Publishing Limited

Designed by James Goggin / Practise

Printed on Symbol Freelife Paper in the EU. Black Dog Publishing is committed to responsible environmental practices. This book is printed on environmentally friendly paper.

British Library Cataloguing-in-Publication Data.

A catalogue record for this book is available from the British Library.

ISBN 1 904772 25 0

Front cover: **James Turrell** *Night Passage* 1987
First and last pages: **Spencer Finch** *Rainbow (Brooklyn)* 2001

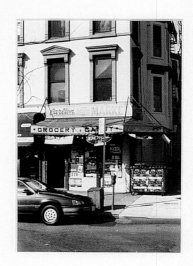

Approximate location
of the right leg of a
rainbow viewed from
the F train at Smith/
9st overpass, Brooklyn
October 24, 1999 3pm